The Life and Art of William Merritt Chase

your children

in art, the students, should
receive as much of your
attention and sympathy
as you can possibly bestow
upon them. They should be
thought of by you as your
own and if you want to
help them to success—lend
a hand.

W. M. Chase

Self Portrait of the Artist painted in his Fifth Avenue Studio
Property of the Art Museum, Richmond, Indiana
The facsimile is from an address given in Washington

THE LIFE AND ART

OF

WILLIAM MERRITT CHASE

BY

KATHARINE METCALF ROOF

WITH LETTERS
PERSONAL REMINISCENCES, AND ILLUSTRATIVE MATERIAL

INTRODUCTION BY
ALICE GERSON CHASE

WITH REPRODUCTIONS OF THE ARTIST'S WORKS

NEW YORK
CHARLES SCRIBNER'S SONS
1917

INTRODUCTION

THE personal reminiscences of my husband which I have been able to offer Miss Roof to add to her material date from the time of his return from Munich. I went with my older sisters to the academy exhibition of 1878, where his picture *Ready for the Ride* was shown, and we were all very anxious to meet the young painter after seeing it. The canvas, it will be remembered, made quite a sensation in art circles. When F. S. Church, already a friend of the family, brought William M. Chase to the house we were all very much excited over the event. But out of all my memories of that early association— and Mr. Chase was a frequent visitor at our house—I can recall very few things that he ever told us of his early life. I suppose there were two reasons for this. In the first place, Mr. Chase had never at any time any tendency to talk about himself. He disliked it extremely and was always embarrassed when he found himself the subject of conversation. The other reason is that my husband was interested in art to such an extent that other things really made very little impression upon him. In his last illness his favorite amusement was

[v]

to review with me the European galleries, asking me to recall what I thought the most interesting thing in each canvas, and living over in his memory the pictures he loved best. His sincere interest and pleasure in teaching was all part of his strong feeling about art.

Miss Katharine Roof was at one time one of his pupils. Mr. Chase always felt that she had the real and right appreciation of art—the principles and feeling of art, not facts about it—and an especially sympathetic understanding of his own work. Above all, she has what he especially valued, the painter's standpoint, which is the exact opposite of the literary attitude, toward art. In his last illness, when the subject of his biography was mentioned, Mr. Chase said more than once that he wished she might write it, and I am glad indeed that his wish, which was also my own, has been fulfilled.

ALICE GERSON CHASE.

₊ * ₊ The author wishes to express her thanks to Mrs. William M. Chase, who has furnished the majority of the illustrations for this book as well as the letters included in the text. She also acknowledges her indebtedness to Mr. Chase's mother, Mrs. David Hester Chase and to his brother, George Chase; to the Misses Gerson, Mrs. Candace Wheeler, Mrs. Rosina Emmett Sherwood, Mrs. Dora Wheeler Keith, Miss Gladys Wiles, Miss Annie Lang, Mr. Frank Duveneck, ᵛ Mr. Frederick Dielman, Mr. Carroll Beckwith, Mr. Alden Wier, Mr. Irving Wiles, Mr. Will H. Low, Mr. Walter Palmer, Mr. Henry Rittenberg, Mr. Walter Pach, Mr. William Henry Shelton, Mr. Siddons Mowbray, Mr. W. J. Baer, Mr. E. G. Kennedy, Mr. James Kelly, Mr. Howard Chandler Christy, Mr. W. S. Macy, Mr. C. P. Townsley, and all others who have assisted her in securing necessary data.

CONTENTS

[ix]

CONTENTS

ILLUSTRATIONS

ILLUSTRATIONS

ILLUSTRATIONS

LETTERS AND SKETCHES BY CHASE AND HIS FRIENDS

CHAPTER I

CHILDHOOD AND BOYHOOD

WILLIAM MERRITT CHASE was born in the little town of Williamsburg, Franklin County, Indiana, on November 1st, 1849. His father, David Hester Chase, was a native of Indiana to which State his father, William Chase's grandfather, had emigrated from Kentucky. His mother, Sarah Swaim, was also born in Indiana. The Chase family lived in Williamsburg until William Chase was about twelve years old.

It would be difficult to imagine an environment more remote from æsthetic suggestion than the small Western town of that period. Art taste in the world at large was at its lowest ebb. Such indications of a turning tide as were working below the surface in the Old World had caused no ripple in America. In these days when every little foreign child of the tenements is taught to draw in our public schools, when the elaborate nurturing systems of education in this country, and especially in the West, coax the most indifferent child into an attempt at art expression, naturally the awakening to the mere existence of beauty is often mistaken by child, parent, and even teacher for a "talent for art," so that, art schools are as numerous as dandelions, and as over-

crowded as the New York Subway. That being the situation to-day, it is almost impossible for us to picture the bareness and limitation of such an environment as that in which the childhood and boyhood of William Chase were passed. His early concepts of art were gained from chromos, the crude, naïve, preposterous chromos that adorned the simple homes of the period, and the illustrations of such books as found their way into his circle, for the most part religious or moral works illustrated by a few woodcuts equally crude in design and reproduction. These the boy used to copy—not in his playtime, but in the hours dedicated to "studying lessons." As far back as he can remember he had the ambition, as he expressed it then, "to make pictures for books." His attempts to draw began very early, but he did not have any painting materials until he was twelve or fourteen, and then only such colored pencils or water-color paints as are given to children for playthings.

His mother tells an anecdote of his early childhood which, while it has nothing to do with his art development, shows that William Merritt Chase even at the tender age of five years could plan how to obtain his desires without doing violence to his conscience.

One morning while out on some errands, she left her

little boy in the yard of a friend's house for a few moments. There was a small tree full of ripe pears within the child's reach, and his mother before she left him forbade him to pick any of the fruit. When she came back she found that her young son had quite literally obeyed her; he had not picked a single pear, but he had eaten several directly from the tree, leaving the cores still attached to the parent stem.

The oldest of seven children, Chase said he was dimly conscious of being unlike his brothers and sisters. He did not, however, isolate himself from them but played all the usual boyish games, not lacking the normal American boy's enthusiasm for baseball. A fellow townswoman still recalls a peculiarly hideous baseball costume he used to wear, which would seem to indicate that his art instinct was not unhealthfully precocious.

In the school that he attended, the teacher had a drawing class after school hours. Drawing lessons at that time meant making copies in pencil from a drawing-book, filled with outline pictures of domestic animals, luxuriant trees, church-spires, and old oaken buckets. In this guileless form of art, Chase's prowess soon far outstripped his teacher's skill. Soon he began to draw from life, people and things. He made profile portraits of the members of his family and his friends.

"He had only to make a few marks and the thing was done," his brother said, recalling his boyish wonder over that mysterious gift.

Chase's schoolmates apparently did not hold the young artist's talent in great regard, but reviewing those days Chase never sentimentalized his lack of recognition. "I am not sure that it is a bad thing to go to a school, as I did, where the boys threw things at me, and asked if there was nothing else I could do," he said once to his class.

His brother George tells an anecdote of the young artist's first attempt at making a portrait. The two boys had gone to visit an uncle living in a neighboring town. William was about twelve years old at the time. His fame as a draftsman had reached the little circle of his uncle's friends, and when it was announced that he would draw his cousin, all the neighbors came in to watch the process. Very much as his large class of pupils used to stand absorbed while Chase "painted for the class," the boy's audience watched and marvelled. The picture, his brother recalls, "looked just like the child," which shows that before he had any instruction William Chase could make a recognizable likeness. Then, as in later years, he worked constantly. "He always left a drawing wherever he went," his brother says.

[4]

At another time the patriotic young artist painted the portraits of all the Presidents of the United States, using the woodcuts in an old history as a basis. He used to refer to this collection with mingled amusement and horror. "Covered the walls of my room with them. . . . Terrible things!" No one could invest that epithet with darker implications. To Chase bad art was the world's profoundest tragedy.

Although his youth was not an unhappy one, all through it the boy evidently had that vague sense of being a misfit that is the sum of a child's awareness of his innate essential differences. He wanted something that his life did not give, and had moods of restlessness and unformulated discontent.

A sensitive boy, he would never ask for a thing twice no matter how much he wanted it; if he had been once refused he could not speak of it again, whereas his more buoyant brother would tease their stern father for the thing he desired until he got it. Indeed, young William Chase was on the verge of running away more than once, only his affection for his mother kept him at home.

One of the grievances that he remembered from that far-away time, was an occasion when his father had promised to take him on a "buggy-ride," to the neighboring town of Franklin. For some reason his brother

George was seized with a violent longing to take that particular drive, and drawing his older brother aside he offered to give him his pony in exchange for the privilege of the trip to Franklin. Young William, able to see at once that the pony would last longer than the pleasure trip, readily agreed to stay home while George went to Franklin with his father. Naturally, when the drive was over, George regretted his impulsive offer and began making efforts to recover the pony. The tale coming to the father's ear, he made William, or Merritt, as he was called in the family, give the pony back to its original owner. Whether the boy felt that his superior foresight entitled him to possession of the pony, or whether he was simply unhappy at having to give it up, its loss and the fact that his brother was not made to live up to his part of the bargain rankled in his memory for long afterward.

When William Chase was twelve years of age, his father moved to Indianapolis. The larger town broadened the boy's horizon somewhat. He gained among other things new ideas of entertainment. The moral code of the Chase family forbade cards, dancing, and the theatre; but in wicked Indianapolis William permitted himself to be led astray. One day a boy called his attention to the fact that a travelling theatrical company playing

WILLIAM MERRITT CHASE, ABOUT 1861.

in the town had advertised its need of warriors for "supers" in a so-called "classic drama." The boy confided his intention of offering his services, as one could then see the play for nothing. Young William decided with some misgivings to accompany his friend. Both boys were engaged, and so fitted out with a helmet too large, a misfit tunic, and an embarrassingly long spear, William Chase made his first and last appearance on any stage. So successful was he, in spite of his agonized fear that some friend would pierce through his heroic disguise and report him to his parents, that he was promoted to a speaking part of one line after a few days. For a time he was held by the lure of the footlights, then the fear of discovery conquered, and he gave up his double life.

When Chase was about fifteen or sixteen his father, who was a shoe-dealer, took him into his shop as a clerk. But the boy spent so much time drawing on the wrapping-paper, and paid so little attention to customers that Chase *père*, a good Methodist, began to regard his erratic and useless son as a visitation of Providence. It was evident that young William Chase did not have his heart in the shoe business. He was likely to slip out of the shop at the most crowded hour to look at the works of art displayed in a neighboring shop-window.

WILLIAM MERRITT CHASE

Before these chromos, story-telling pictures, "Terrible
Things" to the understanding of later years, young
Chase used to stand enraptured; hoping, he said, that
some day he might be able to paint like that, yet fear-
ing that he could never attain to such heights of achieve-
ment. Chase of the hat, the stick, the spats, the white
carnation, Chase the master, standing enthralled be-
fore a chromo in an Indianapolis window! A picture
in whose incongruities pathos and humor are mingled.

As he grew older, with a restlessness born of the fact
that he had not yet found the thing his nature demanded,
the boy decided that he would like to be a sailor, and
begged his father to let him enter the navy. When he
found that he was too old to be entered at Annapolis,
for he was then nineteen, he still clung to the idea of
going to sea. He consulted with another dissatisfied
spirit, a young clerk in his father's store, and they both
decided that if they could not start as middies, they
would begin as sailors, from which humble position their
virtues and talents would soon raise them to the ad-
miralty. "For Merritt always had the idea of being
somebody of importance in the world," his mother
said.

The father, glad to have his son interested in some-
thing more tangible and lucrative than art, gave his

consent, and William and his friend boarded a train for Annapolis. No doubt that desire to be a sailor was but an expression of the imaginative impulse of the boy born inland to whom the unseen ocean stood for mystery, romance, escape—what Lafcadio Hearn calls the mesmerism of the sea—for contact with the actual life soon proved that he had no real liking for it. The two boys were accepted and were placed on the school-ship *Portsmouth* which was then starting on a three months' cruise. But very soon after the ship had left land William Chase found that he had made a sad mistake.

It is an interesting parallel between the lives of two distinguished American painters, that both Chase and Whistler should have started life in the service of their country. In Whistler's case the misfit career was forced upon him, and was continued for a longer period; but Chase's desire to become a naval officer did not long survive the hardships he found himself called upon to endure at the foot of the ladder.

On the ship he was not very popular. One of the petty officers disliked the absent-minded boy and made him perform all the unpopular tasks. The sailors were rather a rough lot and William Chase, an artist to the soul, was thoroughly unhappy among them. He remembered

one day as he sat apart that an officer stopped to speak to him, and asked him how he happened to be there. His only pleasure in those miserable days was watching one of the officers paint pictures of the sea.

When the tale of the boy's suffering had been poured into the parental ear, Chase's father, who was not unkind but only rather bewildered by his inexplicable son, travelled in person to New York to obtain his son's discharge. Indeed so moved was he by William's pathetic story that, despite his puritanical idea of the proportion that should be given to the pleasures of life, he made an event of the emancipation, and not only bought his son a new suit of clothes, but took both boys out to dinner and the theatre—a form of dissipation to which the father had gradually made concessions.

William Chase returned for a time to the uncongenial task of clerk in his father's shop, but the art impulse still persisted and found its way to expression. At the time that he returned from sea his father's new house built on the outskirts of Indianapolis was just finished, and the workmen's materials were still lying about. Up to this time the young artist had never had the opportunity to use oil-paints, but when he found a number of cans of house-paint standing in one of the empty rooms an idea struck him and he took possession of

CHASE AS A SAILOR ON THE "PORTSMOUTH," 1868.

them. With these and the house-painter's brushes he painted a portrait of the captain of the *Portsmouth* on a large piece of sheet iron, also left behind by the workmen. Nearly forty years later Chase, the arrived artist, made unique and original experiments in the use of house-paint, his first medium. But it is doubtful if any success of his maturity, so rich in expression, could compare with the joy of that first adventure in paint.

Delighted with the possibilities of this new medium, William Chase made a second experiment, and painted next a picture of his father's calf. His manner of posing his subject was ingenious to say the least. He had found, also among the house-builder's débris, a board containing a particularly large knot-hole. Through this hole, according to his plan, the calf's head was to be thrust while his brother George, pressed into service, was expected to hold the calf in pose from behind.

George consented, but found his position no sinecure, as the bewildered calf struggled violently in his arms. From time to time he urged the absorbed artist to "hurry," but the young animal-painter's calm reply was, "Just hold him a little longer," as he leaned back and squinted critically at his work. And his brother, feeling somehow compelled to comply, continued to hold

on until the artist laid down his brushes. This picture is still in existence, and is the property of the painter's assistant.

Another day Chase decided to make a plaster cast of his mother, but being inexperienced in the art of cast-making, he found himself unable to remove the hardened plaster which stuck to the patient lady's eye-brows. The frightened younger children stood about while young William chipped away the plaster bit by bit in the work of rescue. It is testimony to the maternal devotion that Mrs. Chase, after this highly unpleasant experience, consented to the operation again. That time the craftsman had learned his lesson, and removed the cast without accident.

In the new house, which was large and commodious, William Chase had a room to himself which he used as a studio, often pressing his brothers and sisters into service as models. The attempt to reproduce what he saw with his pencil had an unceasing fascination for him, and at last, not many months after the Annapolis fiasco, the father consented to take his son to "an artist," and get his opinion about the advisability of having the boy study drawing.

But the artist would have none of William Merritt Chase. Without hesitation he condemned him and

prophesied that the boy could never hope to succeed in his chosen career.

This discouragement while confirming the father's worst fears, had the opposite effect upon the son. He started in with even greater determination, bought his first box of real painting materials, and began to experiment with them. Eventually his father was persuaded to take him to another artist. This man, Benjamin Hayes, a person of a more advanced type, realized at once that the boy had talent and gladly accepted him as a pupil.

Chase made great strides now. One day he sold a picture for ten dollars. That helped to convince his father of the practical value of art. Soon after that the young artist took a room outside for a studio. One day, shortly after he had established himself in his new quarters, a man came in with a black eye which he requested the young artist to paint. This Chase did so successfully, according to his brother, that his afflicted client bestowed five dollars upon him in recognition of his services.

Chase studied for several months with Benjamin Hayes. Needless to state, art as studied at that period was as far from the art-school curriculum of to-day as a chenille mat in a farmhouse parlor is from a fine bit

of Oriental embroidery. What William Chase learned from his Indianapolis teacher could not, of course, have amounted to much as art instruction, but it proved a starting-point, for Hayes did Chase the immeasurable service of convincing his parents that their son should have an art education. Before long he declared that his pupil had learned all that he could teach him, and suggested that the young man should be sent to New York. He gave him a letter to J. O. Eaton, and armed with this introduction and a number of his finished canvases Chase went to New York to study art in earnest.

This was in 1869. At that time William Chase was exactly twenty years old.

CHAPTER II

NEW YORK: ART-STUDENT LIFE IN THE SEVENTIES

THE New York in which the young Western boy found himself was a very different city from the New York of to-day. In the early seventies New York was still an American city. All the region above Twenty-third Street was "up-town," and horse-cars jingled their deliberate way along the uncrowded streets. In the afternoon the aristocratic New Yorker took a discreet ride in a barouche in "The Park." Nurse-maids pushed baby-carriages along the curving paths of the city squares. Union Square was then a residence district. The "brownstone front" represented the acme of elegance. The red-brick houses with white pillared entrances in Washington Square and the neighboring cross-streets were considered old-fashioned. There were no specifically foreign quarters in those days. The population of the Bowery was mainly Irish, although the Germans who began to emigrate to America in large numbers about that time were settling there.

Although it must have seemed a teeming metropolis to the boy from the small Western town, it would look like a sleepy bit of the Old World to us to-day. Art was a negligible term to the New Yorker of the seventies. The

thing he knew by that name was a naïve and lifeless product. A better art, the outgrowth of eighteenth-century English portraiture had preceded it, but at the time William Chase first saw New York in 1869 the darkness of the Victorian age lay upon the face of the waters, and it seemed that they moved not. Some pictures of the Düsseldorf School, the first continental art works to be exported to America, were to be seen in the shops of the dealers; but as a rule landscapes of the Hudson River School adorned the walls of the wealthy New Yorker, together with family portraits, poor copies of Raphael, Guido Reni and Carlo Dolci brought home from Italy, and steel-engravings of American historical subjects. Leutze, a German painter who came to live in America, had something to do with introducing Düsseldorf methods in this country. William Hunt had acquainted Boston with the Barbizon painters, but Boston and New York were far apart in those days, and while many good Bostonians had followed where Hunt had led, it was doubtful if he had succeeded at that time in imparting any real recognition of the lesson of Corot, Millet, Diaz, and Daubigny. George Fuller was one of the few Americans of that generation to work out his own salvation, but non-recognition of his original talent had discouraged him into temporary abandonment of his art.

ART–STUDENT LIFE IN THE SEVENTIES

Broadly speaking, American art was first influenced by the English painters, thence successively by the art of Düsseldorf, Munich, and Paris. Subsequently national characteristics were lost in acceptance of the ideas underlying modern art which have been drawn from various sources. To-day we have schools and movements—a new one almost every week—but it is a question if there is any longer any special nationality in the art of the western world. The chronicler anxious to label and classify, perhaps mistakes such external facts as characteristic costume and landscape—the thing which causes one to know *where* a picture was painted—for a national character in the art itself.

With the return of the so-called "younger painters" to America from Paris and Munich, came the beginning of that invasion of the new ideas which was to revolutionize art, but as the pilgrimage of American students to Munich did not really begin until 1870, it was not until a year or two later that the first men returned to America with the result of their studies.

The Munich influence seems to have somewhat preceded that of Paris, yet neither worked an immediate and complete reform. Throughout the remainder of the nineteenth century the pernicious ideal of prettiness still lingered—that quality which so infuriated

[17]

WILLIAM MERRITT CHASE

Chase and Whistler in the work of the Royal Academi-
cians of the Sir Frederick Leighton type—"the bon-
bon-box sort of thing," Chase with infinite scorn used
to call it. Indeed, survivals of that black-walnut-furni-
ture period in art may still be found from time to time
upon our exhibition walls, despite impressionism, post-
impressionism, and futurism. At the time that Chase
came to New York in 1869, the ideal of academic paint-
ing remained unchallenged despite the example of a
few painters of more spontaneous talent like George
Fuller and Winslow Homer. The individuality of George
Inness' work, like Chase's, did not develop until he
came in contact with Continental art.

Upon reaching New York, Chase made his way at
once to the studio of J. O. Eaton. Eaton was just about
to sail for Europe when the young man arrived. He de-
clined at first to have anything to do with his prospective
pupil, but when he saw the boy's work, he gave him the
key to his studio and told him to go in and use it until
he came back, so young Chase took possession of the
place. He also worked in the classes of the Academy of
Design. For almost two years he studied with Eaton,
the second year taking a studio of his own in the Young
Men's Christian Association building—only two blocks
away from the Fourth Avenue Studio where he worked

PORTRAIT OF CHASE BY HIS MASTER, J. O. EATON,
PAINTED IN NEW YORK IN 1870

the last eight years of his life, and a short distance from the house which was his home for over twenty years.

Eaton painted a portrait of Chase at this time which is now in the possession of Chase's mother. It shows a fine, not to say romantic, looking young man seen in profile without the beard, with which all who knew him in later years associate him. Although well-drawn, it is of its period in the manner of painting, yet J. O. Eaton ranked high in his day. Wyatt Eaton (who was not related to him) was another of his talented pupils, and Mr. W. S. Macy, a fellow student of Chase's both in New York and Munich, recalls interesting gatherings in Eaton's studio where Chase and Bret Harte were guests, also Sarah Jewett, a popular actress who was then leading lady of the Union Square Stock Company. It is probable that Edwin Abbey was also one of the group, for James Kelly, the sculptor, remembers an interesting drawing that Abbey made of Miss Jewett about that time.

Studio life at that period was scarcely in its beginning. The studio with a skylight was practically unknown. The painters and students had rooms if possible with a north light, but frequently without, in which they painted landscapes indoors, portraits or "ideal heads" without a model. A number of them lived in the beau-

tiful old University building on Washington Square, now destroyed, but associated for all time with the name of Samuel Morse. Ivy-covered and lighted by dim lamps in the side streets, it had a strong suggestion of London. Booth's Theatre, at Sixth Avenue and Twenty-third Street, harbored a number of artists, among them George Inness. The Young Men's Christian Association building at East Twenty-third Street, where Chase lived and painted, the second studio building of New York, was then new and full of artists. On the opposite corner of Fourth Avenue and Twenty-third Street was the new building of the Academy of Design, built in the style of the Doges' Palace. This pioneer art institution, which in its early days had known so many vicissitudes, had progressed gradually up-town from its first ante-bellum quarters in Bond Street to its fine new gray-stone building, and was finished and opened to students just about the time that William Chase reached New York.

The Metropolitan Museum of Art was founded that year, and was located in West Fourteenth Street. Cooper Union Art School had been in existence about ten years. The Tenth Street Studio building, the first studio building to be erected in New York, was then about fourteen years old. It must have been a familiar sight to the young student with whose career it was afterward to

be so closely associated. At that time it was the stronghold of the Hudson River School, and yet even then within its walls two men were freeing themselves from the formalism of that Victorian art which is not art at all—Homer Martin and Winslow Homer.

"Art atmosphere" did not exist in New York in the early seventies. That there were touches of innocent Bohemianism we gather from certain chapters in Hopkinson Smith's "Oliver Horn," which deals with artists' life in the sixties and seventies. But judging from the testimony of the older painters who remember that period, life then was as different as possible from that of students and artists to-day. The painter of the Victorian age was a decorous person, professorial rather than artistic, yet not entirely devoid of characteristic touches. Will Low remembers that "they wore soft hats," and recalls the long locks of Beard, the animal-painter, which hung to his shoulders. There seems reason to believe that they wore velvet coats.

Models were almost unattainable in those days. The undraped model, the model for the figure, did not exist as such, although certain pictures and pieces of sculpture done at that period proved that such models were in some way obtainable. Usually the janitor of the building, or one of the children of the laundress, was pressed

into service if a model was desired for what was called the "life class," which corresponded to what is now the portrait or illustration class.

A Philadelphia friend writing to Samuel Morse in 1813, when he was studying with Washington Allston and Benjamin West in London, remarks: "Our Academy of Fine Arts has begun the all-important study of *the live figure*. Mr. Sully, Mr. Peale, Mr. Fairman, Mr. King, and several others have devoted much attention to this branch of the school, and I hope to see it in their hands highly useful and improving." Nevertheless, the regular professional model did not become an established fact until a number of years afterward.

In 1871 Chase exhibited his first pictures, a portrait and a still-life of Catawba grapes and blue plums. Rosina Emmett Sherwood, who was one of Chase's first pupils at the Tenth Street Studio, recalls that Chase in describing his artistic efforts of those days, said that every grape was highly polished and showed the reflections of surrounding objects. The difference between that still-life of 1871 and, say, *The Belgian Melon*, of Chase's later years, would constitute a whole history of the development of modern art.

Although Chase had not yet been able to formulate or even vision the thing he was to create, all the while

there was a spark growing in the boy's soul that reached out for something beyond, something better than the dry and dead art that surrounded him. That devotion and that outreach toward an ever more complete expression that he carried to the end, was stirring within him even in those days of Prussian blue and the camel's-hair brush.

The pictures sold by popular American painters at that time were mostly landscapes, and the works of Wyant, Bierstadt, and other favorites of the period brought prices that seem excellent even at this day. Co-operation between the dealer and the native artist scarcely existed then. The American painter disposed of his works principally at the annual exhibitions. Less frequently he sold them to the patron who went to his studio.

There seems to have been little in the way of incident to leave an impression on Chase's mind during these years in New York. Although it was his first contact with the world to which he belonged, he seemed to remember that period of his life as a time of opportunity and hard work, opportunity achieved after long waiting and heartache, and appreciated to the full measure of its value.

It was characteristic of Chase that out of his own

hard experience came not severity and intolerance, but sympathy. He wanted things made easy for the art student, not as they had been for him. It distressed him to hear of struggles and obstacles. If he had had his way the road to achievement would have been level and smiling. He used often to refer to Sargent's career (which had not been obstructed by poverty or lack of parental understanding), not with envy, but with pleasure in the thought that the beautiful thing did sometimes happen.

Chase did not make himself felt in New York in 1871. He was only a boy of twenty-two, and his painting did not differ from that of the men about him. If it had he would probably have been snubbed into oblivion as George Fuller was. The hour had not yet struck.

After about two years in New York, he returned to the West. His family had in the meantime moved to St. Louis.

Just how deeply the sensitive boy had felt the contempt in which his father held his gift may be imagined. He knew that the art he revered and aspired to was a great and beautiful thing; he knew that it was true, and equally he realized that his father did not know it. When he went home after his years of study in the East, he said that the evening of his arrival his father asked

PHOTOGRAPH OF CHASE TAKEN IN ST. LOUIS ABOUT 1872.

him to walk down-town with him, thus recognizing him on equal terms as a grown-up man. As they walked along the street his father hailed a friend: "Judge Brown, I want you to meet my son the artist." My son the artist! Chase never forgot the thrill he felt at those words; pride he called it, but assuredly it was also something far deeper and finer, the son's joy in his father's recognition of the art he lived to serve and express.

In St. Louis Chase shared the studio of James William Pattison. It was there that he saw the canvases of one John Mulvaney, who had studied in Munich. Whether extraordinary or not, they had something that the art he had previously known did not have, and with that perception he saw a new light. An idea took possession of him—the pilgrimage to Europe, a dim, imperfect vision of the wonders of the Old World that awaited him.

Chase remained about a year in St. Louis painting pictures, of which he sold a number. The subjects he painted at that time were mostly flower and fruit studies, and still life as it was then understood. Before long he attracted the attention of some generous men of means, who raised a sufficient sum of money among them to send the boy to Europe to study. These men were Samuel Dodd, S. A. Cole, Charles Parsons, and W. R. Hodges. In return the young man was to paint a picture for each

patron at the conclusion of his period of study, a condition of course gladly carried out.

Although the majority of men studying in Europe at that period were in Paris, Chase, like Frederick Dielman, Walter Shirlaw, Frank Duveneck, and John Twachtman, elected to study in Munich. Doubtless in the Western cities, containing as they then did many Germans and the children of German emigrants, Munich seemed nearer than Paris. In any case, destiny carried Chase to the Bavarian city, and there his real art life may be said to have begun.

CHAPTER III

AN AMERICAN STUDENT IN MUNICH

CHASE reached Munich at the time when new ideas were germinating. He entered the Munich Royal Academy and was also a student in the studio of Karl von Piloty, a painter of vast canvases, historical in subject, who was then believed to be a great master. But, although he studied with Piloty and Kaulbach, it was William Leibl, who represented in Munich what Couture did in Paris, who influenced Chase and the other impressionable young students in the seventies.

That, as has been said, was at the beginning of the migration of American art students to Germany. American portrait-painters had gone to Europe to study from the days of Sir Joshua Reynolds and Benjamin West, but to England, not to the Continent. Before the Civil War, Italy was the Mecca of sculptors and artists. Romantic creations in marble as well as copies of Madonnas and Magdalens were brought home in those days, and accorded a respect which real art fails to inspire to-day. These naïve importations survived for many years in decorous New York drawing-rooms. It is said that much of this "statuary," as it was then called, was subsequently presented to the Metropolitan Art Mu-

seum, where it still stands in the twilight of its cellars.

Doctor Charles Miller, a National Academician who had gone to Munich in 1867, was practically the first American painter to go to Munich. He returned to America in 1870, the year that Frank Duveneck arrived at the Bavarian city. C. S. Reinhart, a Pennsylvania painter and illustrator, went there about the same time.

After the Franco-Prussian War a number of American art students went to Paris and Munich, but the Munich influence seems to have been felt in American art a little before the French school made its impression.

There were about forty American students in Munich at the time Chase went there, but soon the number was increased to seventy. Frederick Dielman and William Chase registered at the Royal Academy the same day. The academy was a building that had been an old monastery, divided off into stalls for the students. Duveneck, who was in Munich when Chase arrived, but who went away for a time shortly afterward, recalls the swiftness. of the young man's progress, for when Chase entered the art school he went into the antique class like any beginner, but when Duveneck returned a few months later the young American student had become a celeb-

rity. Indeed, Chase and Currier were then considered the most talented of the Munich students.

Walter Shirlaw, Chase's roommate, was another American student whose gifts had received recognition. Duveneck had already made his mark. His criticism was of great value to Chase as it was later to Twacht-man. Julius Rolshoven recalls that Duveneck, Shirlaw, and Chase were nicknamed "the Father, Son, and Holy Ghost" by the other students.

In Chase's portrait heads of that period it is interest-ing to trace the Leibl influence. The strong, full technic, the characteristic drag of the paint, with here and there the light skill, the grace, that revealed the touch of Chase.

Eventually that influence ceased to be apparent in his work as Chase's own individual manner became definitely formulated but he retained his admiration for Leibl to the end of his career.

So much in those days was the young artist possessed by his appreciation of the beauty of the sketch, of the power of the unfinished thing to suggest what the finished work so often lacks, that his fellow students used to be afraid that he would never finish anything. At other times, overwhelmed with the delicious quality of these loose free sketches, they would beg him not to add an-

other stroke to his canvas lest it lose its freshness and magic.

Among the most interesting records of that period are the canvases painted "from" the old masters. By this method the student would first study the picture in the gallery, then with a photograph for reference paint his memory of the picture in his own studio, a much freer and more valuable aid to his art education than the literal copying of a canvas in the museum.

Chase and Walter Shirlaw lived together in rooms on the *Promenade Platz* opposite the spot where the *Bayerischer Hof* now stands. Munich was a small city then, still retaining its ancient walls, of which now only the gates remain.

Munich was Chase's first experience of real student life, the first actual contact with art atmosphere that he had ever known. It is small wonder that he remembered those days with so much sentiment and affection. Student life in München, although not lacking in the delightful absurdities characteristic of student life everywhere, seems to have been soberer than that of Paris. "The best place to study is anywhere," Chase used to remark afterward when his advice was asked. "I went to Munich instead of Paris because I could saw wood in Munich, instead of frittering in the Latin merry-go-

round." But that point of view doubtless represents the result of after-reflection rather than a deliberate choice at the time, since all of Europe, its art and life, was then an unknown quantity to the young American student.

Those were the romantic days of King Ludwig in Bavaria, the golden age when Wagner created a titanic new world in music. Chase often saw the dark, picturesque King drive past, his horses at a mad gallop. But opera, cheap as it was at that time, was a little beyond the means of the poor art student. Moreover, Chase's interest in music, though genuine, was not profound, so that that phase of German life which is concerned with the history of modern music, the figures of King Ludwig, Richard and Cosima Wagner, and the first Wagnerian opera-singers, made little impression upon him, although he often saw those beings who have now, even while one of their number still survives, become almost a legend.

The students' tickets entitled their possessor to admission to the theatres, however, and this diversion Chase greatly enjoyed, spending many evenings at the Volkstheater. Incidentally, these bits of pasteboard insured a certain immunity from arrest, although the officers would take the student's ticket number and utter official words of warning when the record of punishable

pranks had become too long. But Chase's interest in those days, as always, was centred with great singleness of purpose upon his art. He lived the usual life of a serious student, who is yet a normal human being, enjoying the theatres and cafés, and association with the new type of femininity affiliated with student life in Europe; but from his essential purpose he never permitted himself to be in any way deflected. He never, Duveneck says, indulged in student nonsense as much as the other boys. From the beginning his time and thought were concentrated upon his work.

The Max Emmanuel Café was the one most frequented by the students. The conduct of such places was as simple in those days as that of the humblest and most remote *Gasthaus* in Bavaria to-day. The men procured their own beer, pretzels, and radishes, a few cents covering the cost of an entire evening's entertainment. In these low, dark, panelled old rooms, so vivid a contrast to the Western American architecture of the seventies, the students sat about until all hours drinking beer, telling stories, and discussing the living subject of art.

The stories Chase told of those days were of all sorts, from the tale of the exhilarated student from Boston, a roommate of his, who, in a spirit of alcoholic fantasy, stole a Christmas tree from the sidewalk of the

Platz on Christmas eve, thus embroiling himself and his roommates in a farcical encounter with the German law on Christmas morning, to his rapt memories of the first revelation of the art of the old masters. Chase tells of going to the old Pinakotek to study the pictures and running home like a child to put in practice the lesson learned while it was still fresh in his mind. The story is descriptive of a phase in the development of the ambitious student eager to learn the lesson of the old art. It was also peculiarly characteristic of Chase's special type which, although individual, was perhaps more derivative than inventive.

The students went to balls of all sorts, varying from an informal students' carouse to the stately pageant of the annual artists' ball, where all the guests wore period costumes. These occasions ended only with daylight, excursions into the suburbs after the close of the ball being a frequent occurrence.

There were absurd memories too that Chase enjoyed recalling, such as the trick played on the German student who always told his friends how they looked. They were ill or well, fat or thin, old or young. Finally, the other students decided to break their companion of this habit. That day every youth greeted the croaker with consternation and a shake of the head: "My poor

[33]

friend, how ill you look—you should be in bed—you should see a doctor," etc., etc. When he had heard these lugubrious suggestions from a dozen different classmates, Chase said, the susceptible German youth succumbed to suggestion, and went home to bed with all the sensations of one dangerously ill, and summoned a doctor.

Von Habermann, now one of the strong painters of Germany, was one of Chase's fellow students in Munich. Chase painted a brilliant and striking portrait of him which has been often exhibited. He had a great admiration for the ceremonious and courtly young baron. Accustomed as the Indiana boy had been to the simplest forms of our less formal democracy, the graceful habit of speech and manner of the aristocratic Bavarian impressed him deeply, and he frankly set himself to imitation. There was in Chase's type a natural taste for the amenities. When he came back to New York after his long contact with continental manners, he felt deeply annoyed with the lack of courtesy of the man in the street. One day, standing before the window of an art shop in Union Square, a very large and unpolished person trod heavily upon his foot. Chase turned upon him in exasperation: "Do you realize, sir, that you have almost crushed my foot? In such circumstances the least

you can do is to apologize." The man looked at him in surprise. "Well, if you are not a damned fool, you must know that I didn't do it on purpose," was his rational if ungraceful reply. Chase's wrath faded at once. "And, of course, he was right," he said.

Mr. Henry Rittenberg, a pupil of Chase's who met him by chance in Munich, on Chase's only other visit there in 1903, recalls an anecdote his master told of a still-life he painted in his student days when his classmates gathered about to advise him. Always susceptible to a certain extent to influences, a quality that was part of his broadness of mind on the subject of art, Chase says he inclined his ear to advice from all directions. "That piece of brass isn't right; why don't you take it out?" "I don't like that apple." "That piece of copper spoils your composition." Acting with great docility upon all the advice he received, Chase said that presently he found his canvas quite empty and ready for a fresh start.

Chase used to tell another story of a favorite practical joke of those days with Prussian blue which was practised upon the crusty *Hausmeister* of the studio building who complained of the students and thus won their enmity. Any one who has ever met this peculiarly virulent pigment knows that its potency is such that a

single tube will practically last a lifetime, and its pervasive power is so great that a fragment let loose upon the world will penetrate in all directions for an indefinite period. In this case the students filled the *Hausmeister's* keyhole with Prussian blue. The unsuspecting victim having used the key in the dark, replaced it in his pocket without suspicion. His life thereafter for many days was poisoned by Prussian blue and his opinion of the American students was less flattering than ever.

A student of Chase's recalls his using this same means of retaliation upon one of those tormenting street urchins that crowd upon the painter's painting arm, breathe in his ear, and stumble into his paint-box in continental countries. When he had endured his annoyer as long as he could, Chase with a pleasant smile gave the child a tube of Prussian blue to play with, and, kind father though he was, watched his victim running off with his prize with chuckles of satisfaction. As the painters of to-day practically never use this color, it is to be feared that its presence in their paint-box is for purposes other than those of art.

Once a number of American students were expelled for smoking in the studio. Chase, Dielman, and a Boston student with a haughty manner—the same one, indeed, who stole the Christmas tree—went armed with an ex-

cellent cigar to Kaulbach, the head of the academy, to ask him to reconsider his decision. According to Chase and Dielman, the excellence of the cigar and the indomitable manner of the Bostonian accomplished a reversal of the edict.

Chase almost immediately attracted the attention of his master. Piloty, although of the old grandiloquent school, was evidently one who left his students open to influences. Discussions concerning the old and new ideas of art were rife in those days. Chase recalled one that had an amusing result. He had been insisting that the exact reproduction of nature had nothing in common with art. (I remember well the harassed frown with which he used to say to his students: "You have all heard of the picture of the fruit which was so natural that the birds flew down to peck at it? I do not need to see that canvas to know that it was a Terrible Thing!") Talking, no doubt, along some such line as this, another student challenged Chase with the remark that whether art or not, such painting represented skill of a sort, and that Chase himself was doubtless unable to paint an object so that it would deceive any one. As a result of this friendly contention the student agreed that if Chase *could* perform the feat, he would give all the students a dinner. Chase accepted the challenge.

WILLIAM MERRITT CHASE

The next day when Professor Raab arrived to criticise his pupils, he turned, upon entering to hang his hat on its usual peg on the wall. The hat before the eyes of the waiting class fell to the ground. The professor picked it up and tried again, thinking he had missed the nail; but again his hat fell to the floor. When the same thing had happened a third time, the old German looked intently at the wall, then without a change of expression laid his hat upon a chair, and began his criticism. After his departure the class gathered to examine the highly successful imitation of a nail painted upon the wall by William Chase in place of the real peg of which he had painstakingly removed all traces. That night the students enjoyed an excellent dinner at their favorite *Kneipe*.

It was the custom of the Royal Academy of Munich to give out each year a subject for the prize competition. During Chase's last year the subject given was some incident from the life of Christopher Columbus. Most of the students submitted conventional compositions. Chase, who loathed the idea of the historical subject, put off the evil day until the time was almost up. He set to work then in the presence of a number of his fellow students and painted his sketch with the figure of Columbus placed with his back to the spectator,

CHASE'S ORIGINAL SKETCH MADE FOR THE COLUMBUS COMPETITION AT THE
MUNICH ROYAL ACADEMY.

THE SECOND COLUMBUS SKETCH MADE AFTER PILOTY'S CRITICISM OF THE
UNCONVENTIONAL COMPOSITION.

which was the young painter's way of showing his contempt for the academic. Despite this highly irregular treatment of his theme, Chase was awarded the prize by the jury, but old Piloty was furious when he discovered it. How dared he, Herr Chase, thus represent the distinguished adventurer with his back to the public! He first raved, then implored his gifted pupil to make a more dignified presentment. At last, Chase, most concessive of human beings, promised to change his composition, and turn the figure of Columbus so that it was in profile. Both of these pictures, as well as the original ink-sketch, are the property of Mrs. Chase, and are most interesting in their suggestion of a certain touch and use of color that we have come to associate with the mature Chase.

But the result of his amiability dismayed Chase. Piloty, filled with enthusiasm, decided that the talented young painter must treat his subject upon a canvas thirty feet long. "And I myself will use my influence to have it placed in the Capitol at Washington!" Piloty declared. Chase was filled with consternation. His ready wit came to his rescue, however.

"Alas, Herr Director," he faltered, "I am too poor to buy a thirty-foot canvas." But Piloty was generous. "That makes nothing," he declared. "I will provide

you with the canvas and, yes, with the studio as well!"

So the overwhelmed Chase found himself in possession of paints, canvas, and a studio, and no excuse for not painting the loathed historical picture. He made a feint of beginning, then went to his master with a new excuse.

"It is not right, Herr Director," he said, "that I should enter upon a work so great without proper preparation. Surely, before completing this important picture, I should first go to Spain, so that I may be familiar with the types I am to represent."

So at last Piloty, outwitted, yielded. The picture was never painted. But before Chase left Munich Piloty showed his appreciation of his revolutionary pupil's talent by commissioning him to paint his five children, an appreciation which, despite the different manner and method of the older painter, was still a valuable and valued tribute. These pictures after Piloty's death became each the property of the child painted. One, that of a son who has since died, now hangs in the Piloty house in Munich.

Chase had a studio of his own in Munich, and it was in this studio that he and Duveneck painted at the same time *The Turkish Page*, and also his portrait of

ONE OF THE PILOTY CHILDREN.
Painted in Munich about 1877.

Duveneck called *The Smoker*, done in 1875. Even in those days Chase had begun collecting beautiful art objects and furniture. It was through one of his purchases that this fine portrait of Duveneck, which was afterward unfortunately destroyed by fire, was painted. Chase had bought an old chair that had fascinated him. He exhibited it upon its arrival to Duveneck with his enthusiasm. "Just look at it, man! Isn't it a wonderful thing, a beautiful thing?" And feeling that he must paint it at once, he commanded his friend: "Here, sit down there a minute, I want to see how it looks." Duveneck sat carelessly on the arm of the chair, his long pipe in his hand. Liking the way it looked, Chase set to work at once to paint it. "The chair, of course," Duveneck explained; "I was of no importance, merely an accessory." So that is how the portrait, which received honorable mention at the Salon in 1881 and in Munich in 1883, came to be painted.

It was in 1875 also that Chase painted *The Jester*, which was exhibited at the Philadelphia Centennial in 1876. He used to tell a tale of the model for this study, who was fond of imbibing anything of an alcoholic nature that happened to be available. One day while the painter was out of the room the model consumed a considerable quantity of hair-tonic which Chase had put in

a whiskey-bottle, with the result that the next day the jester was not present at the studio.

The Dowager, exhibited at the Memorial Exhibition at the Metropolitan Museum in February, 1917, and also at the exhibition of the National Arts Club in 1910, was painted a year earlier, in 1874. The splendid head of Von Habermann already referred to was painted in 1875 and about the same time *The Old Cavalier*, *The Apprentice Boy*, and *The Broken Jug*. This last was exhibited at the National Academy in 1877. *The Boy Feeding a Cockatoo*, painted about that time, was done from the same model as *The Turkish Page*. *Ready for the Ride*, painted in 1877, was exhibited at the National Academy in 1878. This picture, now the property of the Union League Club, was one of Chase's first experiments in painting the face in full light.

The Munich artists painted out-of-doors to some extent, but most landscapes, in the traditional way of the period, were painted in the studio from notes made in their sketch-books. The Frenchmen were the first to paint in the open as students do to-day; therefore, the landscapes of Chase, Currier, and others in that Munich period were often done indoors. Even the interesting Venetian pictures painted by Chase and Twachtman in 1878 have the darkness and tone of the interior sub-

ject, for the painter of that school did not see light or atmosphere. A morning landscape was as dark as a night subject. Gradually emancipating himself from the extreme of this influence, but retaining its lesson of tone quality and brush technic, Chase continued to paint in a manner very definitely adapted from the old masters, whose art had illumined his mind through his study of the Munich galleries. At that time he was most enthusiastic about Van Dyck, who was well represented in the old Pinakotek, and that admiration is apparent in many of his portrait heads of that period.

The art that bore the stamp of the painter's own individuality came later, as under the various influences that played upon him, he evolved the distinctive thing we call a Chase manner or subject.

Duveneck still recalls with vividness the interesting effects Chase contrived in his studio by posing a model in a frame in the semblance of some famous canvas of the great masters. Those were his first experiments in the old-master tableaux with which he afterward familiarized New York.

Chase left his mark upon student life in Munich. It was he who inaugurated the custom of having a student dinner about every two weeks, when photographs of old and modern masters were hung upon the walls,

and one of the students chosen to talk about the art and work of the painter or painters represented. The American Art Club in Munich was the outgrowth of these meetings. At one Thanksgiving dinner given by the students of this club, Mark Twain, who was passing through Germany at the time, was a guest.

In the spirit of those days, indescribably conveyed in the words of the men who lived through them, one is conscious, as in the picture of Paris shown in Du Maurier's "Trilby" of that free and beautiful thing, the joy of creative youth. Whether successful or not, the student of that time was the farthest possible remove from the self-conscious posturing type that we find so often to-day in New York and Paris. For that was before the day of the dilettante, and the amateur was usually one perforce through lack of gift or application, rather than because his attitude toward art was trivial and insincere. They were artists in spirit at least in those days, not actors.

Chase won a number of medals during his years in Munich, and his position as a brilliant young painter became fully established. Before he left he was invited to become an instructor at the academy, an honor he deeply appreciated but declined. To this day he is well known and honorably remembered in the Bavarian city.

CHAPTER IV

VENETIAN DAYS

IN 1877 Chase went from Munich to Venice, where he spent about nine months in company with Duveneck and Twachtman. The three painters lived together in the simplest and most economical fashion. Indeed their stay was prolonged to a greater length than they had originally intended because they lacked the funds necessary for the act of departure. But the Venice period was one full of interest, and as they painted outdoors together the art of the associated painters grew steadily stronger and more individual.

Mrs. Bronson, the sister of Richard Watson Gilder who at that time was living with her family in Venice, proved a good friend to the young men and it was through her kind offices that they were eventually helped out of their financial embarrassment, for Chase became very ill with some sort of Italian fever. The money of all three gave out, and their situation was quite desperate. Duveneck nursed the invalid as best he could, taking all the night duty, for Twachtman, he still remembers, could not stay awake, and at last Chase began slowly to get better.

It was during this illness, which had drawn heavily

upon their slender resources, that the men, reduced to absolute penury, were obliged to borrow of a comparative stranger. Chase, who actually needed food, had asked for soup. Duveneck went out under the spur of this necessity, and with great reluctance asked a young Englishman he knew slightly to lend him five francs. The money was lent (and subsequently returned) but the situation remained desperate. Duveneck says that they all acquired a distaste for beans at that time, for being the cheapest food obtainable, and fortunately nourishing, they bought a large quantity and lived almost exclusively upon beans for a long period. Finally Chase recovered, although his friends had despaired of his life, and he had, indeed, come very near the borderland. At the eleventh hour help came—Mrs. Bronson secured a portrait order for Duveneck.

Duveneck was high up on a ladder in one of the galleries making a copy when a card was brought to him. He was never more excited in his life, he says, than when, after having reluctantly descended the ladder, he found that his caller had come to order a portrait. He was still further overcome at the excellent price offered, "for at that moment," said Duveneck, "if he had but known it, he could have had it for five dollars!"

Chase's collecting impulse received a tremendous im-

petus in Venice, for there beautiful old things were to be had for the traditional song. Mr. Macy, who was also in Venice at the time, tells how the dealers would take the painters into a room literally stacked with old pictures and tell them they could have anything in it for five dollars. Needless to state, despite the condition of his finances, Chase availed himself of these opportunities to acquire a number of valuable things, including pictures, among them some still-life studies, as well as brasses, old furniture and picture-frames. Those which he could not pay for he left behind to be afterward sent to America.

Chase's well-known picture *The Fish-Market* was painted during his stay in Venice, also *The Antiquary's Shop*, subjects which, strong in the lure of obvious picturesqueness, lay at his very door. In them, however, there is no attempt to paint light or atmosphere. That lesson Chase learned later from the French and Dutch masters. *The Antiquary's Shop* is an interesting study in tone, a rich and harmonious color composition, that is all. Chase also did a number of still-life studies at this time. While these were all much darker than his later still-life painting, yet they are beautiful examples of tone painting, and not by any means monochromic studies, for he has made varied and interesting use

of such notes of strong color as are furnished by a red lobster and rich-hued bits of drapery. The fine still-life containing his monkey Jocko was painted at this period, as it was at this time that in picturesque fashion he acquired Jocko.

Wandering one day along the water-front Chase paused to watch a paintable group of Spanish sailors, and as he did so he noticed with them a forlorn little monkey. His quick sympathy aroused by the appearance of the little animal, which looked particularly desolate in its gay garments, he entered into negotiations with the sailors, with the result that the monkey changed owners. The Spaniards, thinking the foreigner did not realize that he was entitled also to Jocko's wardrobe, ran shrieking after him, holding up the diminutive garments. It was almost impossible to persuade them that their customer did not want them. They plainly considered him a reckless spendthrift.

Chase took the monkey back to his studio, arranged an Italian canopied bed for his new pet and fed it generously. But it seemed to him that Jocko moped. Thinking that perhaps the monkey craved simian companionship, he fared forth and purchased another extremely small monkey named Jim as a companion for Jocko, but the ungrateful Jocko turned his back upon the new

[48]

arrival. At last Chase, fearing that Jocko might hurt the smaller animal, decided to remove the undesired Jim, but when he attempted to carry Jim away Jocko intervened suddenly and violently, insisting, so to speak, that Jim remain. After this the two monkeys became great friends. One day Chase returned to the studio to find them both missing. Going out to search for them he was met by an irate *signora,* who complained that the monkeys of the Americano were in her fig-tree stealing her ripe figs. Arriving at the spot, Chase discovered the devoted Jocko at the top of the tree swiftly gathering figs and handing them over to Jim.

Another day Chase came home to find Jocko gone. While walking about the narrow streets by the side canals looking for him he noticed a gesticulating crowd gathered at the corner of the Accademia di Belle Arti with faces turned upward. Stopping to discover the cause of the excitement, Chase looked up also, and there, lightly attached to the topmost pinnacle of the lightning-rod, he saw an undisturbed monkey at ease, apparently enjoying the view. For some reason this state of affairs seemed to be contrary to law and order, for two *carabinieri* were wildly demanding that the monkey be taken down at once. When the officials found out that the Americano was Jocko's owner they became quite vio-

lently insistent. "Take him down. *Subito, subito!* It is not possible for him to remain there. You must take him down." Just how the details of Jock's descent were to be accomplished was not clear.

Jocko, however, survived this and many other adventures; but an experimental mood that seized upon him once in his master's absence proved fatal. It happened while Chase was away from Venice on a trip. In exploring the gondolier's pocket Jocko came upon a handful of matches which he unwisely consumed but failed to digest. Combustion of a sort must have occurred within, and Jocko died. Chase's friends, much disturbed that this tragedy should have occurred while he was away, felt that all possible attention must be bestowed upon Jocko's last rites. Hunting among the painter's belongings, they took a piece of brocade that he especially valued for Jocko's shroud, and wrapping the dead monkey in it, put him in the canal and let the tide carry him away. When Chase returned his grief for his lost pet was mixed with consternation at the discovery that his devoted friends had bereft him at the same time of his Venetian brocade. When he left Venice to return to America he gave the bereaved Jim to Mrs. Bronson.

While in Venice, Chase received an offer from the newly founded Art League in New York to teach there.

It is amusing to realize now, familiar as we are with Chase's extraordinary career as a teacher, that he had grave doubts of his ability to teach and, had it not been for Duveneck's urging him to try it, would probably not have accepted the offer which had such important consequences.

Long before he had made plans for returning to America the dream of having a beautiful studio possessed him, for once, while buying something in Venice with Macy he said to his friend: "I intend to have the finest studio in New York."

Duveneck's portrait money carried the three painters back to Munich where Chase gathered together his belongings. Before he left, his fellow painters, inspired by Duveneck, planned a farewell celebration for him at Polling, a little Bavarian town where the students often went to paint and where Chase had once organized a Fourth of July celebration.

At Polling the students worked in a deserted monastery for which they paid a small rent, using the monks' cells for studios and utilizing the picturesquely costumed peasants for models. The lower part of the monastery had been turned into a cattle-stable, and of the material it offered they also availed themselves, painting the cattle and sheep. It was there that Walter Shir-

law painted his *Sheep Shearing*, a canvas that attracted considerable attention at the time.

In those days Polling lay beyond the terminal of the railway, and certain red tape had to be gone through with in arranging this festivity which was designed and successfully carried out as a surprise to Chase. Permission had to be obtained from the Mayor of Weilheim, the town to be passed through before the merrymakers could proceed on their way.

The students had built a sort of throne covered with studio stuffs, draperies, rugs, skins, and brass plates and placed it on an ox-cart. In order not to be too flatteringly saccharine, a large caricature of Chase made by one of his friends was placed above the seat he was to occupy. The white Bavarian oxen harnessed with the quaint picturesque brass bands across their foreheads were decorated with garlands, as they would have been for a peasant wedding.

When Chase descended from the train at Weilheim whither he had been lured upon some pretext, he was overwhelmed when he found himself set upon by a shrieking mob of friends and lifted to the throne, and thus seated aloft (under the caricature of himself) he was slowly drawn along the road to Polling amidst the acclamations of the populace—Bavarian peasants in

costume—in a manner truly operatic. "As luck would have it," said Mr. Duveneck, enjoying with the unction of a boy the memory of that little joke, "Chase had worn the very hat represented in the caricature, which was so good that it was recognized all along the way!"

On the back of the cart was a keg of beer from which the guest of honor as well as his entertainers refreshed themselves. To the accompaniment of cattle horns, Tyrolese mountain horns, and copper kitchen-ware beaten with a spoon, a veritable pandemonium, they proceeded on their way. When they entered the little town the men took the oxen from the traces and drew the cart themselves up to the door of the inn. Here Chase was wafted to earth and into the low panelled tap-room, where the festivities continued until a late hour. A thoroughly decorous account of this frankly uproarious occasion, written by one of the participators and printed in an American paper at the time, described the night as "pleasantly spent in mirth and song." A piece of parchment covered with seals, coins, and ribbons containing the names of the men who were present at that celebration hung for many years in the Tenth Street studio.

CHAPTER V

THE ARTISTIC AWAKENING IN NEW YORK

WHEN Chase returned to America in 1878, the
hour had struck for the passing of the old, and
the coming of the new art. The canvases of the younger
men exhibited at the academy, which would have been
ignored and laughed at in the zenith of the Hudson River
School, came now at the psychological moment when
the time was ripe for their recognition and influence.

The art exhibition of the Philadelphia Centennial in
1876, had given American artists a new outlook. The
Barbizon painters were quite generally known now, al-
though America had not yet heard the name of Manet.
The young men who had been sending their pictures
home to the academy were beginning to return from
Paris and Munich; prosperity followed the Civil War,
and change was in the air.

Chase's fame, as has been said, had preceded him.
His *Jester* exhibited at the Centennial had been widely
commented upon; *The Broken Jug*, exhibited in 1877,
was bought by a National Academician, Doctor Charles
Miller, who still owns it; and in 1878, shortly before his
return, *Ready for the Ride* was exhibited at the academy
and created a sensation. The preceding year the So-

READY FOR THE RIDE.
Exhibited at the National Academy in 1878 just before Chase's return to America from Munich.
Property of the Union League Club.

ciety of American Artists, called at first the American
Art Association, had been organized, the first meeting
taking place at the home of Mr. and Mrs. Richard Wat-
son Gilder in their famous East Fifteenth Street house.
The Art Students' League was then in Fourteenth Street.
The Metropolitan Museum had just moved into its new
quarters on the edge of Central Park; in short, the new
life had begun.

But New York itself had not greatly changed. It went
its placid way unmoved. The presence of the young
American painter in a Munich student's hat, accom-
panied by a picturesque hound or two, did not cause
much comment on lower Fifth Avenue. Yet Chase was
a natural creator of bizarre effects. He provided New
York with spectacles that would have set much journal-
istic talk and advertising in motion in these days. When
his colored servant, Daniel, wearing a red fez, stood
outside the entrance of the Tenth Street Studio, while
the Russian hound, a conspicuous exotic in the seven-
ties, gambolled about the street, and two brilliant-hued
macaws and a white cockatoo perched upon the iron
railing of the building, the resulting effect was certainly
not similar to that of the rest of the quiet street, yet it
was passed over with an indulgent smile by the passer-
by of that era.

On the steamer returning to America, Chase discovered that Carroll Beckwith, whom he had met in Munich, was also a passenger. That meeting was the beginning of their long friendship. Shirlaw and Dielman had already returned from Munich, and the men resumed their old companionship in New York.

Chase accomplished his dream when shortly after his arrival in America he acquired his Tenth Street Studio. This building, now so associated with his name, was built as early as 1857, and was the first real studio building in New York. Chase at first occupied a small studio, but later managed to secure a large room which had previously been used for exhibition purposes. This latter was the room known to fame as Chase's Tenth Street Studio, although he retained the smaller studio and had an upper room as well. Doctor Charles Miller, M.A., rhapsodically describes Chase's appearance upon the scene: "Mr. Chase upon returning to New York virtually took the town by storm, capturing its chief artistic citadel, and the exhibition gallery of the Tenth Street Studio building became the sanctum sanctorum of the æsthetic fraternity, affording midst painting, statuary, music, flowers, and flamingoes, etc., symposia most unique and felicitous, never to be forgotten by charmed participants, notably a banquet with F. Hop-

kinson Smith as toastmaster, animated by the sparkling wit of Homer Martin, Beckwith, Reinhart, Shirlaw, Minor, and Sartain."

The flamingo, be it explained, was stuffed and not a part of the studio aviary.

Chase was also a member of the Art Club, of which Doctor Miller was president. Beckwith, Shirlaw, Dielman, Saint Gaudens, Frank Millet, Reinhart, F. S. Church, and Swain Gifford were among its members. It met at The Studio, a chop-house on Sixth Avenue, where many of the artists dined quite regularly. It would have been interesting to be an eavesdropper at that dinner-table. Doctor Miller still has a portfolio of interesting pencil-drawings, both portraits and caricatures, that the men made of each other at these meetings of the Art Club. During its five years of existence the club held exhibitions of work by its members, and collected funds to send an exhibit of American painters to the International Exhibition at Munich in 1883, an enterprise in which Chase was especially interested, and which was important because it was the first time that American painters had been collectively represented in an international exhibition.

Walter Palmer, who met Chase soon after his arrival in New York, and who was a neighbor of his in the Tenth

Street building, remembers another dining-place where art was discussed nightly—a little restaurant in the basement at Broadway and Eighteenth Street, where he, Chase, Shirlaw, and Church used to dine together. For these revolutionary young painters literally lived art in those days. It may well be that in some further future the story of that time will take on the atmosphere of a legend.

Among Chase's first pupils at The League were Irving Wiles, Edward A. Bell and Edith Prellwitz. A year or two later, Mrs. Sherwood (then Rosina Emmett) and Mrs. Keith (then Dora Wheeler) were private pupils in the Tenth Street Studio. Chase often used to take his dogs to The League—a pleasant little run from Tenth Street—where they created something of a sensation in the classroom.

Irving Wiles distinctly remembers his first criticism, which is interesting because it is an example of the thing Chase meant to American students at that time. Trained in the careful methods of the academic art school of that period, Wiles said he looked with scorn that first day upon the charcoal-drawings of the students about him. To his eye they seemed rough and careless, so he took out his little hard crayon, whittled it to the finest possible point, and began to show what careful

and accurate work *he* could do. What was his surprise, when Chase came along to criticise, to see him look with disapproval upon his work. "No, that isn't the idea," said Chase. "Give me your charcoal. Something more like this," and he proceeded to draw, only with infinitely more skill, in the rough and unfinished manner of his pupils. After this Wiles said he did not let his master see any more of his work until he had mastered the trick. But at his next criticism he believes that Chase did not recognize him as the careful manipulator of the pointed crayon.

Chase became a member of the new Society of American Artists, and soon made himself so much felt in the organization that little more than a year after his return home he was elected its president.

Those were days of organization and new movements. With the Art League and the Society of American Artists in operation, and young artists returning in increasing numbers from Europe, more studios were required; models were in demand and not to be had for the asking, for models were an art property not greatly needed in the preceding period. The first and for a long time the only model in New York was one Henrietta, a Jewish woman who lived to be very old, and was for many years a well-known figure in the studios. With the

organization of plans to procure models, orphan asylums and homes for old ladies and old men were scoured, also the tenement sections in which the Italian immigrants were settling.

The Sherwood Studios were built about a year later by Carroll Beckwith's uncle, on land that had depreciated in value because of the newly erected elevated road, an enterprise suggested by Beckwith, who was unable to find a suitable studio. But in spite of the erection of the Sherwood, it was a long time before Fifty-seventh Street became an actual art centre. For many years after that the life in the studios was still below Twenty-third Street.

In many cases photograph-galleries had been taken over by the artists, and all along Broadway, from Prince Street up to Twenty-third, many an old building had an artist or two housed in its garret. The old Vienna bakery building, next to Grace Church, on Broadway, was one that remained dedicated to this use for many years. Some of the cheap flats in the neighborhood of South Washington Square were also used by artists then as they were for many years afterward. Thomas Janvier's amusing "Color Studies," a collection of stories of the artists' colony of that time in the region south and west of Washington Square known as Greenwich

Village, give an interesting picture of the period despite their invariable fairy-tale endings.

It was in every sense a transition period. The dusty art of the past decades was crumbling. The old academicians used to meet at Martinelli's, a little Italian restaurant on Third Avenue near Tenth Street, where they exchanged reminiscences of their European travels. Third Avenue was a much less squalid neighborhood then, a place of junk-shops and dime museums; a few Italians had now added themselves to the Irish and German residents of the neighborhood, but English was still the language of the Bowery.

The academicians of those days seemed rather dry and conventional beings to the revolutionary younger men. Some of them were sympathetic with the new ideas, but the majority had little or no understanding of the thing that is the very life principle of art. Their attitude toward it was gentlemanly and scholarly. They had gentlemanly, rather dull dinners at the time of the annual exhibitions, and upon occasion something that they called "a spread," in which beer was the wildest form of dissipation. They seemed to have enjoyed themselves very much in a correct and gentlemanly fashion without the faintest suspicion that they were living the *vie de Bohème*. They belonged to a moribund organiza-

tion called the Palette Club. With the younger men who met at the Art Club or in each other's studios the talk was nonsensical or practical and constructive, rather than reminiscent. Their dreams became our actualities.

For recognition outside their own circle did not come at once. Chase was a great deal talked about, but the critics—so-called—of that period dealt severely with his work. Accustomed to photographic accuracy and prettiness, they of course had no understanding of the art of suggestion. Their eyes were filled with the dry dust of the Victorian School, and could not see the new beauty before their eyes. Doubtless it was because of that long conflict with Philistinism that as long as he lived Chase never expected any one but the artist to understand art. He never entirely realized that even the layman's standards have changed with the years, and that many people who know nothing of the technical side of painting have learned that Ruskin was a misleading light.

If the kind of Bohemianism now characteristic of certain art circles happily did not exist in those days of the American Renaissance, a species of artistic indigence prevailed that is unknown now. For although New York is filled to overflowing with art students to-day, many of them are the children of foreigners whose fortunes

CHASE DRESSED IN VAN DYCK COSTUME FOR A MASQUERADE BALL, IN THE
EARLY EIGHTIES.

have prospered in the New World, and who are able to provide comfortably for their sons and daughters through their student days and those of their novitiate. But such was not the case in the day of the "real American" artist. Many of them were gentlemen's sons, but from whatever environment, their parents were usually people of moderate means. The few men of humble foreign parentage among them came from poor homes, for in those days hand labor was not well paid as it is to-day so that from whatever class, the majority of the painters of that period had bitter struggles with real poverty. With a superb disregard of practicality, however, they lived on nothing a week, paying the landlord, the butcher, and the tailor with pictures. Restaurants and boarding-house walls were extensively decorated in exchange for meals. There are tales surviving from those days of shirt-fronts renovated with Chinese white, of coal-boxes used as beds, and a general condition among many of art's disciples nothing less than squalid.

Their improvidence may not have been greater than that of the artist of any and all time; perhaps it was only that it presented a greater contrast to the habits and customs of that generation, but the irregularities of artist life seem to have created an astonishment in the breast of the well-regulated American of the early eighties that they do not inspire to-day. An article

[63]

that appeared in *Scribner's Magazine* at that period comments with consternation upon the fact that the proceeds of an artist's order were squandered in advance on a banquet of rejoicing before the work for which the money was paid was begun.

There were not many ways in those days for the poor artist to eke out his income. One source of revenue to the landscape-painters was known as shanghaiing. A sort of continuous landscape was painted on a long strip and cut off anywhere to make a picture. The impoverished painter did these by the yard, and sold them for twelve dollars a dozen.

Chase's life, however, was never conducted along these lines. With nothing but his salary at The League to be depended upon for a certain income, he took his large studio, and there, surrounded by much beauty, he started his artistic career in America in the grand manner. This scheme of grace and dignity he maintained without concession to the last, for Chase would not accept small quarters or poverty. If he was a spendthrift it was because he had so little sense of the limitations and comparative uses of money; and lacking the restraining consciousness that comes of practical realization of values, he had to a great extent what he demanded of life until the end.

CHAPTER VI

NEW FRIENDS AND A PERMANENT RELATIONSHIP

A DAY or two after his arrival in America, Chase, armed with an informal introduction from Shirlaw, went to call on F. S. Church, a painter of decorative panels in which nymph-like young women are fantastically companioned with polar bears and rabbits. Besides being a man of original gifts Church was an amusing and delightful companion. The two men became friends at once, and their association in those days of gay impecuniosity was one colored with much entertaining nonsense. In addition to the pleasant companionship it was a friendship with consequences, for it was Church who introduced Chase to his wife, at that time a very young girl, and Church was afterward the godfather of his first child.

One of the professional enterprises in which the two painters were associated was the organization of a series of exhibitions at the Art League, primarily for the benefit of the students. Even that simple move was initiatory, as before the Society of American Artists came into existence the yearly exhibits of the National Academy and the Water-Color Society were practically the only exhibitions of the year.

[65]

WILLIAM MERRITT CHASE

Simpler than the life of the present generation, one wonders if the young artists of the eighties did not experience more real pleasure in their comparatively meagre entertainments than is found in the more sophisticated diversions of to-day. "For there were not," Church says in recalling it, "so many things to do in those days. We used to walk along the Bowery. Sometimes we went into the dime museums, which were comparatively dignified, institutions then. Chase was the first to call my attention to the fine old ironwork about the steps and entrances of the old houses."

Frequently, of course, Chase made purchases. An affectionate term of opprobrium which Church bestowed upon him as a result of his collecting proclivities was "Tomato-Can Collector." When the men could afford it they went to Tony Pastor's or to the theatre. They had a number of convivial meeting-places, the Morton House and a German place below Fifteenth Street on Broadway, which was in fact a saloon, but a resort having a different sort of patronage from the present-day New York barroom. Church's studio was at Thirteenth Street and Broadway only a few blocks away; and when they were not dining at The Studio or the basement restaurant referred to by Walter Palmer, the two men usually took their evening meal together.

It was at this Fifteenth Street place that Church remarked solemnly to Chase one night, "those two men over there must be going to the devil fast, we see them here every time we come," a remark Chase was fond of quoting.

Church who for economical reasons wanted to break himself of smoking, said to Chase one day: "I'll give you twenty-five dollars the first time you catch me smoking a cigar." On their way to dinner that night, Church inquired: "How much will I have to pay you if I smoke a cigarette?" "Fifty cents," Chase humanely decided.

Church smoked his cigarette and gave Chase his half-dollar. It was a cold, stormy night. After dinner as they walked up Broadway to the theatre a small, wretched-looking newsboy came up begging them to buy a paper. The sympathetic Chase gave Church's half-dollar to the little Italian, who promptly threw his entire bundle of papers into the gutter and ran off. In such fashion as this did the artistic temperament deal with things.

The young painters lived a happy, improvident life together, borrowing and lending, apparently without keeping very strict accounts, a genuine communism of art and youth. There is a story of Chase's meeting Bleecker Mitchell, a brother artist, on the street one

day. Chase was in a hurry and walking quickly. Mitchell tried to stop him. "Oh, Chase, Chase, wait a minute!" "What is it?" Chase called back. "About that fifteen dollars," Mitchell called after him. "All right, all right," Chase replied on the wing, "I'll give it to you next week." "No, no!" shrieked Mitchell across the widening space, "*I owe it to you!*"

Speaking of the value and inspiration of Chase's criticism, Church recalled the occasion when Chase entered his studio as he was about finishing his etching called *Silence*. Coming up beside him, Chase gave a quick glance at his work, then said: "Stop right there." Church of course accepted the suggestion. "And it was," he added with appreciation, "the best etching I ever did."

Through an elderly Austrian baron, a friend of Mrs. Chase's father, who did heraldic illuminating and had a room in the same building, Church had met the Gerson family. The next link in the chain was Church's introduction of Chase to the Gerson household.

Mr. Gerson, himself a delightful and witty person with much esprit, had three attractive daughters and a musically talented son. To his home came many of the young artists of the day, among them Walter Shirlaw, Frederick Dielman, F. S. Church, Napoleon Sarony,

and James Kelly, and a little later Sarah Cowell Le-
Moyne and Robert Blum; also that singular and now
almost forgotten product of the Western mountains,
Joaquin Miller. Mr. Gerson was intelligently interested
in art in general, and subsequently his son-in-law's art
in particular. He was a native of Germany, although not
racially Teutonic, and his wife, an American on the
maternal side, had an interesting French strain in her
blood, for her grandfather, Doctor Paul Barbe Bremond,
was court physician to Napoleon I, and a cousin of the
Empress Josephine. At the time that Chase met the
Gersons, the eldest daughter, a young girl of seventeen
or eighteen, had been left head of the family by her
mother's death.

When the Gerson girls saw Chase's picture *Ready for
the Ride*, at the National Academy, they felt a great
desire to meet the talented young painter. Not having
seen the young women, however, Chase at first declined
the invitations of his brother artists to accompany them
to the Gerson home. Finally, one evening he went, and
there saw for the first time his future wife, a small, dark,
picturesque young girl who looked like a child. That
evening, before he left, he asked the eldest sister if Miss
Alice (known to her family and intimates as "Toady")
would pose for him.

[69]

WILLIAM MERRITT CHASE

From the first, William Chase was a hero to young Alice Gerson. A sculptor friend of those days said: "When she was a little girl she sat on a stool beside him and held his finger. When she was older she sat with her arm around his dog."

Mrs. Chase denies the authenticity of the first picture, although she admits a sentiment concerning the dog which Chase left with her during one of his summer absences in Europe.

Both of the paintable younger girls had often posed for Church, who has made such fanciful and charming use of girls and children in his pictures. Indeed both Alice and Virginia Gerson, and especially Alice, frequently did this service for the painters who were their friends, sometimes because the men were too "hard up" to pay for a professional model, sometimes because the artist felt that no one else could serve his purpose so well.

The painters spent many pleasant evenings at the Gerson home. While Mr. Gerson and the baron played cards in one room, the younger people sat together amusing themselves in various spontaneous ways in another. The men made silhouettes of each other and of the girls, sometimes they drew fantastic pictures in their cigar ashes on a sheet of paper. Sometimes they went in groups to the theatre together. Often Church,

Chase, and the "Gerson girls" went on pa $_i$ es that had been presented to the popular Church. Church's letters announcing the presentation or purchase of seats were invariably illustrated. Upon one occasion, when Miss Gerson was away in the summer Church wrote to her telling of an excursion they had made to a neighboring ice-cream saloon. This letter, written from the Gersons' house, shows Alice and Virginia Gerson and the writer adorned with wings, but Chase, since it was Church's hypothesis that he was a hated rival, is represented with hoofs and horns.

"DEAR MISS MINNIE:

"We have just returned from the ice-cream saloon. Had seven dishes apiece. Chase ordered only one dish. I got the others. Wasn't he mean? The sea-lion is well and the young elephant is still posing. Toady is grinning. The weather is very warm. We are thinking of getting a big dish of cream over here, and all getting into it to keep cool. Good-by.

"L. L. C. FREDDY."

The initials stand for "Long-Legged Crane," Church's self-applied nickname. The allusion to the unequal division of expense, needless to state, was made in that

vein of mock abuse which characterized the remarks Church and Chase made to and about each other. Both men were generous to the verge of bankruptcy.

Church was very fond of young Alice Gerson who often posed for him. In one of his letters to her his supposed jealousy of Chase was couched in these terms: "Anyway I know a dog that can lick thunder out of old Chase's Fly."

The life that these young people led together had the informal charm of the artist's life. All three of the girls used to go to Chase's studio in Tenth Street, often taking their needlework with them. Sometimes they posed, sometimes the older sister or brother would play on a little organ in the gallery. Frequently, their father went with them. Chase soon grew to feel that he belonged to the Gerson family. When he wanted to buy a black silk dress for his mother, he went to Minnie Gerson as to his sister, asking her if as a great favor she would accompany him to the shop to help him make the purchase. As an evidence of his thoughtful affection, Miss Gerson remembers how he insisted upon purchasing every smallest detail of the costume from the lining to the buttons.

There were many informal gatherings at the Gersons' house, and the painters often stayed to dinner or sup-

per. Minnie Gerson remembers Chase's delight in a
bouquet she had on the table one evening, a combina-
tion of different little fine flowers, pink, white, blue, and
yellow, in a blue jar. Chase declared it was like the bou-
quets in Alfred Stevens's pictures and begged her always
to have one like it on the table.

When Chase's mother and sisters came on from the
West he invited the Gerson family to dine with them
the night of their arrival at the Casino restaurant in
Central Park, where they used often to dine outdoors
on summer evenings.

The sisters recall one occasion when strolling home
with Chase, Shirlaw, and Church along the path bor-
dering one of the park lakes after one of their al fresco
repasts, that Chase, burlesquing a state of despair over
some pretended neglect, ran to the edge of the lake as
if to throw himself in, and it being a combination of
dusk and nearly moonlight mistook a reflection for the
solid earth, and promptly and unexpectedly disappeared
beneath the surface of the lake, to the horror of
all.

Presently his head appeared, and he soon climbed
up beside his companions, dripping with mud and water
and speechless with laughter. Even at that early period
Chase was fastidious in his dress, and reckoned some-

thing of a dandy. He took his clothes seriously and was always immaculate in appearance, so that the picture he presented seemed funnier to his companions than if one of the others had been the victim. Chase soon realized that he was in a predicament, for Tenth Street was at least fifty blocks away. At the Fifty-eighth Street station of the elevated road the guard firmly refused the streaming passenger. The conductor of the surface-car was equally unsympathetic. It was early summer and the evening was a trifle cool. At last the painter faced the fact that he must walk home to Tenth Street, a treat to gamins and idlers. His friends, who had courageously supported him in his futile attempts to board cars, abandoned him to his fate. Virginia Gerson recalls that in spite of this disaster he reappeared at their house not so very long after they had reached home themselves, looking as immaculate as if he had never known contact with the oozy bottom of the lake.

When the Gersons moved to an old house in Hackensack for a year or two, their friends faithfully followed them. Sometimes the girls rowed down the river to meet them, sometimes the men walked the two miles from the station to the Gersons' home. The necessity to take a leisurely suburban journey did not in any way interrupt the pleasant companionship.

NEW FRIENDS

All through the six years of association preceding his marriage Chase's friendship and affection for the Gersons grew, and to the last his wife's family were to him as his own.

CHAPTER VII

A TILE CLUB PILGRIMAGE

SOON after Chase's return to America the Tile Club asked him to become a member. This famous club, which lasted for about eight years, was originally limited to twelve members, and was composed of some of the most distinguished artists in America. Augustus Saint Gaudens, Edwin Abbey, Elihu Vedder, Arthur Quartley, Swain Gifford, Alden Weir, Hopkinson Smith, C. S. Reinhart, Frank Millet, Frederick Dielman, Alfred Parsons, John Twachtman, Stanford White and Napoleon Sarony were among its members. Edward Strahan and W. M. Laffan of the New York *Sun* were the club scribes. Later, some musicians were admitted.

The members all had amusing nicknames. Chase because of the large amount of work that he turned out was called Briareus; Abbey, The Chestnut; Hopkinson Smith, The Owl; Saint Gaudens, The Saint; Elihu Vedder, The Pagan; Alden Weir, Cadmium; Frederick Dielman, because he came from Baltimore, was nicknamed The Terrapin.

The Tile Club was started in the studio of Walter Paris, in Union Square. Its first meetings were held there or in Quartley's studio. Later on it had picturesque

quarters in Tenth Street, the entrance to which, judging from descriptions, must have been almost as circuitous as that to Alice's rabbit-hole.

The club was organized before Chase's return from Munich. It had its origin in the chance suggestion of one of the men that the painters should indulge in some form of the decorative craze that was then raging in England and America. The meetings were held once a week. A different member furnished the tiles and the supper each night, and afterward became the owner of the baked and decorated tiles. Pipes, beer, and cheese usually constituted the evening's entertainment, although such delicacies as sardines were also offered.

It was the custom of the Tile Club to take a pleasure journey *en masse* each summer, and so it happened that Chase spent part of his first summer in America with his fellow club members on their famous canal-boat trip up the Hudson River and through the Erie Canal. The idea is said to have been Hopkinson Smith's. The financial condition of most of the club members was extremely precarious. Several of them admitted cheerfully that they did not know how they would get through the summer. Then why, suggested Hopkinson Smith, should not the amiable *Scribner*, first aid to American artists, finance their trip? The literary members would

[77]

write the tale of the pilgrimage, the artists would illustrate it, and *Scribner* would pay a lump sum for the whole which would be justly divided.

No sooner said than done. *Scribner* agreed to pay a goodly price for the article, and the Tile Club set about to plan its communistic enterprise with much enthusiasm. After a diligent search of the wharves and the rejection of innumerable coal-sodden barges, and others reminiscent of the occupation of mules, a suitable boat was found and engaged for three weeks at the price of seven dollars a week. Its name was the *John C. Earl.* Chase's famous colored man Daniel, according to his own version "Dannel," was to be their cook, and Chase's Tenth Street Studio trappings were loaned without stint to decorate the cabin of the boat, not to speak of the mules. Napoleon Sarony also lent a number of rugs and draperies. The partitions of the canal-boat were knocked out so as to make one large salon. Cots converted into Oriental divans by day furnished beds by night. There were two pianos for purposes of music, professional or amateur.

When they were about to sail, it was discovered that a second server had been provided by Daniel, an amiable, preposterously lazy negro to whom they all became much attached, and whom they christened Deuteronomy.

Daniel won the admiration of all by his perfect African breeding, exhibiting no surprise of any kind at his first sight of the richly decorated canal-boat, as if canal-boats were always tricked out with ancient brocades, Oriental rugs, and pianos. Daniel had been a slave, and confided to Mr. Dielman: "Yes, sah, I'se from Baltimore, too. I'se one of de Ringolds," thus allying himself with the aristocracy of Baltimore.

They sailed away toward evening, Knauth, Lümeberg, and Beard, the musical members, playing and singing, banners flying, Japanese lanterns lighted, and Sarony's gorgeous rug which covered the deck trailing in the water. The "Gerson girls" stood on the old Tenth Street pier, and waved them farewell. When their lights were almost invisible the echo of their music came back over the water.

Life on the canal-boat as it drifted up the Hudson was simple in the extreme. Water for ablutions was drawn up from the river in buckets. Some of the men sketched while others watched and criticised. They told stories, talked art, and discussed with sarcasm the Hudson River School of painters, and "The Griffin" (Swain Gifford) is recorded as saying that most of the backwardness of American art was due to those worthy Victorians, since they had chosen material which because

of its grandeur and sublimity was not suitable for purposes of art: "Therefore," concluded The Griffin, " simplicity has evaded us all."

As they progressed on their journey it was decided that Daniel must have another assistant, as Deuteronomy was practically useless. No one seems to have suggested parting with the amiable drone, but at Troy one of the men went ashore and returned with a slim and smiling young man whom they at once christened Priam. Priam not only proved satisfactory for the term of the trip, but found art atmosphere so congenial that he remained in employment in artistic circles for many years afterward, serving as factotum and model. Chase made a sketch of Priam which was used as one of the illustrations for the magazine article.

When the party reached the Erie Canal, their mules, decorated with Spanish bridles, their Japanese lanterns and Oriental hangings created great excitement among the populace. When the excited children upon the banks became too vociferous, Laffan, by previous arrangement with the willing Twachtman, ran out upon the deck crying, "Run for your lives, *The Twachtman* is loose!" whereat the invisible Twachtman uttered frightful groans, and rattled an old piece of chain he had found in the hold.

"PRIAM," A TILE CLUB SERVITOR.

One of Chase's few illustrations, made for the story of the club's canal-
boat pilgrimage published in *Scribner's Monthly*, 1879.

A TILE CLUB PILGRIMAGE

One day, moored under a group of willow-trees, some one called attention to the beautiful Japanesque design made on their awning by the shadow of the willow leaves, and straightway Chase and Sarony set to work to trace it on the white cloth where it remained a testimony to the decorative value of Nature. While Chase and Sarony were painting, Dielman sketched them at work. In such fashion the Tile Club passed its days.

Their meals were ample but simple, usually consisting, with small additions, of a single dish. When it was time for this *pièce de résistance* to be started Hopkinson Smith would call out, "Put 'em in, Dannel," and Daniel would call back: "In dey go, sah!"

At another excursion, in 1880, when Chase was present, the Tile Club took possession of an old wreck at Sandy Hook. As the floor of the cabin was almost rotted away it presented drawbacks even as a temporary residence. Hopkinson Smith, who prided himself upon his great practicality, as soon as he arrived upon the scene, briskly proceeded to take measurements, and ordered several thousand feet of boards for repairs. The boards arrived promptly, were paid for, and lay upon the shore. They were never used. But they were long remembered, for one night when the surf was high they began unobtrusively to float away on the tide. Some one discovered

[81]

the fact and sounded the alarm. Wrathfully the men arose and dressed, and spent an exceedingly damp and active night in rescuing their property.

The Tile Club went on a number of pleasure excursions to the Long Island coast for a day or two or longer. It was at one of their dinners at the beginning of the summer, a rather late and joyous occasion, that the subject of the sea-serpent was discussed, with the result that each agreed to paint his conception of the monster upon his first excursion to the seacoast. Chase, as usual, was prompt to carry out the plan. The result, an interesting bit of color (although as a conception of a sea-serpent its mildness would inspire scorn in the school of Stuck), he presented with irrelevant generosity to that grand dame of the artistic world, Mrs. Candace Wheeler. This canvas, signed "Briareus," still hangs upon the walls of Mrs. Wheeler's summer-home on Long Island, where Chase was a frequent guest.

At Christmas, 1882, the Tile Club artists illustrated a sort of supplement to the *Harper* publications called *Harper's Christmas*. Chase, who never permitted himself to be forced into illustration, made a charcoal drawing of a burgomaster for reproduction in this publication, which is still in the possession of one of the Harper family. In the strength and crispness of its technic it

furnishes a striking contrast to the tame illustration of that period.

C. S. Reinhart, Arthur Quartley, Edwin Abbey, Frederick Dielman, and all the other artist members contributed to this supplement. Although an artistic success, it was unfortunately not one financially, so the experiment was never repeated.

An interesting picture of the Tile Club and of the life of the painters of that period is shown in Hopkinson Smith's novel "Oliver Horn," in which the club is described under the name of The Stone Mugs, and the appearance of Madame Blavatsky at one of their evenings is amusingly told. The painter Munson is a fictional presentment of Chase, although the episode in which Munson is supposed to match foils with Richard Horn (Hopkinson Smith's father) had no real foundation in fact.

To the painters recently returned from Europe the Tile Club furnished the artistic atmosphere to which they had grown accustomed in Munich and Paris, and of which at that time they felt the lack in America. It served its purpose and passed, remaining to this day to the men who were part of it a light-hearted memory of happy comradeship.

CHAPTER VIII

LIFE IN THE TENTH STREET STUDIO

FOR a time in the summer of 1880 Chase was at Lake George, where he apparently enjoyed himself, not forgetting his friends the Gersons, however.

"I think of you all very often and wish that you were all here to enjoy with me" [he wrote to young Alice Gerson while there]. "The darlingest little boat here is named *Alice*. I have a row in her every day and think of you. The handsomest yacht on the lake is named *Minnie*. By the way I dreamed of Minnie last night. I dreamed that I took her to the theatre and lost her. I was in an awful state I can tell you. . . . I suppose you are moved by this time, and are already fixed up. Do you see as much of old —— as usual? Mr. —— the gentleman I am stopping with here has a very handsome daughter. We are having great larks together and we often go out rowing. I have told her a great deal about you. There is also a young lady visiting her who is most charming. The only thing left to be wished for on my part is that you were with me. Please don't forget your Will (I mean myself). Be a good girl and—I was going to say—keep off the bannister" [the railing of an upper

balcony upon which the young girl used to sit], "but I remember you are not living there any more. I would be awfully pleased to hear from you.

"Yours most devotedly,

"WILL."

"P. S. Have lots to tell you when I get home. Give my very kindest regards to your sisters.

"Ever yours,

"WILL."

"I sent a message by Church to you. Ask him for it if he hasn't delivered it.

"AGAIN YOUR WILL."

It was in the fall of that year that Chase was elected President of the Society of American Artists, a position he held for one year. He continued to teach at The League and in his own studio.

Rosina Emmett and Dora Wheeler were pupils in his Tenth Street Studio. Soon afterward Chase took several others. "And you could always tell when the dear man had had our monthly cheque," said Mrs. Keith, "for some new and beautiful object always appeared in the studio immediately afterward."

He painted a number of fine portraits at that time,

among them the excellent one of General Watson Webb. During that winter Chase and Robert Blum met and became friends. Chase was a great advantage to the talented young man, who was then comparatively unknown in New York, while Chase was already one of the prominent figures in the artistic world.

Chase's Saturday receptions had become quite famous. Long before his day the Tenth Street Studios had been thrown open to the public on Saturdays, but Chase made the ceremony an event. Many of the younger painters recall their first glimpse of that studio as the entrance into a new world.

Chase entertained practically all the painters of the period there, as well as an occasional writer and a few professionally non-classifiable guests. Napoleon Sarony was one of his friends of that time. A fashionable photographer and would-be artist, Sarony photographed all the celebrities that came to New York in his little studio on Union Square, and was himself a most picturesque figure. According to William Henry Shelton, Sarony "delighted to show himself on Broadway in a calfskin waistcoat, hairy side out, an astrakan cap, and his trousers tucked into cavalry-boots; accompanied by his wife in a costume by Worth. . . . When Sarony was flush he bought pictures and bric-à-brac furiously."

Upon which ground Chase must have found him con-
genial! His place, Mr. Shelton remarks, "became a sort
of dumping-ground of dealers in unsalable idols, tattered
tapestries and indigent crocodiles." Sarony's rooms
were frequented by all the Tile Club men, among them
Chase in his famous hat, accompanied by his almost
equally .famous Russian greyhound, which, if not the
first Russian greyhound to be seen in New York, was
at least the first one to become a marked character of
the boulevards. Indeed, in those days of his bachelor-
hood there seems always to have been a dog in Chase's
life, usually an English or Russian hound. If he did
not collect dogs at least his supply seems to have been
greater than his need, because he gave one to his friend
Robert Blum, and another to Carroll Beckwith. Walter
Palmer remembers an occasion when one of these de-
voted hounds was almost lost.

I quote the story as Mr. Palmer told it in a letter.
"Chase would board a horse-car, and the dog seeing him
get on it would follow the car until Chase alighted and
attracted his attention. But one day, alighting at Tenth
Street and Sixth Avenue, he forgot to call his dog and
looked down the street just as car and dog were going
around a distant corner. He bethought him of the just-
opened elevated railroad, and hurried to take a down-

town train. Reaching the corner where the Sixth Avenue
horse-cars end their trip, he asked the starter if he had
seen anything of a greyhound following a car. 'Oh, yes,'
said the man, 'he came down behind the car and has
gone back with it.' Chase rushed back and caught an
elevated train up-town, and reached Tenth Street again
just in time to intercept the car and the dog.

Daniel was in possession of the studio. Negro-like,
he identified himself at once with his master's interests.
"*We* have finished a portrait to-day," he would remark
in answer to inquiries about the painter's activities.
Daniel took on the phrases of art with great facility,
transposing them with that indescribably expressive
twist of paraphrase characteristic of the African mind.
Mrs. Sherwood remembers how he referred to "still
life" as "still lights," and Mrs. Keith recalls the oc-
casion when she confided in despair to Daniel that she
had dropped paint on one of Mr. Chase's best rugs, and
how Daniel reassured her—"Dat's all right, miss, I get
it all out with a little pneumonia!"

The old negro regarded himself as Chase's special
guardian, and reproved him in most proprietary fashion
when he failed to take care of himself. On a rainy day if
Chase forgot his overshoes Daniel would scold him with
his soft African familiarity as if he had brought him

up. "How's dat now, Massa Chase? Yo' go out without yore *scandals*. How many times Dannel tell yo' not to do dat? Ef yo' catch cold and die doan yo' hole Dannel responsible."

Daniel took the greatest pleasure and pride in Chase's Saturday receptions. One day he observed that the painter had turned an interesting new study that he had just finished face to the wall instead of putting it on exhibition, and inquired solicitously: "Why, Massa Chase, aren't yo' going to show dat negative?"

Mrs. Sherwood says that one day Daniel brought to the studio a very dark and very unsavory-looking negro that he had met in the street, and offered him to Chase as a model. Afterward Mr. Chase said to him, "Daniel, why did you suppose that I would like to paint that man?" "Well, sah," said Daniel, "I pass him in de street; I see he was a foreigner, an' I knew you like paintin' foreigners, so I brung him in." It seemed that the man was a sailor and had been born in Africa.

There were certain melancholy occasions when Daniel by some mischance landed himself in jail. One of these made a particular impression on Chase's memory because it was the occasion of some colored ball, and Daniel had appeared in the guise of an eighteenth-century courtier clad in white satin, most magnificent to behold,

[89]

and had proudly exhibited himself to his master before he left for the ball. But Daniel did not return the next day or the next. The third day Chase was summoned to the Jefferson Market Police Court to bail out his servitor. There in a cell in painful contrast to his starting forth, sat a crumpled, damaged Daniel still in white satin, a sight which seemed to particularly impress the sensitive eye of his master. In time, however, Chase grew accustomed to these temporary absences. One day he received a desperate appeal from the missing Daniel, again temporarily deprived of his liberty, couched in these words: "Dear Mr. Chase, You an' Jesus am de only friends I got. For God's sake send me some chewin' tobacco." Daniel remained as guardian of the studio for several years, caring for his master's paint-brushes, his dogs, the red macaw and the green macaw, the savage white cockatoo, and all the other studio properties.

Chase, who delighted in all the little ways of his pets, used to tell how one of the macaws would fall asleep trying to perch with one foot crossed on the other, after which attempt he would nearly lose his balance, then half awake rebuke himself: "Look out, look out." This bird, who was quite a fluent conversationalist, taught the other one to talk. He also used to play tricks on Daniel. Chase says that one day when he was in the upper room

he was startled to hear himself calling Daniel, a short, peremptory call that he recognized at once as his own. Daniel came running in from the other studio. "Yes, sah, yes, sah, here I is." But when he got in the room from which the voice had come his master was not there; as the negro stood looking about in bewilderment the seemingly diabolic bird burst into cackles of laughter. Chase saw Daniel go up to the cage, shaking his fist at the parrot. "Yo' mis'able no-count bird, some day I wring yore neck!"

At last Chase was obliged to part with Daniel because of the African's imperfect sense of property rights. A friend of Chase's, a photographer, decided to take him despite the warning of his former employer, but the day came when he was very much embarrassed to learn that one of his sitters had missed a wallet containing quite a large sum of money. Daniel, who had taken the visitor's coat in charge, was questioned, and stoutly denied all knowledge of the matter. It was discovered, however, that the pocketbook had disappeared through Daniel's collusion with another negro to whom he had dropped it out of the window. The manner in which Daniel was led into self-betrayal always delighted Chase. Taking his old servant in hand himself, he said gravely: "Daniel, this gentleman's wallet contained one hundred

and fifty dollars, and it must be found." Daniel's eyes began to roll.

"Is dat so, sah? Is *dat* so! One hunred fifty dollahs? You just wait till I get hold of dat niggah! He give me ten dollahs. He say he give me half, he tell me dere was only twenty dollahs in dat purse!"

Daniel was succeeded by Theodore, another sympathetic African somewhat less picturesque, but of more methodical habits, who fell heir to the red fez and remained with Chase until he gave up the Tenth Street Studio.

CHAPTER IX

EUROPE REVISITED: SPAIN AND VELASQUEZ

EIGHTEEN HUNDRED AND EIGHTY-ONE was the year of Chase's first return trip to Europe. Carroll Beckwith who had spent the summer before in Spain, talked of the Velasquez in the Prado, of the sights and colors of Spain, till Chase could bear it no longer, and when June brought release from teaching he took passage on the *Belgenland* with Beckwith, Blum, Herbert Denman, A. A. Anderson, and a decorator named Lawrence.

After a few days out, Mr. Beckwith's diary relates, Chase, very much bored with the enforced inactivity, proposed decorating the ladies' cabin. Beckwith, not being quite as good a sailor as Chase, and evidently from the record of his diary rather impressed with an attractive young woman on board, was not at all enthusiastic about the suggestion. But the energetic Chase fairly dragged his fellow painters into the project. The captain, needless to state, was delighted at having his ship decorated by modern masters. The ladies' cabin became a showroom while the pictures were allowed to remain, but not long afterward the panels were cut

out and, it is said, were set up in the home of one of the owners of the line.

Chase spent most of his time in Spain that summer, but he stopped for a short time in Paris, and an event of considerable importance to American art occurred during his stay there.

One day as he was strolling along the Boulevard he chanced to meet Alden Weir. Weir had gone over to purchase pictures for a wealthy New Yorker without any recompense save the collector's promise that the pictures should afterward be presented or left to the Metropolitan Museum. As soon as Chase heard his friend's errand he exclaimed: "Come with me right away to Durand-Ruel's. They have two wonderful Manets there. You *must* have them." Weir went with Chase at once, and that is how the Metropolitan Museum came into possession of the *Boy with the Sword* and the *Girl with the Parrot*.

Weir tells of going to Manet's studio not long after that. Manet received him while he was painting from a model. The American painter asked the price of two landscapes in the studio and was told that they were a thousand francs apiece, which price he instantly agreed to. Manet left the room a minute and the model exclaimed: "Oh, Monsieur, why did you not wait? *I* could

[94]

have bought those pictures for you for two hundred francs." An incident, Weir remarked, which showed the valuation placed upon Manet's work by his countrymen at that time.

It was during this trip to Paris that Chase met the Belgian artist Alfred Stevens whose art he admired so profoundly—although that enthusiasm seems to have had no direct influence upon his own work. Stevens gave the highest praise to Chase's beautiful portrait of Duveneck in the Salon, but he made a comment that proved to be a turning-point in Chase's art development: "But why do you try to make your canvases look as if they had been painted by the old masters?"

From that hour, Chase says, he sought to express his own individuality in his art.

In July of this year there is an interesting letter from Blum in Venice to Chase in Spain. The late Gedney Bunce, who spent so much of his time in Venice and who died a few days after Chase, was there also. Blum after speaking of his own inability to get to work refers to his brother artist: "Bunce simply exists and leisurely watches his opportunity to tell you how the Venetians lie and cheat. . . . He has had a falling out with his gondolier. . . . The other day somebody said that Tilden had spoken of himself as discovering Venice.

Bunce leaned back in his chair and said: 'Oh, yes, he may have *discovered* it, but I am the George Washington of it.' "

From Madrid meantime Chase writes to Alice Gerson, but not of Madrid:

"I began to think that *some* of my friends at home had forgotten me altogether. I am awfully sorry and wish I knew what I could do to remedy the misfortune. Perhaps my friends have found someone else who pleases them better than I do and that is the reason why I do not receive any letter from them. I have a great deal that I might tell my friends about. But then I begin to question if they would care to hear it. . . . There is just time for one letter to reach me if it is written *immediately*. Recommend me to your charming sisters and believe me to be one of your most ardent admirers,

WILL."

"Do please write and tell me everything that has taken place since I left. "W."

Chase does not seem to have painted much upon this trip, although his study of the Velasquez in the museum and the closer contact with Spanish art possible in the

country had a very direct influence upon his painting, as is evidenced in a number of his pictures of that period, of which *A Spanish Lady*, exhibited at the Memorial Exhibition at the Metropolitan Museum, is an example.

One of Chase's first experiences in Spain might be called the duel of the dog. It has a piquant combination of farce and melodrama.

Although a peaceable person, Chase had in his nature a great capacity for righteous indignation. When he perceived a wrong he desired to see it righted. Yet his psychological processes were such that the results of his acts not infrequently presented a marked contrast to his eminently praiseworthy intentions.

He had heard a great deal of the cruelty of the Spaniard to animals, stories to which the painful sights of maltreated horses and donkeys usual in Latin countries had given corroboration, and had become quite wrought up on the subject. One of the tales that had particularly inflamed him was a statement that the Spaniards were in the habit of giving a small quantity of poison to dogs, not sufficient to kill, in order to amuse themselves with the sight of the animals' suffering. Whether true or not, the story made a great impression upon the artist's mind. One day as he was passing a house in Madrid a dog frothing at the mouth and con-

torted in apparent agony tumbled out of a doorway accompanied by a pursuing crowd of men. The painter's humane indignation being instantly aroused at this horrid proof of the truth of the tale, he acted swiftly. Mercy demanded that the animal be put out of its misery at once. He raised his cane, and with strong and unerring aim brought its head down upon the animal's skull, promptly ending its supposed sufferings forever. But the result was a mob, much tumult, and an angry and threatening babel of voices in an unknown tongue.

Upon the sea of this picturesque but not reassuring mob, Chase was borne along the narrow street until they chanced upon a circus tent. At its door stood 'a ticket-man who was able to act as interpreter, and then it was revealed that the dog had been suffering merely from a common fit, and however he may or may not have been treated in life, he was now, it seemed, passionately mourned by his outraged master, whose grief demanded that the murderer fight a duel with him on the spot. A sort of truce was patched up, and the painter was allowed to go home; but that afternoon he received an invitation to visit a certain café in the evening in order to discuss the matter further. It became evident that the idea of vengeance still possessed the mind of the bereaved dog-owner.

Now Chase was a crack shot. He accepted the invitation to the café, and while they sat about in clouds of smoke, to the accompaniment of guitars he amiably amused his audience with exhibitions of his skill, such as cutting a thread with a shot, shooting a tiny tack suspended from a moving string, and splitting a card placed edgewise in a crack in the wall. And as the enthusiasm of his audience waxed greater, from the tail of his eye he saw his enemy shrivel against the wall. It was clear that he had lost all desire for a contest of arms with the painter. Chase heard no more of the duel of the dog. But that was not the only occasion upon which his humanity made him a marked character in Spain.

Irving Wiles, who met the painter in Madrid in 1905, remembers Chase's description of a donkey that he made famous throughout Madrid that same summer. Chase decided that he needed a donkey to carry his painting materials and purchases, but when it was brought for his inspection he was filled with consternation at the sight of the wretchedly thin little animal. He ordered at once that a large measure of oats should be fed to his donkey daily. "Oats to a donkey!" exclaimed the donkey-herd in horror, and argued the matter, not believing his ears. Chase insisted, and at last the don-

key's keeper agreed, but evidently only to pacify the erratic American. For the donkey remained thin, and Chase noticing the fact, wrathfully accused the keeper of starving his donkey. This time he made threats that were convincing and the little beast became famous as the first donkey in Spain to be fed with oats. He grew fat and sleek. Tricked out with a decorated harness highly polished and ornamented with tassels and bows, he became one of the sights of Madrid. The inhabitants stood still when he passed to look at the fat donkey in the brass harness, the property of a mad American artist who suffered from the delusion that donkeys should be fed with oats.

Despite his sympathy for animals, which seemed so eccentric to the Spanish mind, Chase developed a great enthusiasm for the bull-fight. Indeed, perhaps through his adoration of Velasquez, Spain was one of the countries that laid a spell upon his imagination which drew him repeatedly back again. That trip in 1881 was the first of many pilgrimages to be made there over a period covering a quarter of a century.

Not only was the effect of Spain and the Prado upon Chase's art noticeable the following winter, it seemed also to give added inspiration to his teaching. At The League, where his invigorating influence had already

begun to show results, his class that year did especially strong work. Chase did not allow his students to putter or relax. Instead of spending a week or more on one study they were given an hour in which to paint a head; they were told not to keep their studies, but to paint them out and use the canvas for a fresh start—commonplaces of the art school now, these ideas, but Chase was the revolutionist who first set them in motion.

"Take off your coats!" he exclaimed one day as he entered the class where the men were placidly working. "Roll up your sleeves and swear at your work!"

Another time, as he came into the portrait class to criticise, he caught sight of a young woman from Boston, a pupil of William Hunt's who had a very good opinion of her gifts and methods. She was standing before her canvas on which she had been working carefully all week with her palette-knife in her hand. "That's right, scrape it out," said Chase as if he had supposed that to be her intention.

"But, Mr. Chase, I was going to keep it," she faltered.

"*Keep it!*" repeated Chase, with affected incredulity. "Then at least take it away where the other students can't see it and be influenced by it."

That was not the infinitely kind and tolerant Chase of later years, but it was not the time for tolerance. It

was necessary to break through the dead methods of the reigning academic school with sharp and vigorous strokes, and the Chase of that day did not hesitate to do it. Yet, then as always, all that he had or could command was at the service of art. Daniel travelled constantly from the Tenth Street Studio to The League with loads of still-life material—draperies, Venetian glass, pieces of copper and brass, and bric-a-brac. No matter how valuable the things were they were lent without stint to students or other painters. To the composition class at The League, held by his friend Shirlaw, he also sent the treasures of his studio in order that beautiful arrangements in still life might be set before the students as examples.

Indeed, it would be difficult to make a complete record of all that William Chase meant to American artists and art students at that momentous period.

CHAPTER X

SPAIN AND HOLLAND WITH BLUM

THE next summer Chase went back to Spain. Depositing his dog Fly with Alice Gerson and his macaws with Mrs. Candace Wheeler, he took passage with Beckwith and Blum. The dog, despite recurrent demands for a constitutional, proved a comparatively easy charge, but the macaws were something of a care to their temporary owner, as one had a trick of pecking the ring from its ankle and flying to the top of the tallest tree, from which at the peril of his life one of the men on the place had to rescue it.

Arthur Quartley, Ferdinand Lungren and Frederick Vinton were also of the party. They sailed on the Red Star liner *Pennland*, for the Red Star Line encouraged artists to make use of it by giving them special rates.

Clarence Beul, of the old *Scribner's Monthly*, went with the painters to write the story of the voyage. This time they decorated the captain's room, the painters drawing lots for their portion. The centre panel went to Chase. There he made a portrait of the captain, arranging the figure so that a push-button in the panel seemed to be the end of his marine glass.

The painters also amused themselves making kites

[103]

of canvas which they sent off from the deck, using up all the spare rope on the ship. Blum entertained himself by making caricatures of every one, himself included, an art in which he was embarrassingly expert.

Indeed, Blum's impulse to caricature was irresistible. Often in Paris at a café Chase would discover his friend at work at a neighboring table. One day while Blum was thus enjoying himself at Chase's expense, Chase rose and went out into the street. A minute afterward Blum heard his voice and, looking up, saw Chase in company with a man, one of the most exaggerated types of the Boulevard. Ceremoniously he introduced this individual to Blum and invited him to seat himself at Blum's table. "This gentleman wishes to make a sketch of you," he said and withdrew, leaving Blum to find his way out of the situation.

After leaving Paris, Chase, Vinton and Blum went on to Spain together. Chase having persuaded Blum to go to Madrid, was unable to get him out of it, for Blum declared that nothing that Spain could offer could possibly be as wonderful as Madrid. Finally, Chase induced his friend to go to Toledo just for the day. He received a telegram from Blum soon after his arrival, requesting to have his clothes and paints sent on to Toledo at once,

as nothing would induce him to leave that wonderful place.

A few days later Blum wrote from Toledo to Chase in Madrid:

"DEAR CHASE,

"The above picture" [an artist surrounded by interested children] "can perhaps express better than pages the state of mental serenity enjoyed in this old place. I think I will include Vinton in the above statement (perhaps more so). We are nicely fixed in a house with a *patio*, and Vinton for once was pleased for two consecutive minutes, exclaiming: 'Ah, now, *that's* the sort of thing I like!' He keeps on making dire and sundry threats to speak Spanish to the natives, hoping and wishing with blood-curdling ferocity to have the whole Spanish nation by the throat so as to kill it once for all. He has an extreme love and fondness for the beggars, of which he is full to his eyes when he passes them.

". . . They have about seven cats and two or three birds including one of those Spanish quails, to the delight of Vinton. I suppose it would be considered a very good singer for it keeps on long after dark. Late last night I heard Vinton, in a dream I suppose, mutter something about preferring quail on toast.

"You ought to come down. How did you enjoy yesterday's bullfight? Let me hear from you soon.

"Yours sincerely,

"ROBERT BLUM."

"I suppose Vinton sends his regards."

Blum remained in Spain longer than Chase did. When he finally returned to Madrid, Chase had gone on to France and Holland. Blum wrote to his friend directly after his arrival:

"DEAR CHASE:—

"Here I am seated in Vinton's room, time Monday 7:30 A. M. I left Toledo yesterday. It really felt like coming home to get here once more. I expected every now and then to have you pop out of some dusky corner, in fact so strong ran my imaginations on this point that getting up this morning and hearing someone in our old room contentedly yawning, I said to myself, 'I'll just give him a rouser.' It was some time before I could resist the terrible temptation and believe that things were not as they once were. I have had an awfully good time of course. I speak Spanish now like a native. I will only state as a proof of this assertion that whenever I open my mouth to speak the natives flock to gather in their

[106]

stock of knowledge and get the correct pronunciation. . . . Just looking up from writing I observed a broken pane in the window. Did Vinton have to pay for it? How did you enjoy your visit to Boldini? Much, I warrant. I look forward with a good deal of pleasure to joining you soon. With heartiest wishes for your enjoyment of Holland, believe me,

"Your sincere friend,

"ROBERT BLUM."

Chase collected a vast amount of bric-à-brac, stuffs, curios and pictures in Spain, only a small portion of which he took back with him on that trip, although later he got together a good deal of it and had it sent to America. Blum, who was too much influenced by Japanese art to care for profusion in decoration, used to say, "Some day you will come to seeing it that way, too, and give up bric-a-brac," but Chase never did.

That winter a new organization called the Society of American Painters in Pastel, of which Robert Blum was the talented but unpractical president, carried on an interesting if irregular existence. It had at least three exhibitions, not held at any stated time, in which some distinctive work was shown. The members were Blum, Chase, Wiles, Blashfield, Beckwith, La Farge, Twacht-

man, Weir, Walter Palmer, H. B. and F. C. Jones. Outside painters were sometimes invited to send pictures to these exhibitions. The last one, which was held in 1889, attracted a great deal of attention among critics and artists.

In 1883 Chase went to Europe in company with Frederick Freer of Boston, again on the *Pennland*. They met Siddons Mowbray on board. Mowbray says that Chase insisted upon a repetition of the decorative feat. This time it was the smoking-room that was honored. Chase drew a panel containing a barometer, a difficulty he got around by painting a clown lying on his back juggling with the barometer with his feet. In another panel he painted a Spaniard in a large hat.

Either on this trip or the one taken the following year, Chase again visited Madrid, and in 1884 he spent quite a long time in Holland with Blum at Zandvoort, where Blum took a little house. It was in the yard of this house that the picture for which Blum posed called variously *The Tiff*, *The Outdoor Breakfast*, and *Sunlight and Shadow* was painted. Under this last name it was exhibited at the exhibition preceding the sale of Chase's pictures in May, 1917.

When Chase had a class in Haarlem in 1903 he went to Zandvoort to see the people from whom Blum had

SUNLIGHT AND SHADOW.

A portrait of Robert Blum in the garden of his house at Zandvoort, painted in 1884.

rented his little house. And again in 1912 when he had his class at Bruges he looked them up. A pupil who went with him that time describes how he hunted through the little streets by the canal until he found the familiar green door. The minute he entered he was recognized by the family. The little girl that he and Blum had painted was a married woman with well-grown children, but she remembered him. The old grandmother, then eighty years old, gave a cry of joy at the sight of him and throwing her arms around his neck, kissed him. Chase was touched to the heart at finding himself thus held in remembrance by these simple people.

During the summer of 1884 Chase painted a number of canvases with the figure in the open. They are on the whole heavier in color than his later outdoor painting and lack the simplification and distinction in arrangement that he afterward achieved. They are perhaps more interesting as examples of a stage in his development than in themselves as pictures.

Before returning to America Chase purchased the beautiful white Russian hound Katti which he used in several pictures, notably the pastel of one of his sisters shown in the sale exhibition in May, 1917.

The dog, a fastidious and aristocratic person, spent the following summer with Chase's parents, where he

was the most considered member of the family. They found him rather a trying guest as he refused to eat anything but beefsteak, and they were in constant fear of losing him. He survived, however, to be painted by Chase and caricatured by Church and Blum for several summers.

CHAPTER XI

IN LONDON WITH WHISTLER

EIGHTEEN HUNDRED AND EIGHTY-FIVE was the year of Chase's memorable meeting with Whistler. He had planned a trip to Holland and Spain after a brief stop in London, but his presentation of a letter of introduction to Whistler considerably altered the course of his plans. Chase's recollections of that meeting, recorded by a writer for *The Century* and published in that magazine in June, 1910, run as follows:

"A friend of Whistler's gave me a letter,—a 'strong-pull' letter,—and armed with this I hastened to Whistler's studio in King Street, determined not to beard the lion in his den, but at least to salute him.

"I rapped and waited. Most callers waited at Whistler's door in those days, and few were admitted.

"Suddenly the door was opened, guardedly, however, and a dapper little man appeared on the threshold and eyed me keenly.

"'You're Chase,' said he quickly, 'are you not?'

"My carefully prepared words took sudden flight, and left me standing in utter confusion. 'Yes,' I said guiltily. 'How did you know?'

"'Oh, the boys have told me about you. Come in.' He tossed the proffered letter, unopened upon a chair, linked his arm affectionately within mine, and led the way to his studio. Our *camaraderie* began at once. For some reason he dubbed me 'colonel,' and in a moment we were chatting like old friends."

In a letter to Alice Gerson, written a few days afterward, Chase refers to this meeting:

"I'll most likely remain some days longer than I expected. Whistler has begun a full length portrait of me, and I will stay to enable him to finish it. He's the most amusing fellow I have ever met. London is in the height of the season now and everything is gay and lovely. . . My friend Mr. Dodd is still with me" (Mr. Samuel Dodd of St. Louis, one of the men who had assisted in sending Chase to Munich to study), "and I find him the same jolly old companion I found him in the beginning. I'll enclose a tin-type we had taken the other night by electric light. After I get through here I will take a boat direct for Holland. Mr. Whistler talks of going with me. I hope he will."

But as we read farther in the article describing those days, we note a certain modification of Chase's enthusiasm:

"Few hosts were ever as charming as Whistler *could* be; few men were as fascinating to know—for a brief

time. For a day I was literally overwhelmed with his attentions; for a week and more he was constantly a most agreeable, thoughtful, delightful companion.

"It had been my intention to hasten on to Madrid; but he would have none of it. 'Don't hurry,' he said calmly and with that sublime egotism he often expressed: 'there are many of my paintings here which you ought to see.'

"He had an exhibition in Bond Street at the time, and we spent some days there together, viewing his wonderful nocturnes. Occasionally he would speak of some painting of his hung in a private home. 'You go and see it,' he urged; 'I can't.' He could not, I found. His biting tongue, his constant quarreling, had made him *persona non grata* in many London homes."

"At the end of a fortnight he was quarreling with me. It was impossible, I believe, for any man to live long in harmony with him. After a brief discussion one day,— he chose to make it brief,—he said flatly, 'My dear Colonel, I'm not *arguing* with you; I'm *telling* you!' It was one of his favorite phrases. This was simply indicative of his general attitude: it was Whistler or nothing in all things great and small.

"I felt Madrid calling me again and determined to be off; but he, noting my preparations, was instantly

the charming, affectionate host. 'Don't go,' he urged. 'Stay, and we'll paint portraits of each other.' As usual, Whistler had his way."

Chase writes again a month later to Alice Gerson and a decided change in his view-point is perceptible:

"I really begin to feel that I never will get away from here. I'm getting on well with my portrait of Whistler which promises to be the best thing I've done. He is most finished with my portrait. I will bring both portraits home with me. Mr. Whistler goes to Holland with me next week. Great goodness, just think of my getting to Holland so late. I have only about three weeks left me to work in. I have not had a letter from you in two weeks. What is the matter? . . Mr. Dodd left me last night and I feel quite lonesome without him."

Chase's comments on his hotel strike oddly upon the ear of the traveller of to-day:

"The Metropole is the finest hotel in London (was finished this Spring). I know of nothing so fine at home. All the great swells come here, a great many Americans among them. Last night I recognized DeWitt Talmage (Brooklyn's famous preacher) sitting with some people in one of the grand parlors. I dine every evening in full dress as one is expected to do, have almost worn my suit out. I have a great deal to tell you about friend

CHASE'S PORTRAIT OF WHISTLER, CHARACTERIZED BY THE
SUBJECT AS "A MONSTROUS LAMPOON."

Whistler when I get home. Things " (he adds darkly) "that I think are better said than written. He continues to be a constant source of amusement. . . . You said in your last letter that Minnie and Jennie thought of going to the city for a while. Did they go? Please give them my love. I hope I shall hear from you soon.

"Yours, "WILL."

Chase's account of the painting of the portraits continues amusingly:

"He had his way with respect to the portraits too, I discovered. It was arranged that whichever was specially in the mood was to paint while the other posed. Whistler, I speedily found, was always 'specially in the mood,' and as a consequence I began posing at once and continued to pose. He proved to be a veritable tyrant, painting every day on into the twilight, while my limbs ached with weariness and my head swam dizzily. 'Don't move! Don't move!' he would scream whenever I started to rest a twitching muscle, or, 'Not yet! Not yet!' when my protests became indignant.

"At length I resorted to subterfuges. He rarely remembered his dinner engagements; so I took pains to keep the dates in mind, and when it was time to stop, to remind him of them.

[115]

"'What?' he would invariably reply. 'Interrupt doing a beautiful thing like this for a vulgar dinner!'"

While Chase was in London, Blum, Ulrich, and Duveneck were in Venice. Blum writes to Chase from there commenting upon his meeting with Whistler, not forgetting to include one of his favorite jokes, the assumption that the entirely Anglo-Saxon Chase was a Hebrew, and that his particularly regular nose was Hebraic in contour. The fact that Blum himself *was* a Hebrew adds an odd turn to his jest.

"I was tickled to hear that you met Whistler in such a splendid fashion and more so at your luck in having your 'picter tuk.' By the way tell him to SPARE THE NOSE. I hope you will find a good summer's work awaiting you in Zandvoort and be sure to act kindly by the natives. DON'T GET MAD. I understand that this summer JEWS will not be allowed on the beach.

"P. S. I shall stay all summer and most likely all through the winter. Ulrich has commenced a stunning thing of the glass blowers. He sends regards.

<div align="right">"Yours, "Bob."</div>

"Write soon.

"Happy thought

write sooner. Rico is in town. Lives next door to us."

Chase, however wrathful at the moment, never really lost his sense of humor where Whistler was concerned. His reminiscences of that summer continue with entertaining anecdote and occasional analysis:

"At one home he arrived at a dinner party at least two hours late. 'How extraordinary!' he exclaimed, glaring fiercely at the gaping guests and the hostess. 'Really, I should think you could have waited a bit. Why, you're just like a lot of *pigs* with your eating.'

"When the portrait was finished he stood off and admired his work. 'Beautiful!' he exclaimed. 'Beautiful!' I was in no mood at the time for the retort courteous. 'At least, Whistler,' said I, 'there's nothing mean or modest about you.'

"He grinned. 'Nothing mean *and* modest,' he corrected. 'I like that better. Nothing mean and modest. What a splendid epitaph that would make for me. Stop a moment; I must put that down,' and he reached hastily for his note-book.

"He was forever jotting down his sayings. No more faithful Boswell—of himself—ever lived. What prompted him? Was it his abnormal conceit, or only the determination that at least when he passed away he should be understood and appreciated? Undoubtedly both. His was a bitter struggle, remember. The critics were con-

stantly scorning him, and a good measure of the harsh judgment and galling neglect he suffered came from his own countrymen.

"As for his conceit, it was self-evident. At times he was most childish about it. 'What a lot you'll have to tell about me, Colonel, when you go back!' he said one day.

"'No,' I replied; 'for you've done nothing, said nothing, new. You're the greatest disappointment of my life.'

"'How terrible you are!' he exclaimed. 'You are watching me!'

"It was good to get even with him in repartee. It was rarely possible; he was as quick as a flash with his wit, and stronger than others sometimes in a brutal and unfair way. It was his delight to pick up an innocent remark and turn it back upon the speaker, or else twist it about so as to make his adversary appear ridiculous. This he did with his severest critic, the art editor of the London *Times*, taking from his articles a single sentence and, by isolating it, making it seem nonsensical in every way.

"The studio was frequented much by a literary light of those days who, it was generally known, fed upon Whistler's epigrams, and retailed them as his own. Everybody knows the painter's famous repartee at the ex-

pense of this man. 'Oh, Whistler,' he sighed one day, after a particularly brilliant sally from the latter, 'why didn't I say that?'

"'Never mind,' said Whistler, stingingly; 'you will.'

"There was a steady stream of creditors at the King Street studio in those days. Whistler made no effort to conceal the fact that he was deeply in debt. One day as we were busily and silently working there came a loud, businesslike rap at the door. Whistler listened attentively as one might to a key of music.

"'Psst!' said he, 'that's one and ten.'

"Within half an hour there was another rap, not quite so loud.

"'Two and six,' said Whistler. 'Psst!'

"'What on earth do you mean?' I asked after a time.

"'One pound, ten shillings; two pounds, six shillings. Vulgar tradesmen with their bills, Colonel. They want payment. Ah, well!' he sighed with an exaggerated air of sadness and returned to his canvas.

"Then came another knock, a most gentle, insinuating rap.

"'Dear me,' said Whistler, 'that must be all of twenty! Poor fellow, I really must do something for him! So sorry I'm not in.'

"I could not take the situation so placidly, and seized

eagerly the first opportunity of financial aid that presented itself. A rich American, sojourning in London, asked me what he should purchase and take back with him from the metropolis in the way of art.

"'By all means get a set of Whistler's etchings. Unquestionably he will make for you a selection. I'll speak to him,' I told him, and hurried back with the good news.

"Whistler was delighted, and for a day worked busily, overhauling and sorting his proofs. The selection was a splendid one, and called for a substantial payment. It was arranged that Whistler should meet the purchaser at a bank in Queen Street the following morning and receive his check.

"Most men, under the circumstances would have thought of little else; but by the next morning Whistler had wholly forgotten his engagement. He had begun a new canvas, and was completely absorbed in it. For a while I expostulated in vain.

"'Come, Whistler,' I said finally, 'you have been away from America so long that you don't appreciate the value of time to the traveler, particularly the American traveler. You must not keep the man waiting.'

"'Very well,' said he, laying down his brushes with a sigh. 'Now we'll go.'

"'Why *we?*' I replied. 'I don't want to go,' I protested firmly. To tell the truth, I was looking forward with a great deal of comfort to a morning all to myself.

"'Oh, but you must,' he said calmly, bringing my coat and hat; and presently we stood in front of the house signaling a cab.

"One came up readily enough, but, after one scrutinizing look upon the 'cabby's' part, drove swiftly by; another went through the same strange proceeding. I looked questioningly at Whistler—this odd circumstance had happened before when we were together—but Whistler was calmly signaling. At length a cabby took us in.

"Whistler always carried as a walking-stick a long, slender wand, a sort of a mahlstick, nearly three quarters his own height. We were no sooner seated than he began poking his stick at the horse's hind-quarters. The animal reared, plunged wildly, and started down the street at a breakneck gallop, while the astonished cabby swore freely and tugged desperately at the reins. Whistler looked calmly ahead, and kept poking.

"Butcher-boys and grocer-boys made wild leaps for safety; outraged cabbies whipped their horses out of the way just in time, burly draymen bawled curses after us, and still we went merrily on. Little wonder, thought

I, in the midst of my amazement and resentment, that Whistler never gets the same cab twice.

"Suddenly he began waving his cane and screaming 'Whoa!' He took the astonished cabby severely to task for driving so fast upon the public highway, and ordered him back to a corner we had just passed.

"Here a greengrocer's shop, with its orderly and colorful array of fruits and vegetables, had caught Whistler's eye as we whirled by. He surveyed it critically now from two different positions, the cabby meekly obeying his orders, under the belief, I presume, that it was policy to humor an insane person.

"'Isn't it beautiful!' exclaimed Whistler. He pointed his long cane at one corner. 'I believe I'll have that crate of oranges moved over there—against that background of green. Yes, that's better,' he added contentedly.

"We drove on to the bank, where we found the American pacing up and down in no pleasant frame of mind; but Whistler soon had him pacified, and we left him waving and smiling adieus at us.

"The incident at the greengrocer's shop reads like an arrant affectation. It was not, however. Whistler, as usual, was merely most natural. The following morning he posted his easel at the corner and painted the shop.

"Whistler's unconventionality was consistently maintained. It was part of his pose, of course. He knew that it puzzled people and made him talked about. Once at a dinner-party at which I was present he appeared without a tie. As soon as I noticed the omission I hurried up to him. 'Oh, Whistler,' I exclaimed in a warning undertone, 'you've forgotten something—your tie, man, your tie!'

"'Stuff and nonsense!' he retorted. 'Would you spoil fine linen—these lines,'—he pointed to his collar and shirt-front,—'this harmony, with a flimsy bit of lawn?'

"It was his custom when drowsy to go deliberately to sleep, no matter where or what the circumstances might be. At one dinner-party his gentle snore suddenly aroused his neighbor, who nudged him violently with his elbow. 'I say, Whistler,' he protested excitedly, 'you must not sleep here!'

"'Leave me alone!' snapped Whistler. 'I've said all I wanted to. I've no interest at all in what you and your friends have to say.'

"One evening he was my guest at dinner at a hotel; Edwin A. Abbey was also there. Right after dinner Whistler went calmly to sleep; on the way to the theatre he enjoyed another nap in the cab, and he slumbered

peacefully through the greater part of the play. The next morning he blandly asked me: 'What did Abbey have to say last night? Anything worth while?'

"There were two distinct sides to Whistler, each one of which he made famous. He succeeded as few ever have in creating two distinct and striking personalities, almost as unlike as the storied Dr. Jekyll and Mr. Hyde. One was Whistler in public—the fop, the cynic, the brilliant, flippant, vain, and careless idler; the other was Whistler of the studio—the earnest, tireless, sombre worker, a very slave to his art, a bitter foe to all pretense and sham, an embodiment of simplicity almost to the point of diffidence, an incarnation of earnestness and sincerity of purpose.

"The Whistler of Cheyne Walk was a dainty, sprightly little man, immaculate in spotless linen and perfect-fitting broadcloth. He wore yellow gloves and carried his wand poised lightly in his hand. He seemed inordinately proud of his small feet and slender waist; his slight imperial and black mustache were carefully waxed; his monocle was indispensable.

"For all who crossed his path he was ready with cutting speech. That apparently was his business in life—to amuse himself at the expense of others; and in this form of entertainment he spared no one's feelings

and stopped at no extremes. He took no one and nothing seriously; he was sublimely egotistical, and seemed to delight in parading his conceit. He was trivial, careless, brilliantly and smilingly disagreeable.

"Now view Whistler behind the scenes. He had prepared his outward blandishments with the skill and patience of an accomplished actor. For hours he had stood before a mirror, with curling-irons in hand, training carefully his hair, in particular that famous white lock, fussing and primping like a woman. He was putting on his mask. A most clever mask it was, most cleverly sustained. Very few who knew him only in public ever saw behind it, and then they saw only the man's attitude, which said: 'You've never taken me seriously; why should I be serious with you? You have never spared my feelings; why should I spare yours? You are ceaselessly sending your darts of scorn and criticism at me; now, I am returning them.' And so he did in full measure.

"This was merely Whistler at play. The real, genuine Whistler had been at work since early morning, working like a fiend—and, in truth, looking like a fiend as he worked. The monocle of the night before had been laid aside for an unsightly pair of iron spectacles, so heavy that they were clumsily wrapped with cloth where

they rested on his nose. His hair was uncombed; he was carelessly dressed.

"Some student admirers from Venice called at the studio one day and found the real Whistler at work. They had seen him previously on the *piazza*, carefully groomed for the occasion. Now they stood speechless with surprise. At length their spokesman exclaimed artlessly, 'Why, Mr. Whistler, whatever has happened to you!'

"'What do you mean?' he demanded.

"'You—you seem so different,' said the young man.

"'Oh,' said Whistler, 'I leave all gimcracks outside the door.'

"Among those who knew him well, Whistler made no pretense at concealing the fact that his public life was a deliberate pose. At home he doffed his mask completely. Why, then, the question naturally arises, should he bring home with him his quarrelsome spirit? Why did he choose also to war with his friends?

"I have spoken of his ceaseless, earnest toil. He was the greatest putterer I have ever known. He had been a poor student, and had little schooling in art. In consequence, he had to dig diligently for everything he got. It must measure up, too, to his high, self-elected standards. So, whatever it was, a harmony of color or of con-

tour, it was necessarily best when he got it. In consequence, there is not a mediocre touch in all his work; neither is there any semblance of the academic. It is all absolutely original and thoroughly distinctive. His art is the unaffected expression of his convictions and impressions of the world about him, and these impressions were worth recording.

"Of detail and construction he knew little and cared less. He would produce a great portrait; you might know that, but you could not feel certain that he would get his subject upon his feet. Inanimate objects—a boat, a building—he chose to depict not as they actually were, but as they appeared to him.

"Many of Whistler's well-known sayings and doings have been misinterpreted, sometimes to his credit, sometimes not. His answer to the lady who coupled him with Velasquez as the world's two greatest painters—'Why drag in Velasquez?'—has been generally taken as a striking evidence of either outrageous conceit or downright flippancy. As a matter of fact it was neither. 'Did you ever really mean this, Whistler?' I asked him one day.

"'No; of course not,' he replied seriously. 'You don't suppose I couple myself with Velasquez, do you? I simply wanted to take her down a bit, that's all.' It was simply

his way of checking flattery so fulsome as to be irritating."

Whistler never spared his Satanic wit where the Philistine was concerned. Chase always enjoyed retailing that question of his about the supposedly beautiful homes of the newly rich in America. "But isn't there always some damned little thing on the mantel that gives the whole thing away?"

Chase also recalled that light and characteristic bit of vengeance wreaked upon the architect of the Tite Street house by Whistler.

"This was the house which the architect E. R. Godwin built for him, and which was seized for his debts. When Whistler moved out, he left this inscription upon the walls: 'Except the Lord build the house, they labor in vain who build it. E. R. Godwin built this one.'

"While the bailiff was in possession, Whistler seized the opportunity to invite several of his friends to an elaborate luncheon at which the bailiff officiated as butler. His subversion of the situation in this way is generally cited as an evidence of his remarkable powers of persuasion. I am not discounting this faculty of his in any way. The man's power was wonderful; he could be, if he chose, a very octopus, wrapping one with subtle but forceful tentacles of suavity, agreeableness, at-

tractiveness. But a London bailiff was not of the fine caliber to be responsive to Whistler's cajolery. The fact of the matter is, I verily believe, that he simply tipped the man to delay proceedings and act meanwhile in the capacity of a servant. In other words, he deliberately plotted the whole affair for purposes of show.

"I might cite in confirmation the following instance, the facts of which I know to be true. Once he invited a distinguished American artist whom he had met casually during the day to dine with him that evening. Arrived at his club, Whistler left his guest waiting outside in the cab while he went in to ascertain if they 'had anything decent to eat.' He appeared shortly with a grimace of disgust. 'Nothing worth while here,' he said. 'We'll try another.' The second club was also lacking in an attractive menu; nothing in it appealed to his fastidious palate, he averred. 'Oh, well,' he said finally, with an air of resignation, 'we'll go home and try potluck.'

"Arrived at his house, he ushered his guest carelessly into the dining-room, where a sumptuous repast was served upon a table brilliantly lighted and most artistically decorated. Of course Whistler had had all these elaborate preparations made in advance.

"Sir John Millais met him outside his studio one

day, and after a brief conversation said cordially: 'Jimmy, why don't you paint more pictures? Put out more canvases.'

"Whistler, with a meaning look and carefully placed emphasis, replied: 'I know better.'

"'The fool!' he muttered as he came into the studio. 'He spreads himself on canvas on every possible occasion—and, do you know, he called me "Jimmy"! Mind you, I don't know the fellow well at all!'"

The rapier of Whistler's wit was always ready for the academician be he never so harmless. Chase was fond of repeating Whistler's remark to the gushing young woman who sat next to him at dinner bent upon eulogy of Sir Frederick Leighton—"You know he is such a clever man—an astronomer, a sculptor, a linguist, an orator—" At which point Whistler interrupted with false enthusiasm: "Oh, yes, and you know he paints, too——"

Chase believed that Whistler's discourtesies were deliberately affected; "even his epigrams were occasionally prepared in advance, and stored up in memory to be ready for a suitable occasion. His spontaneous retorts were his best.

"A well-meaning friend came to him enthusiastically one day to tell him of a pretty spot near London that

would be just the place for him to sojourn in and paint. 'I'm sure you'll like it,' he said confidently.

"'My dear fellow,' said Whistler, 'the very fact that you like it is proof that it's nothing for me.' However, he did go there, and was greatly pleased with his surroundings. He arrived safe himself, but his canvases were delayed in transit, and for one full afternoon he trotted back and forth between the hotel and the station, fretting and threatening, making life miserable for the railway guards and for every one else about him. As usual, he was the centre of commotion. 'Look out, Whistler,' I warned him, 'or they'll find out who you are.' He scowled at me in return.

"Seeing that I knew him, the station-master came up to me. 'Who is that quarrelsome little man?' he asked with an aggressive look. 'He's really most disagreeable.'

"'Whistler,' I replied apathetically, 'the celebrated artist.'

"'Oh,' said he, changing his expression instantly to one of deep humility and solicitude. He approached Whistler with profuse apologies. 'I'm very sorry, sir, about your canvases,' he said. 'Are they so very valuable?'

"'Not yet,' screamed Whistler; 'not yet.'

"Another of his well-known spontaneous retorts was his reply to the English miss, a pupil of his, who greeted him effusively one morning with: 'Oh, Mr. Whistler, coming in on the train this morning the country-side was shrouded with a beautiful, soft haze; and everywhere I looked I seemed to see in the landscape one of your charming paintings.'

" 'Yes, yes,' said Whistler, with exaggerated pomposity; 'nature's creeping up! She's creeping up!'

"As my stay in London drew near its end, our quarreling increased, try as I would to avoid it. 'Don't! Don't!' I cried out in desperation one day. 'At least let me carry away a pleasant last impression of you.'

"His answer I have always remembered, since it indicated, if only indirectly, that he thought of me as a friend. 'You don't seem to understand,' he grumbled. 'It is commonplace, not to say vulgar, to quarrel with your enemies. Quarrel with your friends,' he advised fiercely; 'that's the thing to do. Now be good.'

" 'After all, Colonel,' said he one day, 'the only real objection I have to you is that you *teach*. You're just like all these others—this vulgar crowd.' He waved his hand at the others present. The occasion was one of his 'Sunday breakfasts.'

"It was on my lips to reply, 'Why, you teach too,

in your own way, and your own ideals.' Later he became a professed teacher, opening an atelier in the rue du Bac, Paris. Two former students of mine entered his school, and when questioned by Whistler as to their previous teacher gave my name. 'Ah,' said he, graciously, 'you could not have done better.' A third student replied that he had had no teacher at all. 'H-m-m,' said Whistler, loudly, '*you really* could not have done better.'

"Another student of mine who had become an enthusiastic impressionist began a study doing a purple, pea-green, and orange kind of thing. 'Mercy!' screamed Whistler, as his eyes fell upon the canvas. 'Whatever are you trying to do?'

"'Painting nature,' she replied calmly, 'as I see it. Am I not right? Should not one paint nature as one sees it?'

"'Yes, yes,' said Whistler, 'so long as you do not see it as *you* paint it.'

"My stay in London had been so protracted that I determined to go directly back to America, taking the boat at Antwerp. 'Come to Holland with me,' I suggested to Whistler.

"'Perhaps,' he replied. 'What inducements have you?'

"'The old masters,' I suggested. 'You've seen them

often; but, then, it's different with *you*. *You'll* take delight in seeing them over and over again.'

" 'You're right,' said he, '*sometimes* you are. But they'll keep. What else?'

" 'Our delightful companionship,' I suggested. It was difficult not to be vindictive. 'Should we not prolong it?'

" 'Oh, you'll keep, too,' he answered lightly.

" 'Well, there's the international exhibit at Antwerp —new pictures by Bastien-Lepage, Stevens, and others which you ought to see.'

"At the last moment he decided to go, and we hastily booked our passage. It was too late to secure a stateroom together, a hardship to which I was resigned. The night was stormy, and knowing how bad a sailor Whistler was, I hastened to his state-room in the morning to look him up. He was gone, and in his place I found an Englishman who wore an expression of deeply wounded dignity. 'I say,' said he, in an aggrieved tone, 'are you not a friend of that little antediluvian who occupied the berth above me last night? Do you know, sir, that he had his foot in my face every five minutes all night long. I say, you know; he really must be somebody to behave in such an extraordinary fashion. Who is he?'

"I told him. 'Oh,' he replied, and there was a wealth

of understanding in his tone. 'I wonder,' he asked eagerly, 'if I could meet him.'

"Neither Whistler nor I was in the best of humor at breakfast, and driving out from the hotel, I determined, if possible, to go through the exhibit alone. Arrived at the gallery, I decided firmly upon this course. He had already adopted the exasperating habit he had of shifting to my shoulders the entire responsibility for the enjoyment of our trip. 'Now,' said he, looking sneeringly about the gallery, 'where are your Bastiens?'

" 'There's one,' I replied, 'over there—his portrait of his brother. But, if you please, I prefer to see it alone.'

" 'Eh!' he cried. 'What's this? You ask me to come over here with you, and then you adopt *this* attitude ?'

" 'Yes,' said I, 'for I don't mind telling you—I'll pay you this compliment—you have the ability to say in a single word that which I don't care to hear about these pictures.'

" 'Come, then, you must hear that word !' he snapped. He dragged me up before the portrait, and shot out his finger accusingly at it. 'School!' he hissed. Later, standing before a painting by Stevens, an admirable piece of work, he pointed his skinny little finger at a bit of detail away up in one corner of the canvas, and said, 'There ! One might not mind to have done *that!*'

"The end of a most unhappy day found us in a railway-carriage traveling on to Amsterdam, huddled up in opposite corners, and glaring fiercely at each other. In the same compartment sat two Germans who kept up steadily a loud and joyous conversation. To me it was most interesting and in no way annoying; but Whistler, who affected a dislike for Germans, was fidgeting with evident irritation.

" 'Colonel,' he began presently in a shrill, rasping voice, 'the good Lord made one serious mistake.'

" 'What is it now?' I snapped.

" 'When He made Germans.'

"I have lived six years of my life in Germany, and I am fond of the Germans.

" 'It's a great pity, Whistler,' I replied, 'that you don't understand German. It would profit you greatly to listen to the talk.'

"He grinned spitefully at this, and, turning, answered me fluently and at some length in German! And now he became very voluble, earnestly seeking for new topics of conversation, and diligently expressing his views in German. A gadfly could not have been more persistently and maliciously annoying. Human nature could stand it no longer, and at length I revolted. I was deadly in earnest when I said: 'Whistler, I will not go on to Amster-

dam with you. Frankly, I don't care to be responsible for what might happen. The next station is Haarlem, and one of us must get out there. If you wish to, I can direct you to a good hotel where they'll put you up with a good room and bath; or I'll get out——'

" 'Yes, Colonel,' said he sweetly, in German; 'you get out.' And so I did, with a feeling of utmost relief and thorough contentment. As the train moved out of the Haarlem station and left me standing knee-deep in my luggage on the platform, he poked his head out of the window and screamed back, still in German: 'A pleasant night to you, Colonel! To-morrow—to-morrow you'll find out that what I said about the Germans is true.'

"I saw Whistler only once after this—on the following day, in Amsterdam. At the hotel in Haarlem I found the cards of some young artists from Brussels who were expecting my arrival. They were ardent young revolutionists in art, and when they learned that Whistler—the great Whistler—was in Amsterdam, only twenty miles away, their voices arose in loud acclaim. Could they be presented to him? Would I perform the ceremony? My resentment, as usual, had cooled somewhat overnight and I agreed.

"At his Amsterdam hotel Whistler kept us waiting for a full half-hour. I said nothing to disturb their devotion,

[137]

but I knew well what the great Whistler was doing. He was standing before a mirror, curling-irons in hand, adding endless touches to his hair, white lock, and mustache, or ironing out wrinkles in his face.

"Ah, he came at last with mincing step and monocle set—the dainty, dapper Whistler of Cheyne Walk, Whistler with all his 'gimcracks' on, Whistler on parade, the flippant, enigmatical, cynical, caustic Whistler of the world. And as he stood before his hero-worshipers and heard their murmur of irrepressible adoration, he half averted his face toward me and behind his handkerchief passed me a deliberate, meaning wink!

"Yes, there were two distinct Whistlers, but there was only one genuine one—Whistler the tireless, slavish worker, ceaselessly puttering, endlessly striving to add to art the beautiful harmonies, the rare interpretations that his wonderful imagination pictured for him; Whistler the great artist, in other words, for that was his *real self*, which will live in all its glory when the man's eccentricities are utterly forgotten."

CHAPTER XII

CONCERNING THE CHASE-WHISTLER PORTRAITS

THE fate of Whistler's portrait of Chase is still shrouded in mystery. It has been said that Whistler destroyed it, which is probable if he was not satisfied with his work, but not otherwise. Chase insisted upon taking his portrait of Whistler back to America with him, wisely foreseeing that if he did not do so he might never regain possession of it, but he was never able to get hold of his own. Whistler, as shown in the letter quoted below, returned the sum that Chase had paid for it.

Evidently Whistler did not regard Chase's presentment of him as flattering, for in "The Gentle Art of Making Enemies" he remarks characteristically: "How dared he (Chase) do this wicked thing—and I who was charming made him beautiful on canvas, the Masher of the Avenues!"

Upon the subject of the portraits Chase had the following letter from Whistler before he left London. It is interesting because, in addition to its characteristic flavor, it shows a certain serious vein of appreciation of Chase's kindliness:

"My Very Dear Chase,

"You are by this time of course convinced that I have sponged with my wonted facility all traces of the past few weeks from my memory, and that the colonel and his kindliness and good companionship have all ceased to exist for me!—

"No! *Noo NOO*—Your stay here was charming for me and it is with a sort of self-reproach that I think of the impression of intolerance and disputatiousness you must carry as characteristic of my own gentle self—which also I suppose it will be hopeless for me to attempt to efface by even the mildest behavior when I return your visit in New York. Our little trip to Holland was charming and I only wish I could have stayed longer. Indeed if I had but gone with you to the gallery in Haarlem I might have done something toward rehabilitating myself in your eyes for I had meant to be quite sweet about the pictures as after all 'there is nothing mean or modest about me'—My dear Chase this is really quite perfect! I have never been so daintily appreciated and I shall insist upon the insertion of this resumé of Whistler's rare qualities in the biography of that great painter a century or two hence.

"Meanwhile our two pictures. By the way the world will have to wait, for yet a little while longer. You see

colonel we rather handicapped each other I fancy and neither master is really quite fit for public presentation as he stands on canvas at this moment. So we must reserve them, screening them from the eye of jealous mortals on both sides of the Atlantic until they burst upon the painters in the swagger of completeness.

"This is a disappointment, though only a temporary one, to me most certainly so far as your portrait goes for I should have liked you to have taken it over with you and shown it on your arrival. But in these matters I never deceive myself and I saw at once on my return from abroad that the work is not in its perfect condition and Whistler cannot allow any canvas stamped with the butterfly to leave his studio until he is thoroughly satisfied with it *himself*. Therefore my dear Colonel I shall keep the picture here and bring it over with me to finish in your studio where again I will prove to you that my long suffering is equal to your own as I stand in my turn till you finish the 'pendant'—my artless self. Under the circumstances I send you back the thirty pounds you had given me on your portrait—trust me it is better so —it would only make me nervous and unhappy were I to keep it before my work pleased me. While I shall be delighted to take it from you over there when I have done well—'as it is my wont.'

"I am also awfully sorry that 'the boys' in New York are not to see your impression of Whistler with his wand before I come myself—but what will you! The center of thought is the stomach and we were too far from well—*poisoned!!*

"And now I must thank you again for the delicacy and good feeling you have shown about the other pictures at Graves—It was so nice and kind of you to leave it entirely to me to think out—whereas any one else might have taken the occasion of the pictures being for the time out of my possession to obtain them simply—without consulting me at all.

"You will quite sympathize with me I am sure when I find upon reflection that I would like to get back those things for myself. This I really always hoped to do—but lately I was so absorbed by your picture that I could not think well of anything else. However now if you will when I come to America I will try and bring you something else that you will like quite as well—indeed better.

"Meanwhile again I return the money forty pounds.

"I have consulted my bankers who think that the best way of convoying to you the sum of money is letters of credit on some bank in New York. I told them you would not wish a lot of Dutch metal upon which you

would lose so they have given me for you a letter of credit for seventy pounds. This I enclose.

"Also the paper from the American consul freeing you of all duty on account of the etchings.

"For Heaven's sake my dear Colonel write me at once to say that you have received all this safely or I shall writhe in uncertainty.

"Bon voyage my dear Chase. Write me word of your safe arrival in the delightful country you say the other one is and expect me soon.

"Always devotedly"

[Here the letter is signed with the butterfly.]

"Never wrote such a long letter to anyone.

"I have taken out the papers from the U. S. Consulate to the amount of 160 pounds for I have forgotten the exact sum you paid me—but this is near enough. Anyhow you have the receipt."

The pictures referred to by Whistler as being "for the time out of his possession" were, according to Mr. Algernon Graves, the Carlyle portrait, that of Whistler's mother, also those of Miss Franklin and Henry Irving, the two nocturnes which figured in the Ruskin trial, and a *Battersea in a Fog*. These pictures had been taken to Graves by Whistler's friend Charles Howells as

security for a loan, and Whistler up to the time under discussion had been unable to recover them. Chase, with characteristic generosity, had given Whistler a check for the purpose of regaining the *Carlyle*, and although he longed indescribably to own the picture, left the disposition of the matter entirely to Whistler. Whistler, as the letter shows, while appreciating Chase's generosity and fine feeling, preferred to return the money he offered and wait for the opportunity to regain possession of his canvas himself. After Howells's death Whistler made Graves a deposit on the *Carlyle* and finally bought it back, afterward selling it to the Glasgow museum. Later he secured the portrait of his mother and the nocturnes. The others remained in Graves's possession and were subsequently sold by him.

Whistler took an immediate fancy to the tall flat-brimmed hat made famous by Chase.

Mortimer Menpes remembers how Whistler exclaimed at first sight of it: "Ah, that's very good, very good indeed. I like that," and soon afterward abandoned his much-described white hat in favor of it. Having honored Chase by adopting his head-gear, Whistler used afterward to inquire unblushingly of visitors from America: "Is Chase still wearing my hat?" Later when the originator of the hat had incurred his enmity by quoting

WHISTLER. CHASE. MENPES.

From a photograph taken in 1885.

Whistler's alleged description of Chase's portrait of him—"a monstrous lampoon"—for exhibition purposes, Whistler received the mention of his old friend's name in a different but equally characteristic fashion. "Why, you have a hat like Chase's," a caller remarked one day. Whistler lifted his eyebrows. "Chase? Who is Chase?" he drawled.

After leaving Whistler, Chase's holiday was more restful. He found his friend Walter Palmer in Holland and in his society enjoyed art and art talk in peace.

When Chase returned to New York that fall he received a characteristic letter from Blum in Venice:

"Because Whistler paints your portrait that need hardly restrain you. *I* think just as much of you. I suppose you have seen Palmer by this time. He did some awfully nice things here. Rico is here. He has the room next to mine and is doing some charming things. I have wasted almost all the time I've been here fooling around in oil. Tried some etching, but all were failures. No water colors. Will stay all winter and hope to do something. Ulrich has done some lovely things and Duveneck has under way a large and very good canvas of a water stairway with woman getting water.

"Now I come to think of it I know why you won't

write, but I assure you I was joking when I said that Jews weren't allowed on the beach. I wanted to say 'in the hotels.'

"I like you anyhow.

" BLUM."

Later in the year when Twachtman had joined the painters. in Venice, the two men who were not enjoying the raw Venetian winter sent two nonsensical letters to Chase written the same day and containing caricatures of each other.

Blum's letter reads:

"DEAR CHASEY,

"Now I take my pen in hand to inform you that I am in good health hoping the same of you. (Twachtman suggests to say instead, 'hoping that you are the same.') The weather is fine although it is cold and chilly and the fogs are the same. Piero at the café thinks there ought to be a change very soon. I think the same. I hope you are well and business good and wish you a Happy New Year. The Jews are all going up to Holland next year. I suppose you will see them there. What house are you drumming for now? C—— is going. I suppose you will keep out of his way. He says you cheated him the last time you were here. (Twachtman says the only time you

were here.) Lend me your nose. I may want to go to Holland next summer.

"We hope you are in good health.

"Please answer. Splendid weather, especially the washing weather in the morning. I didn't get your Christmas present yet. What is it? You ought to see the hat Twachtman wears. He has his hair cut and looks like this [picture]. Don't you think so too! What!

"What do you think of pastels?

"Hoping you are well and in good health I now lay down my pen telling you that I am the same and hoping to hear from you soon I remain your friend,

"Bob Blum."

Twachtman's "companion piece" reads as follows:

"Dear Chasey,

"Now I take my pen in hand to inform you that I am well and hoping that you are the same. Blum never knows how to commence a letter. The weather is very fine although it is cold and chilly with occasional rains and fogs. The barber suggests that there should be a change very soon. Don't you think so too? Please answer. I hope you are in good health with fair prospects for the Happy New Year. Jews will not be allowed on the Lido next summer, don't come!!!!!!!!

"Chase your light's out!!! Old C—— asked for your address. We hope you are in good health. Please answer. The weather is very fine and it is snowing.

"I saw your caricature the other day and I hardly notice the smallest change. I recognized you at once. Shoot the hat! You ought to see Blum's hat. He is going to cut his hair and will look like this. [Picture.]

"How do you like his beard? Please answer.

"What do you think of pastels? Blum's got the cholera. His hair's coming out.

"Hoping that you are well for I am the same—Write soon. Your friend,

"TWATTY."

About the same time Blum writes an illustrated letter to Minnie Gerson about the beard, evidently the second letter on the subject, the first having enclosed a photograph of himself thus adorned.

"I forgot to tell you not to show it (the photograph) to Chase. However the damage is done now I suppose, so show it to him whenever you like or he asks for it. I have had it cut (Twachtman did it), I am wearing it to a point something like Chase's."

Chase never saw Whistler again, but he never permitted his enthusiastic estimate of Whistler the great

and sincere artist to be affected by his occasional moods of retrospective exasperation at the man. Indeed, Whistler's childish wrath seemed only to entertain him, and he was fond of quoting that occasion when his name came up for discussion at a dinner-party and Whistler's sister remarked: "Mr. Chase amuses James, doesn't he, James?" To which James, tapping his finger-tips together, retorted promptly: "Not often, not often."

Chase also delighted in that delectable Whistlerism made in his presence when the painter disposed of an urgent patron who was attempting to gain possession of her portrait: "Some people seem to believe because they have paid two hundred pounds for a picture that they own it."

Another remark of Whistler's, profound under its epigrammatic surface, Chase used often to quote to his students; the story of the fashionable woman engaging a portrait who said to the artist: "And if I don't like it when it is finished, Mr. Whistler, I don't have to take it, do I?" To which Whistler, with a diabolic gleam of the eye, retorted:

"Ah no, madam, that is not the case at all. Quite the contrary. If *I* don't like it *you* can't have it."

CHAPTER XIII

EVENTFUL YEARS IN ART AND LIFE

EIGHTEEN HUNDRED AND EIGHTY-SIX was the year of Chase's marriage. That circumstance which can make or mar an artist and which even in the least influential case must in some way affect his development, was a fortunate one for Chase, for his wife then and always complemented his life and his art. Brought up in intimate association with art and artists, married to an artist in whom the impulse to pass on his knowledge of the beauty he had found was irresistible, Mrs. Chase derived from and adapted herself to her environment, and in every way contrived to create in his home the atmosphere of art.

Eighteen hundred and eighty-six was also the year of Chase's exhibition at the Boston Art Club, which was something of an event in his artistic career, since at that time the one-man exhibit so usual to-day was practically unknown.

It was during this year that he was again elected president of the Society of American Artists, an office he held for nine years. They were important years in the development of American art and the value of Chase's influence in that position cannot be overestimated.

Chase gave up his position at The League in 1884, but in the fall of eighty-five he went back and continued to teach there until 1894.

The first winter of their married life the Chases lived for a short time in the Tenth Street Studio apartment, afterward taking rooms on East Ninth Street. The next year they moved to Brooklyn, where they lived for a few months with the painter's parents. It was at this period that Chase first painted the Prospect Park sketches, utilizing the small figure in the formal park landscape in a way that was quite original. Any suggestion that he may have received from other sources for these characteristic sketches came from the French painters, although the canvases contain little more suggestion of the French impressionist's manner of painting light and sunshine than they do of the dark-toned Bavarian school. They are done in a light key, yet without any attempt to suggest atmosphere or to record any special time of day. The color notes—of a child's ribbon or gown, a park bench or a toy boat—have not quite the "touch" that distinguishes the later Shinnecock landscapes, yet they possess in a marked degree that quality of style which Chase unquestionably had. For the next four years the painter was interested in these park subjects. When he returned to New York he found motives of

the same sort in Central Park where he often took with him Livingston Platt, an early pupil whose decorative talent had interested his master.

It was during his stay in Brooklyn that Chase painted at Fort Hamilton that fine and quiet little landscape called *Peace*.

A sale of the painter's pictures that took place about this time was disappointing financially, as they went for prices far below those that the painter usually commanded, but it was an interesting period in the development of his art.

Chase and his wife moved rather frequently at that time. From Brooklyn they went to an old house in West Fourth Street, then an attractive part of Greenwich Village. The following summer was spent in Orange; the summer after that they had a cottage at Bath Beach, where Chase painted more interesting outdoor subjects with the figure in the landscape. It was at this house that the painter came very near being accidentally shot by his young wife. In fact his life was saved by his then famous Rubens ring.

Chase had returned on a late suburban train from a dinner given by Stanford White and conceived the brilliant idea of entering his room through the bedroom window instead of the door, in order not to awaken his

wife. Mrs. Chase, who had been alarmed by the behavior of an employee about the place, had retired with a revolver under her pillow. Hearing some one fumble with the catch of the blind at her window she was naturally very much frightened. The next moment when a man's hand appeared on the edge of the shutter she assumed that the expected intruder had arrived, and raised her arm to shoot when by chance she caught sight of the man's ring and realized that the housebreaker was her husband.

Those were interesting days in the Tenth Street Studio. The studio itself was a thing quite unique. Many an artist who remembers it as his first impression of an artistic studio has said that in creating the Tenth Street Studio alone Chase did an immeasurable service to art.

Overcrowded though it may appear in photographs, the painters who remember it distinctly say that its whole effect was one of great beauty of tone and color. Chase's own sketches give a more adequate idea of what it must have been like.

My own memory of the studio, to which I was taken as a child, was of a vast darkish place containing beautiful spots of color. But despite its unlikeness to anything I had seen before, the memory that remained with me

was the extraordinary kindness of the grown-up painter with the Van Dyck beard in showing me his canvases as if my tastes and opinions were of real importance. Of those pictures I remembered most distinctly the one called *Mother and Child*, recalling every detail of the composition and color and the very shape of the baby's head against the mother's shoulder. Seeing it several years afterward for the second time on an exhibition wall, it held no surprises, it looked just as I had remembered it.

The studio was full of beautiful things that Chase had collected. One of his hobbies was clocks. There was one Mrs. Keith recalls that the artist wound with touching fidelity each night, although the hands were missing, so that although it ticked with life it informed not. Another clock was, it seems, overactive in its time-proclaiming quality—embarrassingly so upon one occasion.

At one of the studio evenings Kate Douglas Wiggin gave an author's reading. While she was in the middle of it this clock began to strike. Having been purchased, like the others, for beauty rather than practical value, it continued to strike until twenty-three o'clock had sounded, when some one had the presence of mind to stop it. Mrs. Wiggin, in recalling the incident afterward, said: "And I was so embarrassed that the only thing I

THE TENTH STREET STUDIO.
Property of the Carnegie Institute.

could think of to say was to stammer: 'Really I had no idea it was so late!'"

It was in the winter of 1890 that Carmencita danced in the Tenth Street Studio before the most distinguished audience in New York.

In those days foreign "artists" were a novelty in New York, where now it is the Anglo-Saxon entertainer who is the exception. But in the eighties and nineties Spanish and Hungarian dancers, Russian actresses, Continental entertainers of all descriptions had not inundated the town. The foreigners who came to New York then were not only of a more distinguished and genuine type than the majority of those we have here to-day, but they had the compelling charm of the "different" thing, the romance of the unfamiliar. And of all the personalities clothed in that illusion the most picturesque seems to have been Carmencita.

The first time that Carmencita danced in Chase's studio it was at the instigation of Mrs. Jack Gardiner. She had danced for a few painters and friends of the Beckwiths in Carroll Beckwith's studio and in the same way at Sargent's studio in East Twenty-third Street. Mrs. Gardiner, hearing of this, was seized with the desire to see the famous dancer in the atmosphere and setting of a studio instead of in a public hall and expressed her

wish to Sargent. Sargent's subsequent letter to Chase shows how the event came to pass.

"MY DEAR CHASE,

"Mrs. Jack Gardiner whom I daresay you know, writes me that she must see the Carmencita and asks me to write her to dance for her some day next week and she will come up from Boston, but my studio is impossible. The gas man tells me that he cannot bring more light into the studio than the two little jets that are there.

"Would you be willing to lend your studio for the purpose and be our host for Tuesday night or Thursday of next week? We would each of us invite some friends and Mrs. Gardiner would provide the Carmencita and I the supper and whatever other expenses there might be. I only venture to propose this as I think there is some chance of your enjoying the idea and because your studio would be such a stunning place. If you don't like the idea or if it would be a great inconvenience speak up and pardon my cheek! Send me an answer by bearer if you can, if not, to the Clarendon soon, as I must write to Mrs. Gardiner. Yours Sincerely,

"JOHN SARGENT."

Carmencita danced twice in Chase's studio. Even at this remote day the guests of the evening vividly recall

EVENTFUL YEARS IN ART AND LIFE

it. Women tore off their jewels to throw them at the singer's feet—although it is true that one emotional lady returned the next day to ask the painter to recover her gems. The kindly painter made an effort, but the canny dancer shrugged and snapped her fingers in true Latin fashion and replied that she hadn't the slightest intention of returning the impulsive lady's property.

One evening after the dancing Sargent asked Carmencita to sing some Spanish songs. For a long time she refused, saying that she was a dancer, not a singer. But Sargent, who knew his Spain, kept insisting that she must know some gypsy or folk songs, and finally the dancer yielded and sang a number of songs with the wild peculiar rhythm of Spanish music, and although Carmencita, as she had said, was not a singer, the little episode made a vivid impression upon her hearers.

But if Carmencita frugally refused to return the emotional lady's jewels, she proved that she was not lacking in Spanish grace of feeling, for both times after she had danced she sent her slipper to the painter's wife who was unable to be present.

Rosina Emmett Sherwood, a guest both evenings, thus describes Carmencita's appearance when she danced: "Sargent and Chase made her rub the make-up off her

face, and brush her frizzed hair back from her forehead, and she was very beautiful and as natural as a country girl dancing on the grass."

Chase and Sargent both painted portraits of Carmencita at this time. Chase's canvas is owned by the Metropolitan Museum and Sargent's by the Luxembourg.

The Lady in Black, one of Chase's fine, distinguished canvases and a portrait of one of his pupils, was painted in 1888 and presented to the Metropolitan Museum in 1891.

In 1888 Chase became an Associate of the National Academy, and in 1890 he was made a regular Academician. He had also an exhibition of his pictures at Buffalo that winter which created a great deal of attention. He began to teach at the Brooklyn Art School and painted and exhibited a number of Central Park sketches of the same type as those painted in Prospect Park.

The Chase household made another move in the autumn to an apartment in East Fortieth Street. That year their friend Robert Blum went to Japan to do some illustrating for *Scribner's.* A letter to Chase from Tokio contains some of his first impressions.

". . . I suppose you are waiting to hear me say something about Japan. . . . It is the most puzzling experi-

ence I have ever had . . . it is simply a new world where life is on another plane—and yet one where with all its strangeness I feel strangely at home through the little insight I had of its art. But how much clearer that has become to me already by seeing the life that produced it. . . . I never thought *I* was so interesting, but you know what a great respect I have for Japanese taste—they stop and look and look and follow me with their earnest eyes wherever I go till I begin to feel proud of being so superior and imposing. But it is rather embarrassing when *you* want to do all the observing there is to be done. . . . Tell Cosy that I think of her every day. The little girls remind me of her every moment. . . It is amazing to watch these mites no older than Cosy walking about with a good bouncing baby tied to their backs. They don't seem to be as fretful as our children, and the way they are coddled and loved does even an old bachelor heart good.

"I found Mr. Wigmore, the man who is to write two articles for Scribner, very nice and Mrs. Wigmore most charming, both with that open kindliness that always wins my heart. . . This is all I'm going to write and it will depend upon how you treat me whether I write you again."

While Blum was in Japan Chase's first son, William

Merritt, was born. As soon as the news reached Blum he wrote to his friend, now for the third time a father.

"I congratulate you most heartily, my dear Will, on the latest addition to the Chase family and am tickled to know that you will now have a chance to hand down to posterity your magnificent whiskers if nothing more! I received your letter just before starting out on a little trip to Enoshima, a little village on an island where I stayed for a week doing some drawings for Sir Edwin Arnold's articles."

Of course Blum always had his joke with the ever good-natured Chase. Besides that favorite one connected with the painter's very regular nose, about which he could well afford to permit jokes, there was another to the effect that the always sufficiently thin Chase had become fat, a condition he greatly disliked and of which he seems to have had an unjustifiable dread. Blum wrote to Chase a few days after his last letter:

"Yes, I suppose it does kind of make a man feel big —this raising a family—sort of important like! I have imagined what you must look like in these days and I think I've caught the spirit of it. You must excuse defects in character and resemblance as I haven't seen you for some time and suppose you have grown a little stouter. So if I had allowed an extra fifty pounds say, I would

just have hit it—eh? Have you thought yet what you are going to name him. I suppose there is no hope for me. My kindest remembrances to Mrs. C—— and a big big kiss for my little sweetheart, that is Cosy Chase.

"You Sinner!"

CHAPTER XIV

AN END AND A BEGINNING

THE next year, 1891, saw the founding of Shinnecock. Mrs. Hoyt, an amateur artist, who had a summer home at Shinnecock Hills, urged Chase to start a summer school there. Mrs. Henry Porter, of Pittsburgh, another summer resident, also became interested in the idea. They offered to give Chase the land upon which to build a summer home for himself and a school studio as well. Chase went to Shinnecock in 1890, was delighted with the place and accepted their offer. McKim, Meade, and White began to work on the plans for the Chase house and studio and the next summer, 1891, the school studio was finished and the class opened to students.

That year the Chases moved from the East Fortieth Street apartment and Chase gave way to a singular desire to live in Hoboken. Perhaps he had seen a subject one day passing through. Mrs. Chase remained in Hoboken with her three children while Shinnecock was in the making. There the first little boy died and a third daughter was born.

Blum's letters from Japan continue on the note of personal banter that only seemed to entertain Chase.

[162]

AN END AND A BEGINNING

Referring to some photographs of the Chase family sent to him, Blum remarks:

"I was more than pleased to make the acquaintance of the boy. He's a beauty if he isn't mine. And Cosy—how sedate she looks! And your wife with the delightful hat—how well she looks. The photographs are all delightful—that is except those of you—*You've* fallen off terribly—so lank and lean. . . . I wish I had you over here I'd give you a good licking for nothing in particular but just because I feel like it and because I think you deserve it. But on second thoughts I come to think that someone in New York must have a dreadful spite against you—I mean the man who 'did you' in the paper and made you look like a cross between —— —— and a Baxter street Jew. He is bound some time to lay for you and do worse than I would, so it's all right. I am going to hand over to him the job of caricaturing especially as I notice that you fail to appreciate my efforts. Of course I know it is all put on when you ask, 'Who these horrible looking things are meant to represent'

"But joking aside, my dear Will, I can't tell you how appalled I was to get a list of the sale of your pictures" [an unlucky sale in 1891 at which Mr. Chase's pictures went for prices far below their normal value], "it wasn't

[163]

only awful but shameful. If you can get any comfort from the fact I will tell you that since receiving it and when I feel blue about my work I say to myself, 'Good God, what does it all matter since nobody will care a rap whether you try or don't try' . . . A fellow works himself into a sweat and after surmounting all kinds of obstacles sees that his labor was thrown away after all. So why not take life easily and give up this damned driving after something. . . . God, I believe if such a thing were to happen to me I would give up painting. One must be pretty courageous to stand it. I can well understand how you feel about it dear boy and what a dreadful shock it must have been at first. And yet I know that in spite of all you will keep on painting as if nothing at all had happened, and God bless you for it.

"With lots of kisses for Cosy and Koto and William Merritt and the kindest remembrances to Mrs. Chase, I am as always, "Yours, Bob."

The next letter, written after he had received news of the baby's death, shows the affectionate side of Blum's nature and the sincere friendship he felt for Chase.

"My dear Will, "Nikko, Aug. 27, 1891.

"The paper containing the sad news of the death of your little boy reached me before I left Tokyo. It would

THE HALL AT SHINNECOCK.

be useless for me to try to tell you how very sorry I feel for your great loss. However much I might wish to say it would resolve itself into expressions of my heartfelt sympathy for yourself and your wife and of this I know you need no assurance. Although I don't believe in time being the healer of all things still I know that it makes us accustomed to the pain it cannot make us forget. Please give my kindest regards to Mrs. Chase and the deep sympathy I feel for her affliction and believe me as ever, "Your loving friend,

"Bob."

In 1892 the Shinnecock house was finished, and the Chase family, which now contained three children, took possession of it. That fall they moved to a little house in West Eleventh Street. Chase continued with his Brooklyn class, and with his private pupils in his own studio. He painted the delightful picture of a little girl known as *Alice* in 1893, and also that same year the *Woman with the White Shawl*. The first is owned by the Chicago Art Institute and the second by the Pennsylvania Academy.

In 1894 he taught for a month at the Art Institute in Chicago, spreading his gospel of art still further.

Eighteen hundred and ninety-five was a year of change and transition. Chase gave up his presidency of

the Society of American Artists, discontinued his Brooklyn class, prepared to give up his Tenth Street Studio, and bought the house on Stuyvesant Square which remained his home until his death.

For two years Chase had been trying to get that house. Several years before it had belonged to some people who were the temporary owners of Whistler's *White Woman*, and there for the first time Chase saw that picture. He took a great fancy to the fine, large old house, partly, no doubt, because of this pleasing association, and finally succeeded in getting possession of it. In it his sons Robert and Dana were born, also his youngest daughter, Mary Content, and his fifth daughter, Helen.

Nothing could have been more characteristic than the last scene of that act of Chase's life which had been enacted in the Tenth Street Studio. Whistler might have played his part differently but no more effectively. In 1895 Chase's financial affairs came to a climax. The difficulties attendant upon carrying on the career of a patron of the arts on a painter's income brought about a climax which might easily have been foreseen by every one except the chief actor in the drama. But in all emergencies of life the future beckoned to Chase. If one chapter must be closed, an even more alluring

ALICE.

one opened on the next page. If he must be sold out then he must. He accepted that fact and began to build a castle in Spain. He decided to give up his New York teaching and to take his family and some pupils to Madrid as soon as his affairs were settled.

His students when they heard the news gave him a loving cup. He gave them a dinner at his house. Not satisfied with that hospitable festivity, he planned a farewell party for his friends, a veritable banquet. It was held in the Tenth Street Studio which was especially decorated for the occasion. Almost the very plates from which they ate were carried away to go under the hammer, but Chase's serene hospitality lasted until an unusually late hour—a courageous climax, an undaunted spirit.

A few days later he carried his family away to Spain. Before he left he purchased a few rings, the nucleus of a new collection.

CHAPTER XV

SPAIN AND THE CHASE SCHOOL OF ART

IN January 1896 Chase and his wife and two of his children, Dorothy and Alice, usually known as "Cosy," sailed for Spain, where they remained until the following June. Chase took a class with him, and the trip was a very happy one for all concerned.

Despite his humanity Chase enjoyed the bull-fights; he also revelled in the markets, but his greatest pleasure was the Prado Museum. It was during this trip that he made one of his most important Velasquez copies, *Las Meninas*, now in the collection of copies of old masters by well-known artists got together by Mr. Nelson of Indianapolis. The others, made in 1896, are still in the painter's house.

One day while Chase was working at his copy of *Las Meninas* in the museum two Spaniards, picturesquely enveloped in dark cloaks, stopped to watch him. Mrs. Chase, who was with the artist, noticed that one was decorated with the Cross of Santiago. When the Spanish gentlemen saw the copy they removed their hats, and one made a remark in Spanish. When they walked away another watcher translated the Spanish nobleman's

tribute to the masterly copy: "Velasquez lives again," he had said.

This recalls a remark that Chase used often to make to his class apropos of that decoration and that picture:

It is told that when King Philip, the patron of Velasquez, had seen the completed picture, which contains among the figures of the group a portrait of Velasquez himself painting at his easel, he turned to the painter and said: "But your picture is not finished." Velasquez, astonished, asked the King what he meant.

"Wait, give me your brush," replied Philip. When it was handed to him he painted the Cross of Santiago upon the breast of Velasquez, conferring upon him by this act the highest honor obtainable by a Spanish nobleman.

"But," Mr. Chase used to add, "I feel sure that Velasquez afterward painted out Philip's decoration and painted it in again himself. It is too well done."

Chase entered thoroughly into the spirit of Spanish life, and when his work with his class was over went with Mrs. Chase in search of picturesque sights and impressions. The evenings they usually spent at the cafés watching the gay pageant of the streets.

One evening returning from a place in a remote part of Madrid where they had gone to see some gypsy danc-

ing especially recommended by a brother artist, Chase discovered when he came out that he had no small change. Familiar with the ways of Latin cabmen, he decided that it would be better to get some before calling a cab. The only lighted place in sight was a small wine-shop, obviously not of the sort that he could take a woman into; so, leaving his wife alone an instant on the street, he went in. As he did not come out immediately, and as she heard footsteps approaching in the darkness, it occurred to Mrs. Chase that it might be better for her to walk slowly along rather than seem to be loitering alone upon the street at midnight. When Chase finally emerged he was distracted to find that his wife was nowhere in sight. Mrs. Chase, having been followed by a man in a cloak, had continued to walk on until she had lost herself. At a late hour she chanced upon the neighborhood of their pension, where, after some difficulties in identifying herself sufficiently to be allowed admittance by the watchman at the locked outer gate, she finally regained her room in safety, where considerably later she was joined by a frenzied husband.

Every market-day found the painter and his wife in the crowd, and many of the beautiful things in Chase's home and studio were bought at that time.

Chase returned in June to his Shinnecock class, and

in the fall of that year he opened an art school of his own called the Chase School in a building on the corner of Fifty-seventh Street and Sixth Avenue. He found a suitable studio for himself in the Glaenzer Building, now torn down, on the corner of Fifth Avenue and Thirtieth Street.

After two unprofitable years as owner and manager of the Chase School, the unbusinesslike Chase wisely gave up all attempt at management and turned the school over to others, who in 1898 changed the name to the New York School of Art. He remained at the head of this institution for eleven years. A little before this he had begun to teach at the Pennsylvania Academy, going over to Philadelphia once a week for the purpose. He always took great pride in the high standard of work maintained by his Philadelphia pupils.

He continued teaching there until 1909. During these years Chase painted some of his best pictures. The portrait of Emil Paur was painted in 1899, and about 1901 he painted the picture of his two children, known as *Dorothy and Her Sister*, the portrait of his daughter Alice called *The Grey Kimono*, as well as the other known as *The Red Box*.

From 1896 until 1900 Chase's summers were spent at Shinnecock. But in 1900 he took a flying trip to Europe

in company with his sister-in-law, Minnie Gerson, leaving her in France with friends while he made a flying trip to Spain to collect some of his belongings there.

Miss Gerson recalls with amusement Chase's idea of a preventive of seasickness, which was to read aloud to her from George Moore's "Talks on Art," the topic which he imagined to be of all others the most absorbing and diverting to the mind.

In the summer of 1902 Chase went to London to have his portrait painted by Sargent. For this purpose a sum was raised by his pupils, who made the picture a gift to the Metropolitan Museum 'as a tribute to their beloved master.

This portrait, while representing with Sargent's customary brilliance a superficial phase of Chase, is yet not wholly satisfactory to those who knew and cared for him. Chase, however, enjoyed Sargent's virtuosity so much that he apparently had no fault to find with the canvas as a portrait.

In a letter to Minnie Gerson from London he speaks of it with enthusiasm:

"MY DEAR MINNIE,

"There is so much to remind me of you here and I have really missed you so much that I don't understand

CHASE IN HIS FIFTH AVENUE STUDIO.
From a photograph.

why I have not written to you before. It is the same
old London except that there is more board than lodg-
ing here just now (*joak*).

"Sargent's portrait of me is now finished. He did it
in six sittings, and I think you will like it. My friends
here say it is perfect. The painting is certainly beautiful.
I shall be most anxious to know how 'Toady' and you
all will like it. He has done me as a painter and they
say he has caught my animation—whatever that means.
Mr. T—— and the Deweys are here and have asked if
they may go and see it. I shall be glad to get away now
that the picture is done as every American I meet (and
there are many of them) wants to go to Sargent's to see
me on canvas. I am afraid it will prove a nuisance.

"Sargent will most likely go to America next winter.
We have arranged to paint one another when he is in
New York again. Sargent's exhibit at the Academy is
magnificent. [Three underlinings.]

"I have been in so many of the same places we visited
together and I always think of you. Love to Jennie.

"Bless you.

"WILL."

That year Chase painted his portrait of Doctor Angell,
the charming little portrait of his daughter Dorothy in

[173]

a Mexican hat, now the property of the St. Louis Museum; also his finely characterized portrait of Louis Windmüller.

In the summer of 1902 John Twachtman, Chase's companion in Venice and Munich, died, and in the spring of the following year Chase was elected a member of the Ten American Painters in his place.

CHAPTER XVI

SHINNECOCK

TO all familiar with contemporary American art the Shinnecock landscape must ever be associated with the name of Chase. To that extent does the thing seen with the eye and recorded with the brush impose itself upon the mind of the beholder.

"How terrible if nature were to come to look to you like that," Chase used to say to the student who produced one of those dreary paraphrases of nature possible only to ineptness; but the reassuring side of that psychic fact is found in the artist's ability to educate the layman's æsthetic sense by revealing to him some selected phase of beauty in nature that his own eye could not have discovered unaided. In so doing, the painter sets his possessive impress upon the landscape.

This thing William Chase did with the sand-hills of Shinnecock. He scorned the picture that told a story; nevertheless he did more than present a fine bit of technical painting in his Shinnecock landscapes, for he was able to lead the imagination over the lonely road winding through the sand-dunes to the sea and make one feel the wide sweep of the wind across the moors.

In the same way he has placed his children in the

Shinnecock landscape, pink-ribboned and red-capped, in a perpetual summer-time. He used to call his oldest daughter "his red note" because, having usually a touch of red in her costume, she was constantly called upon to add that accent to his composition.

Surrounded by bay, sweet-fern and vivid patches of butterfly-weed, Chase's house is set, as it were, in the midst of one of his own landscapes, its nearest neighbor off on a distant hilltop. On one side lies the ocean in vista, on the other Peconic Bay. The water is not near enough to be heard except in a storm; its place is decorative rather than intimate. Indeed, it would seem as if house and studio must have been designed to make pictures from within, for every window and doorway frames a composition.

Chase's studio, built a few steps below the level of the house floor, is a part of the house, yet shut off from it in such a way that intrusion was impossible..There some of Chase's best work was done—fish pictures, interiors, and kimono portraits.

The sky, which so impresses itself upon the imagination in those wide Shinnecock spaces, always strongly compelled Chase's painting impulse. Some days he spent hours at his wide studio window simply painting the changing clouds, veritable sky studies.

IDLE HOURS.

The artist's wife and children on the beach at Shinnecock.

SHINNECOCK

The school studio, where his criticisms were given, was located about three miles from the house. The group of small houses surrounding it was known as the Art Village. These cottages, designed by prominent architects for a nominal sum, were occupied by Chase's pupils, several of them sometimes combining to rent one for the summer. The students came from all over the country, and many painters now well known were among them. The school grew to such proportions, however, enrolling some years as many as a hundred students, that many of them had to find lodgings in the village. The school building contained besides the large room where criticisms were held, a studio for indoor painting on rainy days and a supply shop for materials.

Chase gave two criticisms a week. Every Monday morning the week's work was taken to the studio and put up on a special sort of easel resembling a blackboard, which held a number of sketches at a time. After the criticism Chase remained at the studio until lunch time, so that the students could ask questions or submit for further criticism some sketch made the preceding week.

On Tuesdays Chase went off with the class for the entire day, a wise arrangement, as there could be no more stimulating time to put into effect what had been

learned than after one of his criticisms, for he always made the student feel that the *next* time he was going to do the best thing he had ever painted. Chase gave a talk once a month. He also painted regularly as a lesson for the class, a landscape, a head, or a bit of still life. Students were encouraged to ask questions. These were written on slips of paper and dropped in a little box. During his lectures and his weekly criticisms Chase undertook to answer all these faithfully.

The students soon discovered that if they chose a subject along the road leading from Chase's house to Southampton they were sure of an extra criticism. Chase could seldom pass a painter at work—pupil or stranger, at home or abroad. Especially if the unknown artist seemed poor and uninstructed did that generous soul want to offer all he had to give, so beautiful was his feeling for the thing that the worker was struggling, however obscurely, to express. Therefore, the pupil with her back toward the approaching vehicle, but her canvas turned toward the road, was sure sooner or later to hear her master's voice: "Drive slowly, please. Stop here just a minute." Then words of warning or commendation were offered. On days when several pupils were imbued with this same happy thought, Chase's ride to the village was rather a long one.

SHINNECOCK

At no other time did Chase have greater occasion to put into effect his view-point concerning the choice of a subject than during these days at Shinnecock, frequently holding up as an example of what *not* to do the student who had walked miles over the moors to find something sufficiently paintable. The pupil in question was not always pleased at being told to paint the rail fence across the way instead of the panorama of sea and sky, but if she had arrived at any real perception of art in the course of her studies, she came eventually to understand her master's purpose.

Although Chase never lost sight of the eternal principles underlying the art of painting, and while at that peaceful day he could not have foreseen the variously evoked nightmares of Futurism, he had as deeply rooted a hatred of conventionality as a sane painter could possibly have. Above all things, he warned his students against the rut, and the danger of seeing things "in a tiresome way." Of himself he said: "I have experimented always." In order to uproot any tendency to routine in the minds of his students he carried his suggestions to them to "queer" their compositions to the point of arranging at intervals actual "queering" contests in which the student was advised to imagine the most unlikely seeing of his subject. To stimulate competition,

Chase offered one of his own sketches as a prize for the best result. "And some of them were *very* queer," his daughter, Mrs. Sullivan, remarked pensively, recalling them, and yet we may be sure, after all, very proper and dignified arrangements compared with the compositional chaos of the hysterical hour now blessedly passing. For while the erratic subject handled with real professional knowledge may provide the mental fillip that Chase recommended for jaded seeing, the neurotic, ignorant, or charlatan production is now disappearing, as we all knew it must, into the limbo of forgotten things.

Many characteristic comments, profound, satirical, constructive, were made at those Monday criticisms.

One summer when a hectic wave of impressionism was agitating the students' colony, several canvases were brought into the Shinnecock class showing lurid patches of yellow and blue. When Chase saw them upon the screen he began to hem and hum, tug at the string of his glasses, tap his stick upon the floor, and twist his moustache. Finally, with a slight frown, he turned upon the perpetrator—it was seldom necessary for him to ask his or her name. "And it was as yellow as that?" he asked.

"Oh, yes, Mr. Chase. Really it was. The sun was right on it, you know, and it was very yellow." The

pupil babbled on, imagining that she was being very convincing.

"Hm," was Chase's reply, after another glance. "And September not here yet! Give the goldenrod a chance, madam. Give the goldenrod a chance."

Howard Chandler Christy, an early pupil of Chase's at Shinnecock, recalls his master's reply to one of those serious-minded muddlers who infest summer painting classes. The efforts of this rather mature lady were particularly hopeless, but apparently quite unaware of limitation she looked up brightly at her instructor as he approached: "There is just one thing I am worried about, Mr. Chase. Will you advise me about my colors? I'm afraid I'm not using the right kind. I'm afraid these colors may fade."

Chase bent a cold eye upon the enthusiastic lady's canvas and, after the familiar manifestation of sounds and movements recognized as a danger-signal by the accustomed pupil, he replied: "In your case, madam, the very *best* you can possibly use!" and passed on.

But Chase was always considerate of the sensitive pupil, talented or untalented, sometimes giving a private criticism after the general discussion in order to spare a nervous girl the embarrassment of public comment upon her deficiencies.

He was, however, disturbed by the problem of the industrious but ungifted pupil. Pausing one day beside the easel of a young man of this type, after regarding his inharmonious and painstaking work with distaste for a moment, he inquired in a troubled tone: "Do you really *like* that manner of painting?"

The perplexed pupil looked up. "Why, no, Mr. Chase, I can't say that I do."

"Then try some other way. Try some other way."

Chase's wit was likely to emit sparks in contemplation of artistic futility, but it seemed inspired by, rather than at the expense of, the hopeless pupil. Christy remembers another case of a boy quite devoid of talent, whose admiring family were determined that he should be an artist. One day as the master walked over the sand-dunes seeking out the various pupils camped about in the landscape, he came upon the boy seated in a little hollow, painting nothing in particular as there was really no subject in sight, but industriously covering his canvas with paint and whistling cheerfully—a sound that Chase never enjoyed.

"Well, and how are *you* getting on?" he inquired with perfunctory pleasantness, but we can imagine with a perceptibly ruffled brow.

The inartistic youth looked up brightly. "Fine, sir,

fine !" he replied, full of good spirits and his healthy igno-
rance of art. The painter gave a look at his canvas and
turned away.

"*Quite* the contrary, I assure you, sir," he remarked,
and without further elucidation passed on to the next
disciple.

For the pupil showing the faintest trace of the gleam
Chase's kind helpfulness was always ready. But like
others who have had to overcome obstacles and opposi-
tion to their chosen career, he had little patience with
the ungifted pupil surfeited with opportunity. For that
reason he sometimes made the retort that seemed un-
sympathetic.

"Consider nature as the painted thing," was one of
his suggestions helpful to the imaginative student.
"Paint a tree that the birds could fly through," was
another criticism of the same rather cryptic type. "Make
your sky look as if we could see through it, not as if it
were a flat surface," is a little more tangible; and, "No-
tice how the darkest spot outdoors is lighter than the
white window-sill within," is an entirely practical hint.

One afternoon in the week, usually Saturday or Mon-
day, Chase's studio was open to students, friends of
students, and, indeed, all of Southampton, for Chase's
talks and receptions were one of the features of the

place, and always all that he knew or had to give was at the disposal of the interested, whether it was a brother artist, a student, or the merest outsider.

So much did Southampton appreciate the social aspects of the School Studio and Chase's talks that at one time it became necessary to make clear the fact that the school was primarily for the benefit of the art students.

Another Shinnecock event that combined art with the social side of things was the Old Master Tableaux given by Chase and his wife at the School Studio and at the houses of the summer residents.

These pictures, which were never produced under more fortunate conditions than at Shinnecock, had interested Chase ever since his Munich days when as has been told he used to pose his model in a frame in the semblance of a favorite Van Dyck for an audience of his fellow students.

The artist's children and his pupils usually posed for the Shinnecock tableaux. Among the most interesting experiments were the pictures arranged in sunlight in a room in Mrs. Porter's house, where a certain atmospheric effect of indoor light suggested possibilities to the painter's wife. Two of the pictures devised for that occasion were especially successful; one hurriedly arranged at the last minute as an eleventh-hour substitute was of Mrs. Chase posed as the Dagnan-Bouveret madonna,

which Chase found so much like her. In her lap she held one of her own babies, the mysterious nimbus of light around the child's head created by a concealed night-candle. The other picture which so impressed the audience was of Helen Chase, then a small child, posed as the Velasquez *Infanta*, an effect so charming that Mrs. Porter ordered a portrait of the little girl painted in that costume.

Several of the Chase children were born at Shinnecock. The fact was always proclaimed in Japanese fashion, with a fish floating from the housetop. The fourth daughter, Hazel, is said to have been the first white child born on Shinnecock Hills, which were formerly occupied by the Indians. For that reason the child was given an Indian middle name, Neamaug, meaning "between two waters," which perfectly describes the location of the Chase home.

A deposit of clay opportunely placed by nature near the painter's house was much appreciated by the Chase children who used it for modelling, and enjoyed also a privilege that is not the portion of many children, for both Chase and Blum, who often visited Chase at Shinnecock, entertained themselves by making it into architectural blocks. These were then baked in the sun and used for the construction of Greek temples or any imag-

[185]

inative structure that happened to strike the artists' fancy at the moment. A particularly successful building was cemented together and kept for a permanent plaything. The men also made serious experiments in modelling.

Chase's mother was his first guest in his new home, and her portrait was the first thing he painted in his new studio. Mrs. Chase says that as she watched the progress of her portrait she wondered why a spot on the top of her head was ignored by the painter. The next day, after a trip to town, he brought in a dainty little lace cap and told her to put it on. Ever since that day she has worn a cap.

Chase's mother was anxious for any opportunity to do her son a personal service during her visits. One day he sent home a pair of new white trousers and remarked to his wife in his mother's presence that they were too long, and asked her to shorten them so that he might wear them the following day. That evening his wife remembered the request and shortened the trousers according to instructions, but when the painter put them on the next morning they proved to be about knickerbocker length, for his devoted mother had taken her turn at shortening them first!

The Shinnecock Indians, a mixture of negro and In-

CHASE'S MOTHER.

The first portrait painted by the artist in his Shinnecock studio.

dian, played their part in the life of the summer school. In the beginning the students, like other residents of Shinnecock, were not allowed to enter the reservation at all. Before long, however, the tactful Chase made one of the old Indians a friendly call and obtained permission without asking it. The students often went there to paint and a number of the Shinnecock Indians served as models both outdoors and in the studio. One girl named Romaine, of whom Chase made a study, posed frequently for the painter and his students. Chase's relations with the Indians remained friendly to the last and the Indians were always interested in the school. One of the Shinnecock students tells a story of Chase's spontaneous generosity upon one occasion when he was painting for the class near the reservation while a fair was being held for the benefit of the Indians. When his sketch was finished Chase presented it to the fair committee to be sold at auction.

Although the house was not near enough to the school to permit of the intrusion of the thoughtless, the students often enjoyed the hospitality of the Chase household. Chase liked to bring sympathetic students home to lunch. The day when, after having carelessly stated before going to his criticism, that he had invited a student to lunch and brought home seventeen was one remembered

for some time by the painter's wife, for the nearest market was six miles away and motors and telephones then practically non-existent.

Nineteen hundred and two was the last summer of the art school, although the Chase family continued to spend their summers at Shinnecock.

The Art Village is now a popular and artistic summer settlement. Mrs. Porter, who had so much to do with the founding of the school and had always a heartfelt interest in its success, now uses the School Studio as her summer home, having extensively added to and built around it, thus preserving both the room and its associations.

The school was never larger or more successful than in its last year and every one concerned regretted Chase's decision to give it up.

During the eleven years of its existence a far-reaching influence had been set in motion, for in that time—little more than a decade—Shinnecock had set its impress upon the landscape art of America.

The following summer Chase began to hold his summer classes in Europe.

CHAPTER XVII

MUNICH REVISITED

CHASE'S contact with European art and life, if brief, was continuous. The story of the summers that he spent abroad, usually teaching for part of the time, is told in outline in his letters to his wife and the other members of the family, but except for an occasional sentence here and there they do not reveal much of his personality, the charm of which was not somehow communicable through his pen.

The letters to his wife are the literal affectionate chronicles of the day rather than interesting comments upon his experiences. Even when he speaks of the pictures he admired he substitutes emphasis for selective characterization. It is true that this was also his way, although to a less extent, when he talked about art; but in talking the personality of the man, his enthusiasm, a certain dramatic gift of implication that he had, made his hearers feel that they felt the thing that had impressed him in a canvas, although "a beautiful thing, a wonderful thing" was generally the extent of his comment. And so in his letters he used a system of underlinings, one, two, three, and even four, to indicate the degree of

his enthusiasm or admiration rather than the descriptive adjective.

In the summer of 1903 Chase went to Holland, where he held his first European summer class. His daily letters to Mrs. Chase at this time give a faithful account of his doings. As was his invariable habit, he first visited London and Paris, but before he proceeded on to Holland he revisited Munich for the first and only time since his student days.

Writing from London in June to Mrs. Chase, he tells of going with a Mr. Howard, an American artist living in London, to a sale of pictures and art objects.

"I bid on two pictures," he remarks, "but did not get them. I did get however a small statuette in china of Benjamin Franklin with Washington's name lettered on the base, a rather interesting piece. Three shillings is all I had to give for it."

A guilty consciousness of his almost uncontrollable spending impulse causes him to add:

"You must congratulate me by the way—*I haven't yet bought a single ring!* After the sale I went to Mr. Howard's studio. Some people came in for five o'clock tea, among them Mrs. Meyer whom Sargent painted. She asked Mr. Howard and me to take lunch at their house to-morrow and see the Sargent portrait and other

pictures. . . . After dinner I went to a house in Covent Garden where I was asked to drop in any time between ten and twelve. I found a very large dinner party in the most magnificent house I have ever been in, filled with fine old masters. I arrived a few minutes before the gentlemen joined the ladies when we went up and saw an assemblage of the most magnificently gowned and bejeweled lot of ladies *ALL* smoking cigarettes. Three of the ladies are Americans who have married titled lords or earls. There was music and a bridge whist game later. I did not stay very long. It is now twelve o'clock and I will go to bed. So much excitement is likely to keep me awake for a while. I'll think only of you and the children if I am. Bless you, I love you. Kisses to the chicks. Goodnight.

<div style="text-align:right">"Love. W<small>ILL</small>."</div>

The next letter describes his second day.

"Early this morning I called on Lavery and after called on Brangwyn. At one o'clock went to lunch at Lady M——'s, another fine house, lots of pictures, servants and all. The luncheon was pleasant. If I stayed long enough here I would find myself introduced to all the swells. One gratifying thing about it all is that they all seem to know about me. This afternoon I went to the

National Gallery and tonight I had Kennedy to dine with me. Afterwards we went to the hippodrome and saw a fine performance. . . . It is now eleven thirty. I find on consulting my watch that it is five o'clock in the afternoon with you, and I am imagining you packing for Shinnecock with Roland holding on to you.

"I got a letter from you this morning which was written the day before I sailed. I shall hope to find more letters in Paris. How I wish you were all with me. God bless you and our dear children.

"Love.

"WILL."

A few days later he writes from Paris:

"This morning I went to the Salon. . . . Only a few really good pictures. Tomorrow I shall go at once to Munroe's hoping to get letters from you. I suppose you will go down to Shinnecock tomorrow. I dream about you and the children very often. I find on consulting my watch that you are probably having lunch now at home. I am wondering if you went to Shinnecock today. I watch my watch and have reckoned the time you would take a train."

In his next letter he alludes to the death of his friend Robert Blum.

"I got yours and Dorothy's letter this afternoon. I

PORTRAIT OF ROBERT BLUM BY CHASE.

had already heard of Blum's death. Isn't it awful? I lunched with Knoedler and Alexander Harrison today. Harrison told me of Blum's death. I can't get it out of my head. Was he sick long? Just think of his being no more. I am afraid he did not take good care of himself for a long time back."

Further on he relates with the evident expectation of being commended: "I have not bought anything as yet although I have seen some tempting rings."

In another letter from Paris he inquires: "How is our baby getting along? Does he walk yet? I am so glad you gave me the photographs of the children. I would like some more when you can send them. I haven't any very satisfactory ones of you or Cosy. It is still raining and so cold. The boulevards are dismal and deserted. . . . Bless you, sweetheart, I wish you were with me. . . .

"Tell Dorothy and Cosy that I will write to them soon."

He mentions in the course of his next letter that he is proud of himself because he "has not bought a single trinket," which shows that he at least made some attempt to restrain his purchasing vagaries. From Munich his first letter reveals the frequent grievance of the traveller who asks information not dealing with France from French officials.

"Well darling here I am. Owing to a stupid French-man's putting me on the wrong train I reached here at three P. M., instead of ten A. M. When I reached Ulm, a city about three hours from here, I decided to stop and see what the place was like, it looks so picturesque from the train. I was well repaid for the hour's stop. I sent you post-cards from there. I found when I reached here that my trunk and hat-box had been held at the frontier because I was not there to open them for inspection."

Chase was in the habit of blandly leaving all customs transactions to his travelling companion; in this case he did not have one. He continues with his impressions of Munich:

"I have been looking Munich over and find much of it so changed that I do not recognize the place. I am astounded at the beauty of the city. It is simply magnificent." [Three underlinings.] "I did not run across any of my friends this afternoon. I am in a hotel directly opposite a place where Shirlaw and I lived for several years. The hotel is now made a magnificent one, every modern convenience. I have a room superbly furnished. They tell me my breakfast will be served in my room tomorrow morning. . . . Tomorrow morning I

will go to the gallery. I feel sure I am going to enjoy my stay here and thank heaven it is warm. I was almost frozen in Paris. Goodnight darling. God bless you. Kisses to all the children.

"YOUR DEVOTED HUSBAND."

The next day he tells of going to the New Pinakotek, where he "saw some good pictures, among them that splendid picture by Dagnan-Bouveret which looks so wonderfully like you. I choked with emotion when I saw it and I also forthwith had a spell of homesickness. I would give anything to possess this picture. It is more like you than the other one owned by Shields Clark. I shall go to see it often while I am here.

"I went to the Secession Exhibition. I am a member of this society and I told the man at the entrance who I was and he admitted me free and told me that I had many friends in Munich who would be glad to see me. It is a very good exhibition. I got my trunk all right this morning. Have not seen any of my friends yet. I got three crosses for you today, pretty good ones. I went to the Gartner Platz Theater tonight. It is the theater I used to go to so often. It is not changed at all, even the same drop curtain. For the moment I was taken back to the student days."

WILLIAM MERRITT CHASE

The next day he continues his story:

"Today I went to the old Pinakotek and enjoyed the pictures very much. They looked like old acquaintances and old friends. I have been strolling about seeing parts of the city that I had not seen since my arrival. Tomorrow I will look up some of my former friends. I am served with *splendid* coffee in my room every morning. Of course I am thinking of you all in Shinnecock. It will be several days before I can know any news from home as I have ordered my mail forwarded to Haarlem. Goodnight sweetheart. Love and kisses to the chicks.

"WILL."

The following day he writes of meetings and renewals:

". . . I went to call on some of my artist friends today, found Prof. Dietz and Prof. Dietrich in their studios and enjoyed a very pleasant call. They expressed themselves as delighted to see me. At the old gallery I met my summer pupil Mr. Rittenberg. He said that he and Mr. Ullmann had been looking all over the city to find me. I have been with them all day. We went to the two modern Exhibitions which are here now. Ullmann who was leaving for Paris tomorrow has decided to go to Vienna and Berlin with me. We will likely leave on Wednesday. Tonight we went to a vaudeville entertainment

at a magnificent theatre, the best of the performance was a young American girl and a troupe. They met with great success with the audience.

"I am always thinking of you and wishing you were with me to enjoy all this. . . . I am sending Dorothy and Cosy a letter by this same mail."

Mr. Rittenberg gives an amusing account of their sightseeing and visiting in Munich. Chase, resplendent in summer white, with black-ribboned glasses and a general effect of immaculateness, seated beside him in the open *droschke*, presented, he says, rather the appearance of a naval officer than of an artist. When they arrived at the marble steps of the beautiful new academy building the driver stopped at the entrance for the general public. Within another closer half-circle was the descending place for royalty and titled guests. Chase, democratically unaware of this distinction but with an American determination to effect the most precise descent, waved magnificently to the cabman, "On, on!" The cabman turned in his seat, hesitated, glanced at the glittering attire of his fare, and at the third peremptory "On!" without further question turned into the sacred driveway and deposited the two painters at royalty's entrance. As they entered the hall they found all the eyes in the place upon them. As unfamiliar members of

the royal family they were naturally of peculiar interest to the German citizens.

Chase was delighted with the beautiful new building. Afterward he went to visit the old academy where he had studied, the sight of which revived many happy memories.

Mr. Rittenberg says that their call upon the old painter Dietz was quite touching. Chase had never been a pupil of Dietz, having placed himself in Piloty's class, but in his student days the young American painter had, of course, been known to the other German instructors.

Old Dietz was seated at his easel painting as they went in. Chase went up to him and held out his hand. "Do you remember me, Herr Dietz?" he asked. The old Bavarian looked up, keeping his eyes upon his guest's face an instant, then with a cry of delight he rose, exclaiming, "It is Herr Chase," and welcomed him with almost childlike affection. Chase was deeply touched by this greeting after his twenty-five years of absence.

Carl Marr, whom they visited next, seemed also glad to see the American painter again, but his manner, Mr. Rittenberg says, was more that of the bashful schoolboy than the well-known painter. Marr, he thought, was embarrassed by his consciousness of their artistic differences.

Another letter from Chase to his wife alludes to these Munich meetings.

"I am afraid I got to bed rather late last night. I spent the evening with the boys who seemed never to know when to stop talking. Yesterday was a very interesting day for me. I visited several of the dealer's places and after lunch went to Lenbach's studio and after that to Baron Schack's gallery where I saw some beautiful pictures by Boecklin. Lenbach's studio and house is simply magnificent. He was apparently glad to see me and first of all said, 'Herr Chase you have made a great name for yourself.' He showed me many portraits which are fine." [Three underlinings.] "I dined with several of the students and after spent the rest of the evening in one of the magnificent cafés they have here. Today we are going out to the Schlesheim palace where we will see some pictures. I used to go there often."

Mr. Rittenberg said that he had never seen von Lenbach more gracious than he was to Chase. He paid every tribute to the American painter and was cordial to a degree most unusual with him. Chase seems to have been deeply impressed with the significance of von Lenbach's beautiful home and commented a bit wistfully upon the recognition given by Germany to her artists. It was at such moments as these that it seemed to Chase

that Europe was a better place for a painter to live in than America. It is doubtful, however, if he would really have been able to adapt himself successfully to a foreign environment. Chase was not a natural linguist. Even his long residence in Germany did not give him any real command of the language. It seems probable that the life he led, pupils and all—perhaps pupils most of all—was the one that made him happiest and that best enabled him to express the thing he was able to contribute to the art to which he gave his life.

The next letter to Mrs. Chase tells of the trip to Schlesheim:

"There are a few good pictures in the palace, one capital Velasquez. I dined with my friends and spent the evening in the café which I have sent postcards of. To-morrow I must make several calls on old friends whom I have not yet seen. I am having as good a time as it is possible to have without you and the children. . . ."

With Mr. Rittenberg, Chase also visited Stück's house, which was decorated with and after the manner of that painter's peculiar art. There Chase's horrified comment was: "How terrible to have to live in such a place!" Stück's childish striving for the gruesome, a development of the German romantic school that might

be considered unwholesome were it less naïve in its efforts to inspire the shudder, his obvious striving for symbolism, his mannered treatment, is after all just Chase's old enemy, "the bonbon-box kind of thing" turned to dank uses. The result is of all things the furthest possible remove from Chase's ideal of art. He admired the exterior of Stuck's beautiful white house set among carefully tended German green things, but he was glad to close the door upon the deliberately contrived ghoulishness of the interior.

Chase went also to call on Fritz von Uhde, who lived in the country outside Munich, and to Piloty's house, where he saw for the first time since he had painted it one of his portraits of the Piloty children, that of the child who is no longer living, the others being in the possession of their respective subjects. In the museum Chase pointed out to Mr. Rittenberg a section of one of Piloty's canvases that he had painted on in his student days, a vast historical subject, relic of a bygone phase of art.

Rittenberg and Ullman journeyed on with Chase. In his letters to his wife from various points Chase continues his faithful, if somewhat unilluminated, account of his doings. From Vienna he writes:

"Mr. Rittenberg, Ullman and I have been to see both

of the galleries here and have enjoyed a rare treat. The pictures by Hals and Velasquez are *very fine*. . . ."

Two days later he writes from Berlin: "Immediately after breakfast I went to the picture galleries," adding characteristically, "I did not know until I had taken a cab and found everything closed that it was Sunday. The Velasquez and Hals pictures also the Rembrandts are *fine* here, especially the big fat man by Velasquez. After seeing the old masters we went to the modern exhibition. The American part of it looks well, is well placed occupying one of the best locations. My picture of Cosy holding the Japanese book looks pretty well. (I think perhaps you would say that it looks better than pretty well.) The exhibit is a good one throughout, the best modern show that I have seen since I left Paris. Berlin is a beautiful city. One sees much of the pomp which is so agreeable to your friend William. I sent you a post-card of him. He is down at Kiel today where he is dining and being dined by some of our naval men and the Vanderbilts. I saw one of his sons drive through the street today. You would have been amused to see the taking off of hats and the low bowing. I was in an open carriage and took off my hat. He saluted me but not the street people.

". . . Ullman and Rittenberg are still with me. . . .

They have been very agreeable traveling companions. . . .

"I can scarcely wait to reach Haarlem and get your letters."

The next letter from Cassel speaks of visiting the galleries, seeing some excellent modern pictures in Berlin, some "*splendid*" works by Leibl. He notes also at the Secession Exhibition "some beautiful pictures." "I am getting almost an indigestion of pictures," he remarks, "and will be glad when I can get to work. I am in great anticipation of getting some letters from you tomorrow when I will arrive at Haarlem. At the different cities I have passed through I have found some crosses for you. Have bought three rings not of much consequence. I will likely drop you another line from here today. I am always wishing you were with me.

"YOUR WILL."

CHAPTER XVIII

A SUMMER CLASS IN HOLLAND

THE next day Chase reached Holland. Henry Rittenberg returned to Germany, but Eugene Ullman went on with him to Haarlem. From Haarlem he writes to Mrs. Chase of his preparation for the coming class.

"The students will arrive tomorrow and I have arranged to give them a little dinner at the principal café here. This afternoon I went down to Zandvoort. I went to the house where I lived the summer I spent there and was immediately recognized by the woman who lives there. It is the place where I painted my picture known as *The Tiff*." *

His letter, written the following day, describes the Fourth of July dinner he gave to welcome his students.

"Early in the morning I had them put out a large American flag. Mr. Townsley went to Rotterdam to meet the party. I had sent to Amsterdam for flags and I must say the room looked very pretty. He got a small picture of Washington and one of Roosevelt. I had flowers and music, a small American flag at each place made especially at Amsterdam. They are funny looking things.

* Subsequently called the *Outdoor Breakfast*, also *Sunlight and Shadow*.

I will bring one home with me for you to see. Mrs. Wadsworth and Frank look well. I thought you might give me a surprise by sending Cosy with them to me. I have found a little studio and will get to work at once. Love to you my darling. Good-by until tomorrow.

"WILL."

The next letter carries on the tale of the students.

"The students will begin work tomorrow. I went over to Amsterdam this afternoon and in the Jews quarter I came upon a market quite like the Madrid one, anything from a rusty nail to a fine cabinet clock or a silk dress. The place would *delight* you—everything spread out on the pavement. I found a few things for the studio and a cross for you. There are very few old rings to be had and they are not very good. I have not bought any as yet. *My* how I would enjoy to go through these old places with you! The weather is still unpleasant. I had to wear my overcoat all day."

A few days later he writes of more pilgrimages to the galleries.

"Mr. Townsley and I went to the Hague and went directly to the gallery. There are some *superb* pictures there and I was just in the mood to enjoy them. After

lunch we went to call on Mesdag (you know I have known him for a long time). He said he was glad to see me, that he had heard I was in Haarlem with a lot of American students and he considered that I was paying Holland a great compliment to come so far to study their pictures. He could not have been more congenial. His collection is very fine, and he is giving it to Holland. . . . We are to have the first private view. We stayed the entire afternoon. Mrs. Mesdag joined us with tea and we returned to Haarlem feeling happy over a most enjoyable time. Tomorrow morning is to be the first criticism. If I decide to go to Spain next year do you think you could manage to go with me? I don't care how many of the children you take, the more the better for me. "Your devoted

"WILL."

The next letter repeats the tale of cold weather, galleries visited, talks to students, the starting of a new still-life, another trip to the market, of crosses and rings he had seen, without any comment upon the facts enumerated. Concerning the still-life he says: "I hope when I see it tomorrow that I wont have to scrape it out. Ullman and I took a long walk after dinner through the beautiful canal streets here and saw many beautiful

mòtives for pictures some of which I shall hope to get done. . . .

"I see in the Herald of yesterday that Whistler is dead. He will be very much missed as an artist."

A letter written a few days later has rather more personality than some of the others. "I found you a cross and a bit of old lace, a collar. It may not be good. You know I am no expert in lace so don't expect too much. The ladies say it is lovely but they would say that of anything I buy I think. I also got two pretty good rings. I did not go with the party this afternoon to Scheveningen but returned here after I had visited several bric-a-brac shops.

"The students telegraphed to London and arranged to have a wreath placed on Whistler's coffin in the name of me and the class. Nice of them to do this, don't you think so? Ullman begins a portrait of me tomorrow.

"Yesterday (in the name and memory of you) I took Mrs. Wadsworth a small bottle of Pond's Extract which I had in my bag. I believe her ankle is better now. She is as enthusiastic as any of the young pupils over what she finds here. I wish you were with me."

Again he enthusiastically describes some early-bird shopping:

WILLIAM MERRITT CHASE

"MY DARLING:

"I was ahead of everyone else this morning at the old market, and got quite a lot of things,—furniture, brass, copper, clocks and some lace for you. You would have enjoyed to look the stuff over and I don't doubt but that you would have found some bargains that missed me.

"The photographs arrived this afternoon. They are *splendid*. I am *very much* disappointed not to find any of you. Bob looks important and fine. Dorothy is *superb*.

"Love from your

"WILL."

A letter written to his wife before breakfast shows the necessity of his affectionate nature to communicate.

". . . Not that I have anything new to tell you. You know that I love you dearly. You have known this for more than twenty years. Oh how I miss you. . . . Today after breakfast we (Townsley and I) take a train for Antwerp. I am anticipating the pleasure to see again the pictures I saw so many years ago."

In a letter to his sister-in-law, Minnie Gerson, written from Haarlem, he shows both the affectionate feeling he had for his wife's family and his omnipresent kindly interest in his students.

He begins by apologizing for not answering more promptly her "lovely letter," and adds:

"I suppose you know how alarmed I was at not having heard from you. You can imagine my relief to know that you are the same sweet Minnie as of old. I think of you often and did so especially in London and Paris. . . .

"I am enjoying my stay here as much as is possible without 'Toady' and the children. My students are very happy and are hard at work. . . .

"It is just two months since I left home, it seems like a year when I think of it. My pupils have about bought all that there is to be had in brass and copper here and the price has actually gone up since our arrival. I am getting some interesting things in furniture. 'Toady' would revel in the old furniture markets here. If I come abroad next year I am going to try to get 'Toady' and you to come along.

"Do write to me soon again. I love to get your letters. My love to Jennie.

"Lovingly yours,

"WILL."

The next letter to his wife inquires anxiously about some promised snap-shots of "Rollie."

"Has he walked yet?" he asks. "I think you expected him to about this time." He speaks of his friend Mr. Kennedy. "He stopped here for the express purpose to see me which I think was very nice of him indeed. He did not know to tell me much of Whistler's death except that Whistler was out with a friend to drive the day before he died."

The letters continue with complaints of dark weather, comments on a day's painting, and finally record the arrival of the promised photographs of "Rollie." "How nice the big ball is with him and Dorothy and Helen in the distance. They make me homesick."

"I think I have something done," he writes, referring to his day's work. "*I don't know what I will think tomorrow. I have (as I wrote you yesterday) been away from you and the dear children just two months today. Only one more lap and then to you as fast as I can get there. Saturday Townsley, Ullman and I are going over to Antwerp and Brussels to see the galleries. I'll tell you all about what I saw when I get back.*"

"I have been at work all day doing a still life," he informs his wife the following day. "I found the work of yesterday not too bad when I saw it this morning. While at breakfast a tiny little letter (also a newspaper and a magazine with the autobiography of Blum) was handed

to me. I do wish you would write me more news of home. . . . I will try to find you something in Antwerp and Brussels."

From Brussels he reports at once upon the pictures which he pronounces *very* fine. He records seeing "six magnificent Stevens" (three underlinings) and describes a present she is to receive. "I was lucky to get a very good long stick for you (a better one than those we saw in Madrid). I got another rather good cross there. . . . Three letters from you today, thank you.

"Love to Minnie. I suppose she is with you.

"YOUR WILL."

Writing to his sister-in-law, Virginia Gerson, about this time he speaks of the death of his friend Robert Blum.

"It is too bad about Blum's taking off. I saw with a keen feeling of regret the little house he occupied here. He is well remembered here. One party showed me a photographic group in which Blum appears." Farther on he remarks that the Franz Hals pictures are "even finer than I remembered them."

In another paragraph he says: "I am getting some pretty good crosses for Toady's collection. Bless her! How I do miss her and the children. Have I offended

Minnie? (my Minnie). I wrote her from London and have not had a line from her. Please tell her I didn't mean it, whatever it is that she may have taken offence at."

A few days later he took the students to see the Mesdag collections at The Hague. The students, he informed his wife, "all came away *very* enthusiastic. Mr. Mesdag and Mrs. Mesdag showed us their studios and were most hospitable. . . . I found two interesting crosses for you. No rings to be found."

Josef Israels was the next painter who had to do his duty by the students. The entire class made the trip to The Hague with Chase. He comments upon their visit as follows:

"We found Mr. Israels a very charming little man. (He does not stand as high as my shoulder.) The students were all delighted with the man and his pictures. After the students scattered, some going to the museum and a number in search of bric-a-brac, I found the cross. It is a pretty good one so I bought it for you.

"This afternoon John Van Dyke the art writer arrived here. He dined with me tonight. I like him. You know I have known him for a long time. He says he simply stopped here to see me and the Hals pictures again.

"I got three letters from you tonight. Thank you.

A SUMMER CLASS IN HOLLAND

"In answer to your question did I get any Brussels lace for you while there, I *did* get a bit, but I am sure it is not good. Only I thought I must get something in that line since Brussels is so celebrated for lace. I believe you will be interested in some of the things I have got for you. . . .

"I went over to Amsterdam early this morning and got my Hals copy going. I worked through for three hours and I believe got a good start."

Nothing that could contribute to the students' pleasure or store of knowledge was overlooked. One of them remembers how Chase took them all to a private house in Holland to see the family portraits, one of which was a fine example of Rembrandt.

Before he left Haarlem, Chase showed his appreciation of the friendly spirit of the townspeople as well as his devotion to their greatest master by laying a wreath at the foot of the Hals monument in the presence of the mayor and the people of the town.

That the people of Haarlem valued the compliment that Chase paid to the art of their country is shown by the fact that before he left a silver medal was presented to him by the burgomaster, Paul Vlissingen, inscribed: "Remembrance of the visit of William Chase, U. S. A., and his class to the Franz Hals Museum in Holland."

CHAPTER XIX

LONDON AND MADRID

IN the spring of 1904 Chase's youngest child, Mary Content, was born. Her entrance into the world occurred one evening when Chase was to have been a guest of honor at a dinner given by the Salmagundi Club. When he failed to arrive and no explanation or excuse seemed forthcoming, Chase's hosts could not imagine what had happened, but as they sat at dinner, having given up their guest, a telegram arrived for Frederick Dielman stating that Chase was unable to be present on account of the birth of another daughter.

Congratulations were telegraphed immediately to the painter and his wife, all present drank a toast to the baby, and a musician, a guest of the evening, instantly improvised a cradle-song upon his violin.

That summer Chase held his summer class in England. The centre of interest was Hampstead Heath, where the students painted daily. Chase rented a furnished studio in Chelsea for himself.

As in all the countries he visited with his pupils, he took them to the studios of the painters, an experience invaluable to his students, as aside from the interest and stimulation of coming in contact with the painters

themselves, it gave them the opportunity to see their studies and half-finished pictures, an object-lesson they could have had in no other way. He escorted his entire class to the studios of Edwin Abbey, Frank Brangwyn, Alma-Tadema, Lavery, Shannon, and Sargent.

At Abbey's house the enthusiasm of the students did not stop with the studio, but, charmed with the quaintness of the English house, they penetrated even into the kitchen, much to Mrs. Abbey's amusement. One of Abbey's Shakespearian subjects was in the studio uncompleted at the time, and Chase, at Abbey's request, criticised it. Abbey was also at work upon a coronation picture for which the Queen was posing. Her gown lay upon a chair in the studio and was the cause of great excitement among the feminine pupils.

Walter Pach, a pupil in the class that summer, recalls interesting pilgrimages to the galleries with their master, his enthusiasm over the work of his favorites, his scornful wit expended upon the treasures of the Tate Gallery. Catholic as was Chase's taste, he found himself unable to discover any virtues in the Preraphaelites. After gazing for some time one day at one of Burne-Jones's heavy-lipped, long-necked, large-eyed ladies, he turned to his companion and said: "If I saw a woman like that coming down the street I can tell you I'd run like a deer."

But if Chase suffered from the Tate Gallery, he found his greatest pleasure in the National Gallery, which he used to say was probably the finest collection of pictures in the world.

Always loyal to his compatriot Sargent, when he paused before the *Carnation Lily, Lily Rose* picture, quoting Whistler's paraphrase, *Darnation silly, silly pose*, he refused to accept the Whistlerism as a just criticism.

It was in 1904 that Chase painted his *English Cod*, now owned by the Corcoran Gallery in Washington, and this is how that particular cod came to be painted: Passing a fishmonger's shop one day, Chase saw a large and opalescent cod lying upon a marble slab. He stood for some time gazing at it, priced it, decided that it was rather an expensive and perishable bit of still-life material and continued on his errand, but he could not forget the fish. Its subtle color haunted his dreams as the face of a beautiful woman is supposed to obsess the painter's imagination in fiction, and the spell of its beauty drew him back to the fishmonger's stall. He explained to the owner of the shop the nature of his interest, and suggested, since it was not his desire to dispose of the fish in the usual and permanent manner, that perhaps he might rent it for a few hours.

The fishmonger, since it was Saturday and a half-holiday, hesitated at first lest he lose the sale of his fish. After a short dicker, however, he agreed to rent the cod to the artist, and Chase went away with his prize, promising to pay for it if he kept it over the allotted time.

When the fish was not returned on time the fish-monger sent an emissary to the painter's studio to find out what was going on. His report, whatever it was, evidently aroused curiosity, for in a little while the fish-monger himself appeared on the scene. He came in so quietly that the painter did not hear him at first. When discovered, he replied most respectfully: "Don't 'urry, sir; it's getting on fine."

Chase kept the fish a little over time, but the fish-monger waited patiently until he was through with it. When the last brush stroke was planted—that final exactly right stroke that, as some one has said, seems always to say "there!"—the painter turned to the owner of the cod and, generous as always, suggested that he ought to buy it since the fishman might by now have lost all chance of selling his fish before Sunday. But the fishmonger, after all an art-lover in his fashion, said that he would take his chances and would accept nothing more than the two hours' " 'ire " for his fish.

The next year when Chase was in London on his way to Spain, finding himself in the vicinity of the fishmonger's shop, he went in and asked the man if he remembered him. The fishmonger replied at once: "Oh, yes, you are the American artist who painted my cod."

"I thought you might like to hear about it," said Chase. "I sold that picture to a museum for four hundred pounds."

The fishmonger listened with interest and remarked that it certainly was a beautiful picture, but that also it undoubtedly was a fine cod. When the generous Chase offered to give the fishmonger an honorarium on the strength of his sale the honest Britisher flatly refused. He would not take any more of the painter's money, but he stated modestly that he would very much like a photograph of the fish picture to hang in his shop, a request which, of course, delighted the painter. A photograph was made of the cod when Chase went home. It was packed in his trunk and carried to England the following summer—and carried back to America in the fall. Since the artist's tangible appreciation never reached him it is a pity that the fishmonger could not know how pleasantly he was cherished in Chase's memory.

Chase became a member of the Institute of Arts and Letters in 1905, from which society he was elected to

membership in the Academy of Arts and Letters in
January, 1908.

The summer of 1905 he had his class in Madrid,
making first his usual trip to London and Paris. Mrs.
Chase accompanied him as far as France, but was obliged
to leave him to return to her children at the end of a few
weeks.

While in Madrid Chase stayed at the pension of Señora
Carmona Dolores, who has entertained nearly all the
painters who have visited Spain. Sargent always stayed
there, also Whistler. Chase said that he could never get
Whistler to admit that he had been to Spain. For some
reason that eccentric being chose to shroud the fact in
mystery. But the leaf in Señora Dolores's guest-book
autographed with the butterfly was conclusive proof.

Chase made a few portrait-sketches from interesting
models that summer, but he painted no landscapes.
He seems never to have painted much outdoors in
Spain, and on this trip did no copying in the galleries.
He found a studio for himself, a beautiful apartment in
an old house. Irving Wiles, who was in Madrid with
him for a few weeks, enthusiastically describes its dec-
oration and arrangement, and tells how Chase's Spanish
landlady, who sniffed with scorn as she saw the dusty
loads of old brocades, crockery, brass, and copper arriv-

ing at her door,' threw up her hands and broke into extravagant exclamations of admiration when she entered the studio after Chase had decorated it.

A pupil in the class that summer remembers how Chase took them all to Sorolla's house, which was filled with that painter's pictures. Sorolla was not in Madrid himself at the time, but his brother-in-law played the host in his absence.

Sunday in Madrid was a gala-day for Chase. He began the day by wandering through the market, where he never failed to find treasures. Irving Wiles still recalls with feeling the active manner in which Chase dragged him about in the hot sun hunting for bargains.

In the afternoon there was the bull-fight. "And I don't think he ever missed a Sunday there," said Walter Pach. Chase not only enjoyed the spectacle, but became an expert judge of the bull-fighter's art, appreciating their points almost as critically as a Spaniard.

In the late afternoon and evening he liked to watch the pageant of the streets from a seat at a sidewalk café or from one of the pay-benches along the Prado. There he delighted in picking out the Velasquez types in the crowd, finding now a dwarf, then a beggar, next an Andalusian horse, quite as if they had stepped out of a Velasquez canvas. I remember his saying that before

he went to Spain he used to think those strange horses in the Velasquez pictures were a sort of artistic license, but that the very first day he went to Spain he saw one coming down the street.

Walter Pach remembers the evening of an informal students' dance in Madrid when Chase sat with Señora Dolores a spectator against the wall. Suddenly he jumped up, inviting the elderly Spanish lady to be his partner, and they both danced off together like the youngest people in the room, much to the delight of the students.

When his face was turned toward home at the end of the summer Chase expressed his anticipations as father and painter in a letter to his daughter Dorothy.

"You must get ready to do a lot of posing for me when I get home. I have brought a lot of things which I know you will look nice in. How is Content? Is she as sweet as ever? . . . Give my love to everybody. Good-bye, sweetheart.

"Lovingly,

"Papa."

That was Chase's last visit to Spain. He always intended to go back, always retained his affection for the country, and often recalled the memories of his days in

Madrid. The very last year of his life he was planning a trip there with his wife, but as practically all of his journeys to Europe were made with reference to his summer classes, and as he disliked the discussion of plans or any necessity to think of details, he left the selection of the place where the class was to be held to others. And so it came about that much as he loved Spain he never went back there again.

CHAPTER XX

THE FIRST VISIT TO FLORENCE

THE summer of 1906 Chase spent at Shinnecock. The following winter he continued his teaching in New York and Philadelphia. In 1907, after his usual visit to London and Paris, he went to Italy. Much of the time he spent in Venice, although he held his class in Florence. It was at the end of this summer, his first visit to the Florentine city, that he bought his beautiful villa on the farther side of the Arno.

When Edwin Abbey heard that Chase was in Europe that summer he urged him to visit them in England. "Do come if you can," he urges. "I should like you to see my stuff." Which shows how Abbey, who used to take his work to Chase for criticism in the early Tenth Street days, still valued his opinion. Chase however was obliged to go on to Italy without seeing Abbey.

As this was Chase's first visit to Florence, it was his first unavoidable contact with Florentine art, for since his natural tastes had led him in quite opposite directions, he had been at slight pains to study the Florentine masters in the English, French, or German galleries. In Florence when he first went to the museums it was merely to enjoy the examples of his favorite masters,

but his attention was finally drawn by the omnipresent Botticellis and other Florentines, and while he cannot be said to have acquired any great enthusiasm for them, he came to enjoy their decorative quality. He liked best the Botticelli *Calumnia* and the *Primavera*. He came also to appreciate the decorative quality of the Paduan Mantegna, but the Fra Angelico angels he refused to accept on any ground.

In Florence Chase ran across his confrère George DeForest Brush (who *does* admire Florentine art, as evidenced in his own work). He also met his friend Julius Rolshoven, and promptly conducted his class to that painter's beautiful old castle near Florence.

In Florence, as in Madrid, Chase enjoyed a spectator's seat at a sidewalk café. There he sat almost every evening with his friend Rolshoven discussing the Munich School, Leibl, and the tendencies of modern art. In the American and English colony in Florence he found a number of old acquaintances and made some new ones. Shortly before his return he sent a characteristic postcard to his little son, Roland Dana, saying: "I am coming home soon to play with you."

In 1908 Chase severed his connection with the New York School of Art. The summer he again spent in Italy, but had no class. That year the Italian Government

asked Chase for a self-portrait to add to the collection of self-portraits of old and modern masters in the Uffizi Gallery, an honor he deeply appreciated. I chanced to meet Mr. Chase in an antique shop in Florence shortly after this compliment had been paid him, and his unaffected pleasure in it was most characteristic of the innate modesty of the man which underlay all the little surface mannerisms and innocent affectations so affectionately remembered by his pupils.

He was full of enthusiasm at that time for his recently purchased villa on the farther side of the Arno, which he asked me to visit, but the fact that I was leaving Florence that day, unfortunately prevented my seeing it.

Chase had the greatest admiration for the competent maternal *contadina* who had charge of his villa. "But it is a good face, a beautiful face," he used to say as he looked at her. He made much of her children and brought them dolls that seemed to the Italian peasant much too fine for use. When Chase returned the next summer with more dolls, supposing the others to be worn out as toys were in his household, he was overcome at being shown the first ones still untied in their boxes. "What shall I do?" he asked one of his feminine pupils in perplexity. "Here I have brought them new dolls and they have never even used the others. Didn't they like them?"

WILLIAM MERRITT CHASE

The winter after he had bought the villa, as he passed the ever-present temptation of an auction-room near his New York studio one day, Chase espied some colonial beds. "Just the thing for the villa," he exclaimed.

"An American colonial bed in an Italian villa," objected the friend who was with him.

"But why not, why not? . . . With canopies, eh?" the painter indicated airily with his expressive hands. "Just the thing." Undeterred by discouraging criticisms, he went in to purchase a colonial bed. He admitted afterward that he had bought two and had ordered them boxed and sent to Italy, after which he thought of them no more. Unfortunately they arrived in Florence after he had left that summer, too late to be installed. Notices from the Italian customs, whose import he but vaguely gathered, followed him about, finally becoming so insistent that he felt that they must be attended. So the next summer, about a year and a half after their purchase, he appealed to one of his pupils who spoke Italian to go with him and disentangle the matter.

At the customs office he was bewildered by floods of incomprehensible language and besieged with gestures. He subsided upon a chair, and gave the pupil with the Italian tongue to understand that he had entire confidence in her and left the matter absolutely in her

hands. The pupil, after listening to duo, trio, and chorus
—no solo—informed Chase that the officers said that
they must know the *exact* number of pieces of the beds
before they could search for them. Chase was over-
whelmed. He did not know how many pieces, he was
not sure how many beds. The pupil gently sought to
draw from him the probable number of beds. At first
he stuck to his original estimate of two. The pupil hastily
multiplied the number of beds by the probable number
of pieces, and an excited search began. *Ma, no!* There
was nothing there of that number of pieces, *niente,
niente.* Under cross-examination by the pupil the be-
wildered Chase admitted that there *might* be three beds.
Eighteen pieces, sixteen pieces. The frenzied search be-
gan again with the same climax of despair. There was
nothing from America in sixteen pieces; no, nor in eight-
een pieces.

The search was started on another basis, suggested by
the feminine American mind, and at last, late in the day,
with every one exhausted—Chase most of all—*four*
colonial beds, the property of Signor William Chase,
Americano, were unearthed, customs duty and storage
charges paid, the beds repacked and sent to the villa,
where they were unpacked, set up, but not canopied, and
never used; there presumably they stand still.

WILLIAM MERRITT CHASE

Chase sent two pictures to an international exhibition in Berlin in the summer of 1908—the well-known *Woman with the White Shawl* and one of his fine fish pictures. The Kaiser, who was naturally the first to inspect the exhibition, was particularly struck by Chase's portrait. He asked a number of questions about the painter and was, of course, delighted at hearing that he had studied in the Fatherland. Mr. Hugo Reisinger, who with von Kämpf, the director of the academy, accompanied the Kaiser on his round of the gallery, noting his enthusiasm, immediately pointed out the still-life canvas to his Majesty, but the Kaiser passed the fish without comment and scarcely a glance.

Mr. Reisinger thought that he had overlooked the picture and ventured to remark: "This is a marvellous bit of still-life, your Majesty, by the same artist." But the Kaiser briefly disposed of the matter: "I do not like *Fisch*."

Von Kämpf then protested: "But it is a magnificent bit of painting, your Majesty."

"But I do not like *Fisch!*" again remarked the Kaiser with greater firmness.

Both artistic enthusiasts, combining German persistence with German regard for their sovereign, set out deferentially to lead the Kaiser to see the merits of this

STILL LIFE.—FISH.

Property of Metropolitan Museum of Art.

most excellently painted fish, only to find themselves cut short after a few protesting sentences.

"*But I do not like Fisch !*" And the voice of the royal one did not admit of further argument.

In 1908 Chase gave up his Fifth Avenue Studio and took the large suite of rooms in the Tiffany Building on Fourth Avenue. The location of this studio was not known to the general public and was not in the telephone-book, in order that the painter might be protected from intrusion as much as possible.

The Fourth Avenue Studio was even more spacious than the Tenth Street place. Partitions were taken down until a connecting chain of four rooms remained, two of which were extremely large. Somewhat overcrowded, yet without seeming actually cluttered because of their size, these rooms were beautiful in tone and color. Rich draperies, Spanish, Italian, Chinese, and Japanese embroideries were in evidence on all sides. Pictures of his own and of other painters, including a few old masters, stood about or were hung on the walls. Beautiful old furniture, including some rare Spanish pieces, bits of porcelain, brass, copper, Japanese carvings; miscellaneous *objets d'art*, Italian, French, Dutch, Spanish, and Oriental, were set each in the exactly right place—for the taste that can enjoy such multitudinous ornament!

Certainly there was in Chase, as an artist friend remarked, something of the Lorenzos de' Medici. He liked magnificence, efflorescence, the multiplication of material beauty, and seemed often to lose sight of the value of simple spaces in his love of ornamentation and bric-à-brac. Fortunately his best canvases have a greater simplicity than the rooms he decorated.

The floor of the Fourth Avenue Studio was of a most delicious transparent mysterious green—the green of water in deep woods. The effect was produced by a covering of heavy green linoleum, stained, waxed, polished, and coaxed by various means into the desired tone. Chase had a peculiar fondness for green. Mrs. Chase was amused once at his absent reply when she asked him what color he preferred for the bathroom wall: "Anything you like, so long as it's green."

Another set of rooms on the floor below was kept for the use of his private pupils. With characteristic trustfulness Chase would descend from one floor to the other, leaving an open door to the possible intruder. It was not surprising in these circumstances that certain treasures were missed from time to time.

The scheme of the classes in the Fourth Avenue Studio was practically that of an art school. A model for the figure was provided, with a separate room for the men

students in that class. A number of the pupils painted still life, with all of the beautiful objects in their master's studio to draw upon for their composition.

That autumn Chase accepted an invitation to teach again at the New York Art League, as he had decided to give up his teaching at the Pennsylvania Academy.

In 1909 he went to Florence, where he again had a summer class. His villa was greatly enjoyed by his students but he never lived in it, although cart-loads of beautiful objects purchased in and about Florence were sent there—some of which arrived at their destination. Chase had an unreasoning trust in the somewhat over-subtle Latin shopkeeper. "Nonsense, the man is honest," was his invariable answer to the person who suggested precautions. When actual proof of disingenuousness was offered to him, his invariable answer was that he could never have believed it of that particular person. Chase was not only trustful to the point of simplicity in his business transactions, but he undoubtedly lacked discrimination at many points, perhaps because his complete absorption in his art had trained his perceptions rather exclusively along one line. Certainly his ability to judge human nature was often insufficient for his self-protection.

A letter to his daughter Dorothy, written in August

from Florence, shows his usual affectionate thought of his children.

"I want to write you a letter and what shall I say? I think of you so often when I am out driving the pony. You would love to drive her, and you shall if Dana doesn't mind (I find myself calling Roland, Dana because you all do, I suppose)."

He inquires how his daughter likes the theatre-coat he sent her, saying: "It was Mamma's choice and I liked it also because it was nice and simple. Now, darling, when you can find time write me a little letter. Give my love to all at home. It sounds nice to say 'home.' I wish I could see you all this morning. Love to you, sweet one.

"PAPA."

Chase had an exhibition of his pictures in Cincinnati in 1909, the third large exhibition of his work to be held outside New York. And in April, 1910, a most interesting and representative exhibition of his pictures was held at the Gallery of the National Arts Club, preceded by a large dinner given him in the galleries. Concerning this exhibit, his confrère Frederick Vinton, an old friend, wrote to Mrs. Chase:

"When I found myself in that superb exhibit I was

THE LADY WITH THE WHITE SHAWL.
Property of the Pennsylvania Academy of Fine Arts.

quite bowled over by it. I really did not realize how rich and varied his work has been during the last thirty years. . . . *The White Shawl* ought to be owned by the Metropolitan. . . . In my opinion that canvas in its simplicity, breadth, construction and sentiment will always rank with the best done in our century not in America alone but in the world."

In the summer of 1910 Chase again had a summer class in Florence. He writes again of the villa to his daughter Dorothy and comments with his unfailing parental interest upon the photographs with which his wife kept him supplied. "I see that Mary Content is again wearing jumpers." Then remarks, feeling perhaps some consciousness of his lack of facility in expression: "It is not easy for me to describe places and things here so you would understand, as you have not as yet been here. Some day I shall hope to have you see it all with me. I go out to the villa almost every day and am doing some painting there. Rollie's little pony is a perfect dear. We get on splendidly together. The pony seems to enjoy going about as much as I do. I have named her Lilly, the abbreviation of Liliputian, she is so like a tiny horse."

Irving Wiles and his daughter Gladys were in Florence while Chase was there that summer and afterward went

on with him to Venice. Carroll Beckwith and his wife were also temporarily settled there in a villa outside of Florence. The friends had many pleasant meetings. Chase instructed them in the technic of feeding pigeons in the Piazza San Marco in Venice, entertained them at the villa in Florence, selected a hat for Wiles's daughter in the absence of any of his own, and generally made himself agreeable.

Gladys Wiles describes a brisk ride behind the pony with the painter, who, apparently unaware of disproportionate effects, snapped his whip with all the air of a horseman driving a blooded steed, while the pony's little feet pattered over the pavement with the exaggerated activity of a black-and-tan terrier. She says that Chase always spoke as if his little son might come at any minute to take possession of the pony, but that dream was never realized. The undertaking of moving eight children and household effects every summer to Italy was too much even for Mrs. Chase's executiveness and willingness to serve her husband.

When Wiles went away from Florence he left a little sketch inscribed to Chase in his room, an attention which touched and pleased the painter indescribably. He alluded to it constantly afterward. "Dear old Wiles, what a beautiful thing for him to do. Wasn't it just like

him?'" One day after his return to New York the sketch was missing and Chase was terribly distressed. He hunted for it for days. He even went to the trust company where his pictures were stored and had everything taken out. At last he found it. A pupil who had listened to his lamentations on the subject says that one day he came to her with a radiant face. "I have found it," he said. "I have found Wiles's little sketch." In such fashion did he treasure the tribute he valued.

The next letter to his daughter Dorothy expresses his great regret at having been absent at the celebration of her birthday. "Soon," he says, "I will see your sweet face again, and I am glad."

Certainly Chase's children can carry with them always the loving memory of a father's affection freely expressed.

CHAPTER XXI

A FAMILY EVENT AND SOME EUROPEAN EPISODES

IN January 1911 Chase's oldest child, Alice, was married. Up to the very day of the wedding the painter refused to take his daughter's engagement seriously, much as he liked the young man of her choice.

"That child to be married! Absurd! Nonsense!" was his only remark when details of the approaching ceremony were mentioned to him. But when at the very last the realization came that little "Cosy" actually was to be married, the first form that awareness took in the painter's mind was that art's tribute to the occasion should be impeccable. Accordingly, his most severe and concentrated attention was bestowed upon the arrangement of the pictures on the walls of his home, his own and those of other painters. The result was dissatisfaction. He decided to have them all changed. But when this imagined improvement was accomplished, his final verdict was that they had, after all, been better as they were. Hastily recalling his man in the act of removing the step-ladder, he ordered them to be placed in their original positions. In the ardor of this task a pot of palms that proved to be abnormally full of earth was overturned upon the carpet, and a great deal of dried

Christmas green—for it was holiday time—was scattered upon the floor and corduroy-covered furniture, where it clung tenaciously. When the mother of the bride, only partly forewarned by the sounds of scratching and scraping from below, descended the stairs to take a last look at the drawing-room before the arrival of the wedding-guests, she silently and swiftly removed her pearl-gray gloves and spent the remaining moments in a greater activity than she had expected.

In short, Chase did not display his usual *savoir-faire* upon this occasion, which he only too evidently found upsetting. Both wife and daughter were relieved when his part of the ceremony was over, as he had required a great deal of prompting in his rôle and showed an almost feeble-minded dependence upon the bride and the bride's mother to help him through. But two years later, when his second daughter, Koto, was married, he had evidently grown accustomed to the idea that daughters are liable to marry, for he did nothing to upset the equilibrium of the occasion.

The afternoon of the day that Koto was married, Chase's first grandchild, Dorothy Sullivan, the child of his oldest daughter, was christened.

In the summer of 1911 Chase went abroad again, first to Paris and London, then to Florence to teach his sum-

mer class and enjoy his new toy, the villa. He made a number of studies of the villa, but in spite of the fine appreciation of the Italian atmosphere they reveal, they lack the inspiration and freshness of his Shinnecock landscapes.

In one of his letters to Mrs. Chase from London that year Chase speaks of his visit to the Royal Academy Exhibition, which he finds "more interesting than usual." "Sargent has some fine things," he writes, "a portrait, a big decoration, part of the Boston series, very fine, also some landscapes. After lunch I went to see Brangwyn, he seemed glad to see me. He is doing a big decoration."

In 1912 Chase gave up his position as instructor at the League, and his New York teaching thereafter was confined to his private class in the Fourth Avenue Studios. That summer was spent in London, Paris, Bruges, and the Dutch cities. His class was held in Bruges. Mrs. Chase and his son Dana crossed with him. In Paris they all went to their first futurist exhibition together. Mrs. Chase and her son reached home first after this curious experience, and while waiting for Chase's return Mrs. Chase conceived the idea of making a futurist exhibition as a surprise for the painter. They got to work at once with colored pencils, and upon Chase's return held him up at the door and demanded admission. Till the last

Chase treasured in his studio one of these sketches, a portrait of him by his wife done in the post-impressionist manner—in all respects an excellent imitation of the sort of thing indigenous to such exhibits.

"But you see it really looks like me," he used to say with what was certainly a most impersonal pleasure in the intentionally horrible production.

During his stay in Paris that summer he went to see La Touche with Mrs. Chase, who describes the unconscious humor of the occasion. La Touche could not speak English nor Chase French. This fact did not prevent their having a most lively conversation about art and the pictures in the studio without the aid of an interpreter. Both painters fairly glowed with enthusiasm. They liked each other immensely and apparently parted with all the sensations of having had a most delightful and congenial interchange of opinion. Who shall say that in that subtler undercurrent that can underlie words there had not been something of communication?

Chase painted two of his most notable still-life pictures in Bruges—the study called *Just Onions* and the *Belgian Melon,* which in richness of color and texture and distinction of handling can stand with the best still life of the old masters.

The winter of 1912–1913 he had a large class of private pupils and worked daily in his own studio. His contribution to the exhibition of portrait-painters in February was an excellent portrait of Robert Underwood Johnson, concerning which he received a letter from Charles Dana Gibson which particularly pleased him.

"DEAR CHASE,

"Your portrait of Johnson is great. It's a fine thing to go on doing better and better all your life. Here's hoping you'll live to be a hundred.

<div align="right">

"Yours always,

"C. D. GIBSON."

</div>

In the summer of 1913 Chase again had a class in Italy, this time in Venice. It was his last European class. His wife and his daughter Dorothy sailed with him but left him in June in Paris to return to Shinnecock.

The story of the summer Chase tells after his fashion in his letters. From Venice he complains of the constant rain and speaks of painting from his sheltered balcony.

"I think perhaps I got a fairly good thing today," he remarks. "The one I made yesterday is well enough to keep and show you when I get home." Remembering the masterly quality of these small Venetian sketches,

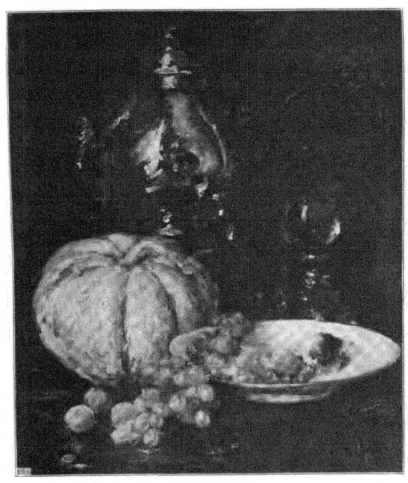

A BELGIAN MELON.
Painted in Bruges in 1912.

one realizes the sincerity of Chase's modesty disclosed in the intimate frankness of these home letters.

Later on he inquires: "Has Helen done anything in the way of sketching, and have you made a photograph of Rollie in the English messenger cap? Did he like it? I wish I could see you all tonight. Has dear little baby Dorothy grown much? I suppose you are seeing a lot of her. I wish I could.

"Tomorrow we go to the Doges' Palace. Do you remember the time we went there and you made the photograph from the balcony? Tonight I met all of the Rolshovens at the Piazza."

The next letter speaks of hunting a studio and of the industry of his class, and another is filled with enthusiasm for a perfect Venetian day in which he painted all morning. He refers to an afternoon visit with his pupils to the studio of Signorina Ciardi, an Italian painter. "She is a splendid artist," he remarks (with two underlinings). "I wish you could see her work. She speaks English quite well and was most agreeable to the students."

Chase's admiration for Signorina Ciardi was such that he very much resented the fact that the Venetians did not appreciate her at her true value. Once an Italian at whose palace he was calling remarked in the

characteristic manner of the Old World disparaging the younger generation, "Oh, yes, Signorina Ciardi she is very well, but her father, ah, you should see *his* work, *he* is a great artist!" Whereupon Chase very promptly set his host right: "Ah, but that is where you are entirely wrong, sir; it is Signorina Ciardi, make no mistake, *Signorina Ciardi, she* is the great artist!"

Chase's next letter to his wife speaks of his unsuccessful hunt for a studio. "Fortunately," he adds, "there is always something to paint here. I want a studio to paint fish in. Tomorrow I am going to try down by the Rialto near the fish market." (It was there that he painted the *Fish Market* in 1878.) "This afternoon I went out to the Lido with my paint box but did nothing because of the great crowds everywhere. How is baby Dorothy? You must be getting lots of pleasure out of her. Love her up for me. I would love to see her sweet little face again. I was in the piazza again tonight—music and the Rolshoven party. All was pleasant."

The next day he went again, this time with the Rolshovens, to see Miss Ciardi and reports: "She had some new and interesting work." Of an interior begun the day before he says: " I am in hopes of making something out of it." He tells of taking the students to the Scuola San Rocco to see the Tintorettos, which he characterizes as

"very fine," and comments briefly upon the death of La Touche, whose work he greatly admired. "He will be missed. His exhibition in the last salon was the best in the exhibition."

Another letter encloses a sketch showing the composition of a still-life which he painted for his class. "The students now want to paint still life the rest of the time while here." Further on he remarks: "I am reading 'Twenty Years After' piecemeal. I find it interesting. What a lot of intrigues there must have been in those days!" Chase never lost his simple enjoyment of the emotion of astonishment.

A later letter from Venice mentions a visit to Madame Fortuny. "She is an old, well-preserved lady of seventy-three. She owns a small palace here where she has lived for a number of years. At the time of her husband's sale after his death at Paris she brought back many of his studies and many of the fine stuffs. The studio and begun pictures are *splendid* and the stuffs are *magnificent*. It was a rare treat which I am sorry you could not have enjoyed with me. She asked me to come again to see some etchings by Fortuny and some by Goya. Of course I will go. I feel a fresh spell of enthusiasm after seeing the things. Oh, Toady, I wish we had the means! We could then have fine things too."

A pupil in Chase's class who went with him to visit Madame Fortuny says that the great artist's widow had a real understanding of art and expressed a great desire to see Chase's work, but as the señora was old and not very strong she did not feel able to make the journey to his studio. Determined that if Madame Fortuny wanted to see his pictures she should, Chase proceeded to take the mountain to Mahomet. He filled a gondola with his work—Venetian sketches, fish pictures and portrait heads—and gave the Spanish painter's widow a private view at her own house. Both Chase's work and the gracefulness of his act delighted Madame Fortuny inexpressibly.

Another letter from Chase to his wife concerning his unfinished picture records a typical painter state of mind at that stage of his work.

"While I don't know what it will look like tomorrow, I feel now that I've got something that you will care for. I will tell you in my next letter how I find it." Before he concludes he acknowledges with profuse gratitude the receipt of some home-made butter-scotch.

The next letter comments enthusiastically on some photographs Mrs. Chase had sent of the two younger children, Mary Content and Dana. "I think those of Mary are quite the best you have made. They are *splendid*, composition and all. Hurrah for you!"

A FAMILY EVENT

In September Chase sailed for home, unaware that he had taught his last European class.

One of his greatest pleasures during those summers in Europe was the buying of presents for his wife and children. According to his travelling companions his thoughts on the homeward trip were entirely concerned with anticipations of his home-coming, the joy of seeing his family again, their probable pleasure in his gifts. "Won't Mary Content be lovely in that little blue coat?" he would exclaim out of a mid-ocean revery, or "That flame-colored lining on Dorothy, eh?" And again: "That blue-and-gold scarf will just suit Helen." "He bought things like a prince," said a pupil who was with him on some of his shopping expeditions. "Nothing was too good for them; the price was not even to be asked when he thought he had found something they would like."

CHAPTER XXII

CALIFORNIA

IN the spring of 1914 Chase went abroad again for a short trip. He called, as usual, on Brangwyn and Shannon soon after his arrival in London. In a letter to Mrs. Chase from there he speaks of the work of those painters.

"Shannon had a sitter on a portrait but saw me. He has a fine exhibit at the Royal Academy this year. I telephoned Sargent this morning and am to see him tomorrow afternoon. Harrison and I are going together. Brangwyn is doing the big decorations for the Pan-American Exposition at San Francisco. They are *fine*."

Chase had a great admiration for Brangwyn's work and never went to London without going to see him. Entering his house that day he stopped to look at a small picture by one of the early Italian painters—not the type of thing that usually appealed to him—and exclaimed: "Where did you get this beautiful thing?"

Brangwyn was delighted. "Do you know," he said, "that of all the painters who have passed that picture you are the first one that has really seen it?"

The trip though pleasant was not eventful. In May Chase returned to America. It was his last crossing.

CALIFORNIA

In June he went to California, where he had arranged
to hold a summer class at Carmel-by-the-Sea. He lo-
cated himself at Del Monte, a short motor ride from
Carmel. Mrs. Chase went with him, but returned after
a short stay. In a letter written to her from Del Monte
soon after her departure he tells of securing a small
studio at Monterey, where he "expects to get a lot
done." And, "you made me very happy all the time you
were with me," he adds with his unfailing appreciation
and affection.

Another letter expresses profound gratitude for a box
of butter-scotch. "You are so thoughtful," he exclaims.
"The others are almost used up." He speaks of receiv-
ing a "nice letter from Arthur," his son-in-law, then
touches on his day's work. "I painted in my little studio
today laying in a large picture."

Writing again from Del Monte, he describes his day's
amusement. "Today I went out with a. young artist
to see the Rodero at Salenas. Do you remember we saw
the sign swinging across the street at Monterey? The
Rodero is a gathering of cowboys and cowgirls, the
performance is most interesting. I wish you could
see it." He records his pleasure in the family letters
and photographs. "The one of dear little Dorothy
walking with you is sweet. You complain that you do

not get letters. I can't understand it as I write every day."

He refers again to the still-life he had started. "My last fish picture I believe to be my best. Tonight I am to give my class and the Carmel high-brows my talk on Whistler. I wish you were here to give me your sympathetic support. I do so wish you and the children could be out here in this wonderful cool climate."

Later he writes of his full-length portrait of Miss Townsley called *The Flame*, his last kimono portrait: "I believe it is one of my best things. The students are quite enthusiastic about it. When you see it you will tell me if it is any good." A letter to his son Dana, written about this time, shows his constant affectionate remembrance of his children when separated from them.

"DEAR ROLLIE,

"You must have begun to think I had forgotten you and your brother and sisters altogether. No!!" [Three underlinings.] "I liked the picture your Mama sent me of you on that funny looking cycle or whatever it is. You appear to be standing straight up and I can't make it out. Mary Content looks as if she were about to split herself. I will soon be home now. I have some new stories to tell you. I wish you were all out here to come

CHASE PAINTING FOR HIS CLASS AT CARMEL, CALIFORNIA.
From a photograph.

home with me. There's lots of country out here. Be good and be glad to see me when I get home. Give my love to your good mother and all the others.

"Love.

"PAPA."

A few days later he writes to his wife: "I worked all day in my studio. I am doing a study of Townsley." He describes some monotypes he has made. "I found that impressions could be had with a clothes wringer so I got one. I will send you some to show you what I am doing in that line. I am enclosing another photo of myself. I am afraid you will grow tired of them. As the students give them to me I send them to you. I wish I could have been home for Dorothy's birthday."

In another letter we find him thanking his wife most gratefully for some paint rags sent in a newspaper. Referring to his grandchild he remarks: "You must have enjoyed having sweet little Dorothy with you. Two sweet Dorothys at one time is a lot."

Another day he refers to the enthusiasm of the students over his portrait of Miss Townsley, a tribute he always prized highly, and adds: "I think myself it is a canvas you will care to have me exhibit."

Again he encloses the plan of a portrait about which

he is more explicit than usual. "The dress is old gold color and a blue kimona background. I think you would like the combination. The girl is rather pretty. I made some monotypes in the studio this afternoon. Tomorrow I will send you some. I played a short game of billiards and was beaten."

A letter written in September, shortly before his return, tells of a stag-dinner given in his honor. "Many speeches lauding me were given," he relates, with the childlike pleasure he had in appreciation. He also makes mention of another portrait upon which he was working at the time with his characteristic lack of special comment. "She is a very picturesque subject and I am enjoying it very much. Today I finished the outdoor thing I was doing of which I told you. I had another game of billiards just now with the attendant and beat him. I am beginning to call back some of the shots I used to make."

The route home from California led through the Grand Cañon. When Chase heard that two of his friends intended to stop off there he was scornful. Why did they wish to see that freak of nature? To Chase that which was not paintable never seemed worth looking at. The cañon he conceived of as panoramic. Being, however, a gregarious soul, he stopped off with his friends, pooh-

poohing a little, but when he saw the impressive sight of the great gorge he was moved as one would be sure he would be.

But the stop-over was shadowed by an unfortunate occurrence, for Chase, having met with some unfair treatment in business matters in California, discovered that his finances were at a low ebb. He was, therefore, unable to make any purchases, and finding, of course, in the variegated stock of the large shop there some things he wanted to buy, he could only hover over them like a wretched little boy with no pocket-money.

The winter of 1915 he painted a number of portraits, among them several of his own children, one of his daughter Dorothy in an eighteenth-century pink-satin costume that he had purchased for the purpose, a seated half-length portrait of his youngest son Roland Dana, and another of his second daughter, Koto. Not any of these pictures are representative of Chase's best work, but a certain personal interest naturally attaches to them.

In 1915 Chase received an order to paint a self portrait for a museum in his native State, in the town of Richmond, Indiana. The amount offered was only sufficient to pay for a head portrait, and that was all that the donor of the picture expected to receive. But Chase, who

delighted in doing the generous thing and knew how to do it charmingly, planned a surprise for Richmond. He painted a large canvas, a three-quarter length figure standing, palette in hand, before his easel in his Fourth Avenue Studio. It was finished in November, 1915. The pleasure that he took in doing this and in keeping his act a surprise up to the moment that the portrait was shown to the envoys from Richmond was characteristic of artist and man.

Having been asked to serve on the Art Committee of the Pan-American Exposition, Chase went to California again that summer, but he did not have a class. An entire room in the art building was devoted to his work, making an exhibit which the painter himself felt to be representative of his best work. He also designed and personally supervised the decoration and arrangement of the room.

Throughout the winter of 1915 Chase continued with his private class in the Fourth Avenue Studio. It was his last year of teaching.

CHAPTER XXIII

CHASE, THE MAN

CHASE was perhaps more individualized as an artist than as a man. On the human side he was a simple person. Witty as well as analytical on the subject of his art, he thought simply about the things outside his sphere of interest where he thought at all. Of those utterances of his that were so entertaining at the moment much of the flavor escapes in print. Chase had the actor's gift of creating the little situation, of giving point and effect to his utterances, whether satirical or violent, and his satire was never intentionally unkind. To quote Birge Harrison: "Chase was the simplest and most sincere of men and also one of the kindest as many a struggling young artist can testify, and this last trait always seemed to me to be the most dominating note in his character. But he could be quite savage in his outspoken dislike of all shams and pretenses."

No man ever lived more completely in the atmosphere and idea of art than Chase did. He had no other compelling interests except his family, and, indeed, in his devotion to them art was inextricably intertwined. At his first meeting with his wife, then a picturesque child, the strong impression she made upon his eye took the

form of a desire to paint her. His children he painted almost from the moment of their birth. Art was talked in his home as it was in his studio.

Aside from his personal feeling and the practical convenience of propinquity, it was evident that something in his wife's type especially appealed to the painter. Yet few of the pictures are portraits in the exact sense of the word, and therein lies one of the mysteries of the art of portraiture. Mrs. Chase never grew to dislike posing, as many members of painters' families do. Indeed, she was as frequently a volunteer as a conscript, devising costumes suitable to her type with the purpose of pleasing the painter's eye or of suggesting a subject. She says that he seldom kept her posing long enough to be fatiguing. The sureness of his seeing made the process swift.

Chase was not a reader, George Moore's "Lectures upon Art" being one of the very few books of this sort that he ever enjoyed, since he had the painter's belief that only people who paint are qualified to write about it. He bought editions of books for his library principally with reference to their appearance and the spots of color they would contribute to the room. He did not indulge much in sports, and, except for his skill in shooting, did not become expert in any of them. He enjoyed music

THE BLACK KIMONO.
Portrait of Chase's daughter Alice.

and the theatre rather in the spirit of light amusement than as seriously considered arts, but he had one other supreme interest—that passion of the collector which was curiously strong in him. Indeed, his impulse to buy was almost abnormal, in that he seemed to be increasingly unable to resist its promptings. That he was extravagant as the result of his desire to possess the thing that attracted his eye cannot be denied, but it must have been apparent to any one who knew him that he was utterly unpractical in all matters of finance. Some bills were paid twice, others not paid at all. At times when buying a present or some particular object that had cast a spell upon his imagination so that he felt he must have it at any price, he spent as if his treasury was inexhaustible, but in the case of pictures he quite often got a bargain through his knowledge of values and his ability as an expert to judge the genuineness of a canvas.

One time in Spain he discovered a Greco believed by its owner to be a Murillo, incredible as that may seem. Chase, not having much money with him, made a deposit on the Greco and told the woman to hold it for him. Meantime Zuloaga strolled in, discovered Chase's discovery, promptly paid the woman the whole amount and bore away his unlawful prize. When Chase returned with the balance and found out what had happened he

[255]

was beside himself. Time did not soften this blow, and later in Paris he hunted up Zuloaga in the vain hope of appealing to his better nature, and very politely and pathetically told his little story; but the Spanish painter was unmoved, in fact he was quite unpleasant and even sneered at poor Chase, who for long afterward suffered at the very mention of Zuloaga or Greco.

Sometimes Chase bought things that did not seem worth his buying where some quality of tone or color attracted him or suggested its possible value in a still-life study, or where his desire to encourage a struggling artist made him anxious to discover any promising touch. He tried so hard to find merit in the work of a person who was really trying. He longed so to give the assistance of his encouragement that not infrequently he would buy from the poor painter—poor in every sense of the word—things that he would have criticised severely if done by one of his pupils. But in general he bought like the connoisseur he was.

In his fondness for tangible beauty he used often to carry about in his pocket small objects that he enjoyed looking at—a rare ring, an interesting button, or some sort of curiosity. These he would pull out to show callers or the called-upon as a great treat. At one time his favorite object was a small Peruvian mummy head. This he

had with him once in Paris while visiting the studios of the French painters. The friend who was with him, another artist, was somewhat embarrassed because Chase after unconsciously giving the misleading impression that he was about to present the mummy's head would placidly return it to his pocket.

But the story of a thing, its authenticity even, except in the case of a picture, was of no interest to Chase. He did not know such facts because he did not care about them. His interest was supremely and simply the artist's lust of the eye. He cared how the thing *looked*, not a jot what its history was, however interesting. That was a characteristic quality, not a limitation.

Yet he seldom felt a strong attachment to things in spite of his collecting mania—for it almost amounted to that. A few objects, not always the most interesting or valuable ones he possessed, he seemed to have a personal feeling about, but in general his pleasure in a thing seemed to be the finding of it. Not so with pictures. He could not bear to part with a picture he loved; he seemed to feel as if he had lost part of himself in giving it up.

At one of those periods usually recurrent in artists' lives when a temporary economy seemed desirable, it was judged wise to part with some pictures out of Chase's large and valuable collection. He came home from the

sale as from a funeral and would not be comforted, but one day not long afterward he returned to his family in excellent spirits. They were not surprised when the explanation proved to be that he had bought back several of his choicest art treasures—at a considerable advance upon the price he had sold them for!

And he was generous in giving. Once he bestowed a cherished Vollon upon his son Roland, who had been patient in posing for him. Quite often he gave sketches to his pupils. Frequently he gave the same sketch to several people in succession, having absent-mindedly forgotten his previous generosity. Quite a number of friends and relatives are thus the honorable owners of pictures touchingly inscribed to some one else on the back. The recipient who bore away his prize on the spot was usually the one who gained possession of it.

Chase was a famous raconteur; more than that, he had a talent for impersonation that almost any monologist might envy. German, Hebrew, African, or Irishman he could imitate equally well. With that ability to imitate and the quite indescribable gift of implication and suggestion that he also possessed he created effects of which it is impossible to give any impression in description. A certain tale of two intoxicated persons, much to Chase's amusement, was a great favorite with his

children, who never tired of hearing it. "Tell us the Robinson story," they would beg when he was in the mood to entertain them.

This story dealt with two convivial gentlemen who had been making a day of it, but as the tea-hour approached and ladies began to enter the restaurant they felt it necessary to brace up and make a proper appearance.

"Do you know Robinson," one intoxicated gentleman then inquired of the other in the attempt at easy conversation. "No," said the other with great interest. "W-w-what's his name?"

"I dunno," replied the first intoxicated gentleman. That was all, but the expression, the tone, the demoralizing touches to hair, beard, and moustache made the dignified painter into the drunkest being imaginable as he told the story.

Sometimes on shipboard Chase would entertain his fellow passengers with an evening of his stories. At one time in his life he says that he seriously entertained the idea of becoming an actor.

Chase did not forget faces, but he seldom remembered names except those of his intimate friends and pupils of long standing. Not infrequently he failed to recall the names of men high in the ranks of his profession if he

did not meet them often. Maxfield Parrish in a letter to Mrs. Chase refers to an old joke on the subject of Chase's non-recognition of him, Mrs. Chase having insisted that at their last meeting Chase really had remembered him.

"MY DEAR MRS. CHASE,

"No, he didn't! I introduced myself as Smith and he remembered me at once, was most charmed and ah to be sure and all that. But I think if I keep it up long enough my face such as it is will finally sink in. The name of course is unimportant."

But the egoist who came into competition with Chase was not likely to get the best of it.

When the violinist Wilhelmj came for his first sitting at Chase's studio he was kept waiting a few minutes. The artist arrived to find the virtuoso in a temperamental state of excitement.

"Do you realize," Wilhelmj violently demanded of the painter, "that my time is worth a thousand dollars a minute?"

"Indeed," replied Chase instantly, without a change of expression. "Mine is worth two thousand."

Another answer of his to a rather persistent author who attended his class criticisms showed Chase's quickness

in retort. The writer had wanted him to enter a contest
in which she should paint a picture and the artist write
a story. "I'll wager that my picture will be better than
your story," she said. One criticism day as Chase was
leaving the class, quite undeterred by the fact that he
had failed to show any interest in her challenge, she ran
after him with a freshly painted canvas.

"Now, Mr. Chase, where's your story? Here is my
sketch."

Chase, thus accosted, gave a quick glance at the can-
vas. "Ah, I see—I have won the bet!" he said.

One day as Chase was walking along Broad Street in
Philadelphia a little ragged street urchin camped in the
gutter caught sight of the painter as he passed. The
child rose, ran up to him, and after looking earnestly at
him a moment, inquired: "Say, mister, ain't you some-
body?"—a tribute to his outer man that greatly amused
Chase.

But if he made the most of his personal appearance in
careful consideration of hair and beard, immaculate
linen, white spats, black-ribboned glasses, rings, and gar-
ments of the latest fashion, it was primarily one felt a
part of his concern with the thing of the eye rather than
personal vanity. One of his idiosyncrasies in dress was
his custom of wearing a scarf-ring. His neckties were

seldom ornamented with a pin, but were preferably drawn through some ring chosen from his interesting collection. At one time a large carved emerald set with small diamonds was his favorite; at another a carved ivory circlet was most in evidence; again it would be a curious carved silver ring, or one containing a turquoise of peculiarly intense blue. Of course, he also wore the rings. In the middle eighties his Rubens ring, an odd, worn old ring of silver and gold, was a familiar sight to his friends and associates of that period. In later years he seemed to prefer one containing a vivid turquoise and another with a seal cut in a reddish, semitransparent stone. It was characteristic of Chase's type that he was able to wear his jewelry like an artist, not like a dandy.

For some reason, although Chase's features were so regular, perhaps because of his marked mannerisms, he was a much-caricatured man. His Philadelphia pupils always made one of him for the annual Academy ball. One youth was famous for his ability to make a caricature of his master in a single stroke. Coming upon another talented pupil one day in the act of caricaturing him, Chase, after a quick glance at it, remarked: "Ah, if I fail in the Uffizi commission I see that I may call upon you!"

The hat that Chase made famous and that Whistler

subsequently adopted was the subject of many jokes and anecdotes. There is a tale that one day the painter ordered something sent home from a shop and forgot to notify the household of his purchase. The maid sent the delivery boy away without making inquiries, but the boy, more alert than the servant, made a discovery that caused him to refuse to carry away his bundle. His eyes were fastened upon the hat-rack. "Does the feller that wears that hat live here?" he asked. "It's all right, then. He's the one," and the boy firmly set his package down in the hall.

A rather ineffectual person in practical matters, Chase frequently amused his friends and family by his excessive appreciation of their assistance in some matter that loomed a formidable mountain before his mind's eye. William Baer, the miniature-painter, still remembers how Chase marvelled at his prowess in packing some canvases for him in Holland. "He seemed to think that I was a most extraordinarily gifted person to be able to do it," said Baer, "and thanked me repeatedly as if he owed me the debt of a lifetime."

One of Chase's replies to a customs inspector upon his arrival at the port has all the effect of intentional wit although it was really only a simple statement of the fact of his helplessness. Having admitted that he had taken

but one trunk over and had bought nothing, the inspector caught him up with: "But you have *two* trunks now." "Yes," Chase explained, "my wife packed when I left home."

Chase's home life was one of special harmony. Although an extremely nervous man, he never seemed to be disturbed by the presence of his children even in his studio, perhaps because they understood so well how to keep their freedom from becoming intrusion. He was proud of them all, from the oldest son to the youngest girl, Mary Content, named for two of his pupils, and always took them to walk, all eight, every Sunday afternoon. One daughter was the object of particular interest to him from her earliest childhood. Mrs. Chase tells of overhearing him tête-à-tête with the baby, a small dark object too young to voice articulate wants, inquiring with helpless but elaborate courtesy: "Is there anything I can do for you?"

Chase was a father more indulgent than disciplinary. He enjoyed nothing more than taking a cab full of children to Coney Island in the summer, where after dining them well the distinguished artist enjoyed the joys of shooting the chutes and all the other characteristic diversions of Coney Island.

He took the most profound interest in the children's school entertainments. The Chase children all attended

CHASE AND HIS WIFE.

THE ARTIST'S WIFE AND CHILDREN AND THE FIRST SON-IN-LAW.

the picturesque old Friends' Seminary opposite their home on Stuyvesant Square, where their mother went before them. At the yearly performance given by the school children the majority of the jokes were personal. There were many in which the size and special characteristics of the Chase family were touched off, all of which highly entertained the painter, who never by any chance missed a performance.

Chase was particularly fond of his father-in-law, whose unfailing gayety was temperamentally attractive to him. One time when Chase was sailing for Europe his father-in-law sent him a box of particularly good cigars inscribed "To William M. Chase, who knows a good thing when he smokes it, with a bon voyage from Julius Gerson."

When Chase came back, however, Mr. Gerson received a package which, when opened, seemed to indicate that his present had been returned unused. But upon opening the box he discovered not cigars but a delicious little Italian landscape painted on the under-side of the cover—for cigar-box wood, as all painters know, makes an excellent painting panel. On the other side was inscribed: "To Mr. Julius Gerson who knows a good thing when he likes it, with best wishes from William M. Chase, Florence, 1907."

Chase's intentions were always sympathetic and con-

siderate, but like many other men he frequently lacked imagination concerning the possible discomforts involved in their carrying out. Mrs. Chase gives an account of one of his attempts to pay his affectionate respects to his mother, who was visiting a daughter in a Long Island suburb.

One Sunday afternoon, immaculately dressed, Chase entered the room with the remark that he believed he would go out on the trolley to call on his mother. The open cars were on, it would be a very pleasant trip. Mrs. Chase, remembering his dislike of the Sunday crowds, the whistling and pushing and odors of chewing-gum, peanuts, and candy, asked him if he did not think that Sunday was rather a bad day for the journey, wouldn't the crowds be disagreeable perhaps. No, he didn't think so. "Of course, *you* needn't go with me," he added. "No indeed, I wouldn't have *you* take the trip for anything."

A few minutes later he entered the room carrying his hat and cane, the invariable white carnation in his buttonhole, and asked his wife if she were ready. She was. So they started forth over the Fifty-ninth Street bridge to swing on straps while the car jerked and crawled its tortuous way to Long Island. After a brief endurance of his pet aversions the exasperated artist turned to his

wife: "Well, *you* can go on if you want to, but *I* shall get out now and go home. This car is impossible." Mrs. Chase, without mentioning the fact that she had really not been the originator of the plan, answered mildly that having come so far it seemed as if they might as well go on. No, he would not go on, Chase declared, it was useless for her to urge him, he was going back at once.

He did go on, however, and by the end of the day had forgiven his wife for the discomforts of the trip. He did not suggest repeating the visit the following Sunday, but experience never seemed to teach him to imagine in advance what might be expected to occur.

The men who travelled in Europe with Chase tell of his constant remembrance of his family in his absences.

"We were always missing him and once almost lost our steamer because he would sit down to write to his wife at any and all spare moments," remarked William Thorne, who was one of the painter's travelling companions.

Thorne, who was a poor sailor, also remembers how Chase, who seemed to him quite offensively strong and active on shipboard, used to come into his stateroom to read him selections from the daily letters with which his wife and children had provided him, one for each day of

the trip. So moved was the seasick painter in his weakened condition by this beautiful spectacle of domestic devotion that he remembers shedding tears over the affectionate extracts that Chase read to him.

Another provision for the voyage made by Chase's wife was the indispensable white carnation which he always wore in his buttonhole. Mrs. Chase always left in the steward's care a sufficient number of these to last for the trip. Chase was very proud of this attention and Mr. William Guard, who made his last return trip on the same steamer, says that he was so much touched at the painter's sentiment about the white carnations that he never remarked upon the fact that they were sailing *toward* and not *from* the devoted wife, even when he caught Chase one day helping himself to the necessary white carnation from the table decorations.

Outside of his family association Chase had few human relationships. Although he did not have intimate friends among his confrères either in Europe or America, he was on terms of cordial friendship with the majority of contemporary painters. He had affectionate memories of his master Piloty and his idol Leibl. He knew Couture, Von Lenbach, Fritz von Uhde, Von Habermann, Boldini, Manet, Alfred Stevens, Whistler, Sorolla, La Touche, Carolus Duran, Alma-Tadema, Lavery, Shannon, Frank

Brangwyn, and Mesdag, and a number of other European painters with the touch-and-go association of artists, nothing more.

The friends of his earlier days, Duveneck, Shirlaw, Beckwith, Church, Dielman, Currier, Twachtman, and Blum, were on somewhat more intimate terms with him. He was also very fond of his one-time pupil, Irving Wiles, whose work he greatly admired. Of his old friends Robert Blum was perhaps the one of whom Chase saw most. When Blum came to New York a talented young man having had little or no art instruction, Chase was already a celebrity in the artistic world. His friendship as well as his criticism was of value to Blum, and Blum's letters show how deeply he valued both.

Chase's artistic dandyism, with which all his friends and associates were familiar, was neatly touched off once by Blum at a rather dull and long committee meeting from which Chase had escaped.

"What's become of Chase?" inquired a fellow victim, suddenly discovering the painter's absence. Blum looked up.

"Chase?" he drawled. "Oh, why, I believe Chase has gone out to change his scarf-pin."

Mrs. Chase tells of an occasion when her husband wished to give Blum a present on his birthday. Instead

of buying something new, Chase hunted about among his treasures for some unique gift that would please his friend's fastidious taste. Finally he appeared, looking very much pleased with an interesting old scarf-pin. "This looks like Blum," he declared. "Don't you think he would like it?"

Mrs. Chase glanced at the pin. "Yes, it does look like him," she agreed. "I am sure he would like it. The only objection to giving it to him is that he gave it to *you* last year."

When I asked Charles Dana Gibson about his association with Chase, he remarked without hesitation: "Why, we usually met at prize-fights."

Chase, it seems, was a great enthusiast on the subject of the modern gladiator, and well versed in all the points of such contests. There is a pleasing incongruity in this picture of the famous illustrator and the distinguished painter ardently discussing the technic of prize-fights on the edge of the ring as if art did not exist.

Chase also enjoyed the prowess of Buffalo Bill and his cowboys. Each year he took his wife and children to see them and each year he went to call upon William Cody in his dressing-room and ardently insisted that he must paint him—a plan that was never carried out. Another celebrity of this type, Zack Miller, Chase met

once on the steamer. We can imagine the polite adaptations of their conversation, the respectful questions of Chase, his astonished comments, the characteristic jargon of the cowboy. In parting, Zack Miller exacted Chase's promise to come to his "show" and sent him a box. Chase went, of course, accompanied by all his family and was made conspicuous in the eyes of the world when Zack on a white charger rode up to his box and saluted him—a public honor greatly enjoyed by the younger children. Another yearly festivity attended by the entire family was Barnum's Circus, which entertained Chase quite as much as it did the children.

He did not even spurn moving pictures. There he also seemed to enjoy the emotion of astonishment. Once he was asked to pose for a screen representation of an artist's hands in his Fourth Avenue Studio. The camera man requested that Chase show himself in the act of painting. Chase, with his dramatic instinct, seized the idea at once. His daughter Helen gives an amusing description of how he painted on a portrait of his wife in the most convincing manner with no paint on his brush, stepped back to view his supposed work, and turned to chat with an imaginary critic. In fact Chase's mind had rapidly visualized an appropriate scene in which the children were to run in and embrace their mother who

was posing; but unfortunately the photographer, who was instructed to be interested only in the hands of the painter, explained that his limited range would not permit him to take advantage of this facile dramatization.

At Shinnecock Chase went fishing regularly with his children on the breakwater, and always, the boys loyally insisted, returned with some fish. He used to play baseball with them on the sand, and the family, including the artist, quite made up the requisite nine—for there are eight Chase children: Alice Dieudonnée, now Mrs. Arthur Sullivan, Koto Robertine (named for a Japanese friend), now Mrs. Kenneth Carr; Dorothy Bremond, Hazel Neamaug, Helen Velasquez, Robert Stewart, Roland Dana and Mary Content, named in order of their appearance.

When Chase came home from Europe the presentation of his gifts was as much of an event as Christmas. The children would wait in the living-room, looking over the foreign periodicals he had brought back, while their father and mother unpacked the gifts. The boys usually got mechanical toys suited to their age and sex, the girls something interesting to wear.

When he found that his oldest son instead of turning toward art was interested in electricity and mechanics, Chase was deeply bewildered. Instead of protesting, how-

CHASE'S PORTRAIT OF HIS YOUNGEST SON. ROLAND DANA CHASE.
Painted the year before the artist's death. *1914*

ever, he contented himself with such dark allusions as that he "was glad that Bobbie was at the top of the house where he could only blow the roof off with his experiments." But in time he came to have quite a deferential attitude toward his scientific son and would inquire quite formally and respectfully when he read or heard of some mysterious scientific phenomenon: "What explanation can you offer of this?"

Of course it was the natural destiny of all the children, especially the girls, to pose for their father. The oldest daughter, Alice, familiarly known as Cosy, has probably posed more often than any painter's child in America, and Dorothy, the third daughter, is a close second. Helen, the original of the *Infanta* portrait, says that one of her earliest recollections is of posing in a difficult position and being repaid with caramels, which she was allowed to eat during her rests.

Often the children were unconscious subjects as they played about the moors at Shinnecock. Helen remembers her surprise as a small child when after having watched her father's canvas she ran off, to return almost instantly, and discovered that in that brief moment her pink hair-ribbon had been immortalized upon the canvas.

At another time, at one of the numerous birthday celebrations in the family, when Helen had put on one

of the little colored-paper caps that come in French motto bonbons she remembers how her father, after staring intently at her an instant, commanded her to go down to the studio, and play was abandoned for posing.

There seems to have been no indolence in Chase's nature. His days were as full as an average man's week. It was no uncommon thing for him to have a sitter in the morning in addition to giving conscientious criticism to his large class, afterward attending a luncheon at which he made an address; then to take an afternoon train to Philadelphia or Washington for some important meeting, returning on a midnight train. All of his life until his failing health forbade, Chase was tireless in the cause of art. If one asked of him in that name he gave to the full measure of his strength.

CHAPTER XXIV

CHASE, THE ARTIST

IN passing through a gallery it is often unnecessary to look for the signature on a canvas in order to recognize the painter. This may be a question of personality or of manner. The big man has artistic personality, the lesser one a manner. The clever painter has mannerisms, the master has touch.

The brush of William M. Chase had touch. More than that, it held the elusive secret of style, and style is a quality of the master. The most talented student's work can only promise, not possess it. The canvases of many a strong painter lack it. It cannot be acquired, it is the most aristocratic and intangible of all the qualities that go to make a good picture. It seems a gift as subtle and innate as magnetism. Yet at this present period—or rather phase—of painting when brilliant but too often unsound technic on the one hand and the hysterical uninspired search for eccentricity on the other have been most in evidence, it would seem as if this precious heritage of the old masters were the rarest thing in modern art.

The influences that worked upon Chase and went to form his individual style are interesting not only because

of the part they played in his own artistic destiny, but because they are concerned with the great transition period of modern art. Although a pioneer of art in this country Chase does not seem to have been of the spontaneously creative type. He had not only a very definite art personality of his own but the bigger thing, individuality. Yet it was a thing variously derived and suggested, not, as occasionally happens in the arts, an innate expression. His art was individual, but his inspiration was derivative. The thing he ultimately produced was a combination of the things he had absorbed, a new thing and his own. To the depths of his soul Chase felt a reverence for the great art of the past, a much needed lesson to the immature, self-assured young students of to-day who confide to each other over their long pipes that "Velasquez couldn't paint and Holbein couldn't draw."

When the talented young American boy was a student in Munich—Piloty's pupil but Leibl's disciple—he painted brilliant old masters. It was Alfred Stevens, the Belgian painter whom he so profoundly admired, who said to Chase after seeing some of his pictures at the Salon: "Why do you try to make your canvases look as if they had been painted by the old masters?" From that time on Chase sought to express himself.

CHASE, THE ARTIST

In analyzing those qualities which constitute the individuality of Chase's art and which have become its influence, one would select as most obvious his painting of the figure in the interior and in the open, his revivification and development of the art of still life and the emphasis he laid upon it as painting material, and a certain distinctive treatment evolved from the study of Japanese art.

In the more direct influence of his teaching he laid emphasis upon two fundamental and all-important points. His reiteration of the fact that a painter's first consideration must be the purely technical side of painting, and his insistence upon what is in truth the Greek spirit in art—the joy of the creative impulse, that essence which should inform the slightest sketch as well as the finished picture. "You must enjoy what you are doing if others are to enjoy it with you," he often used to say to his pupils.

Chase's use of the figure in the landscape was a new and characteristic thing. No one has better appreciated the value of the small decisive human note in relation to the large spaces of earth and sky, the significant accent of that small color note—a little pink hat, a red bow, a child's colored stockings, a woman's parasol—in relation to the wide sweep of the Shinnecock moors, the

fine subtle touch of the little figure in that quiet plane of grass of many colors yet one value—these qualities belong to Chase. They are recognizable the minute the eye falls upon the canvas in a gallery. The figures are often children, sometimes a woman or an old man— whatever it may be, it is always part of the landscape.

In his interiors there is the same appreciation of the relation of the figure to its surroundings. In painting the atmosphere of a dark interior, the sense of light *in* the dark, Chase has been extraordinarily successful and has had many imitators among his pupils. Undeniably from the old Dutch masters he learned much about the painting of interior light, yet he cannot be said to have imitated them. He accepted their lesson and gave out his knowledge in his own manner.

Chase's early interior subjects must not be taken as examples of his interior painting. Neither the picture of his Tenth Street Studio in the Brooklyn Museum which was painted in the early eighties, nor the one now the property of the Carnegie Institute, which is an early sketch quite recently filled in, make any attempt at painting interior light. They are decorative sketches with an excellent handling of patches of strong color, but they are innocent of any attempt to suggest atmosphere. Such pictures as *Hide and Seek*, painted in 1888, and

HIDE AND SEEK.

An excellent example of Chase's painting of interior light. The daughter of Joaquin Miller, the Western poet, posed for this picture.

Ring Toss, of a somewhat later date, are fine examples of Chase's painting of interior light. His mastery of that trick seems to date from his visits to Holland in 1884 and 1885, when he became particularly interested in the art of the Dutch painters and perhaps studied De Hooghe and Vermeer more carefully than he had before.

Chase's interest in still life was awakened by his study of the French masters Chardin and Vollon, but he evolved a still-life technic of his own and revealed the result to America at a time when still life was known only as a dull step in the student's course. In doing this he did more than present new subject-matter to American students and painters, he declared a creed of art, for William Chase, like Whistler, discovered and proved that beauty is indeed in the eye of the beholder and lies therefore in all objects alike, whether the special subject is a fish, a piece of fabric, or a woman's face. "While there is still life there is hope," Chase used to say in diagnosing the health of American art. And another time, with his quaint kindly humor: "If you can paint a pot you can paint an angel."

The lesson he drew from Japanese art became part and parcel of his own. Its direct influence is obvious in his decorative use of the kimono-clad figure, the Japanese arrangement, the introduction of Japanese objects into

his composition; the indirect influence is found in his
sense of elimination and color composition, and most
of all, in his absorption of that indescribable thing that
is the essence of a people's art. In this day when Japanese
prints of a sort are a commonplace to the shop-girl, it
is difficult for us to realize that they stood as a veri-
table entrance to a new world to the painters of the
seventies and eighties, for now we are all familiar with
their influence upon modern art.

The Spanish suggestion in Chase's work is less definite.
In the painting of face, hair, or figure, in the treatment
of the actual Spanish subject, in the masterly handling
of blacks and whites, one glimpses the Velasquez lesson;
but the trail that contact with the art of Spain left upon
the painter's imagination is something less specific than
the influence of any one painter, however great. It is
an essence like the rhythm of a Spanish dance. One can
trace it in the pose of a figure not Spanish, as in the por-
trait called *Dorothy*, or just in some indefinable manner or
detail of treatment.

Doubtless his discovery of the French *plein air* school
in the early eighties helped to emancipate Chase from
the painting of outdoors in the dark tones of the Munich
School. Some suggestion from the French painters may
have assisted his seeing of his Central Park subjects,

but the Shinnecock landscapes are pure Chase, for as has been said, the thing that developed out of these influences and associations, this opening out of new vistas, was so essentially his own that one always identifies as such not only a real Chase, but anything in the manner or imitation of one. More than one pupil never got beyond the stage of making little Chases.

Chase's work, however, does not divide itself into sharp periods. After his emancipation from the Munich manner there was that time early in his career when the specific charm of the Spanish manner and subject—the Fortuny influence intermingled with the Velasquez—caused him to paint a number of Spanish pictures of the type of *A Spanish Lady*, shown in the Memorial Exhibition in the Metropolitan Museum February, 1917, in which white, yellow, pink, and black are combined in a manner peculiarly Spanish. In the early eighties and late nineties the park subjects just referred to absorbed him; but his Shinnecock landscapes and interiors, his Japanese kimono-clad subjects, his still-life studies, all these seemed to be expressions of a painting mood rather than a phase in his development since he painted them at intervals during a period of thirty years.

His first Japanesque portrait, that of Mrs. Chase holding their first baby, called *Mother and Child*, was painted

in 1886. *The Red Box*, one of his best, was painted about
1901. He did another called *The Flame* the year before
his death.

Nothing in Chase's painting was more individual than
his use of color, nothing more distinguished than his
painting of blacks and whites. If not a colorist in the
usual sense of the term, he had a keen and subtle sense of
the value of the color note that was one of the hall-marks
of a Chase canvas.

He never attempted to manipulate a "riot of color."
Indeed his use of large patches of color found in some of
his earlier canvases is seldom entirely successful. His
taste was rather for the reserves of color, the finer tones
and juxtapositions, comparative blacks and contrasted
whites, with the significant accenting touch of light or
dark. But most effective of all is his subtle, economical
manner of using a small quantity of color in such a way
that it tells for ten times its quantity and speaks more
authoritatively than an overwhelming brilliance. *The
Red Box* is an example of this. The most trumpet-like
proclamation of scarlet could not penetrate more keenly,
seize more compellingly upon the imagination than do
the elusive quirls and splashes leading up to the final
"let go" on the wide patch of the pinkish-red sleeve
and the coral glow of the red box. The canvas called

THE RED BOX.
Owned by Mr. Philip Sharpless, of Philadelphia.

Mother and Child shows a slender reposeful standing figure in a black kimono, holding against one shoulder the soft form of the baby. The harmony is quiet and simple—blacks, low-toned whites, a touch of red, a note of smoky violet in the roll of the kimono at the feet, grayish figures on the black robe connecting the light tone of the baby's robe with the black ones, the intense note of the red in the neck-band of the kimono repeated more lightly in the handle of the baby's rattle and in the pattern on the violet border. *The Open Japanese Book* is a portrait of his daughter Alice in a black kimono against a neutral tone. The strong accent of red in the sash repeats through the book of prints and the figures in the robe. The girl's smile and the expression of the hand are happily caught. Another interesting portrait of this class is the one called *The Gray Kimono*, in which the finely felt color note lies in the blue touches in the gown and book.

Although Chase's manner of working was in direct opposition to that of the artist who experiments in glazes and other indirect means of obtaining effects, he objected most of all to fixed ideas, rules, or habits. He kept his mind open and experimented in unconventional ways with his palette. He frequently used siccatif and undiluted varnish as a medium, which, in

the case of his fish pictures, played a very definite part in his method. As fish, of course, will not keep, Chase's directness and quickness in working was never of greater advantage than when he was painting them. His method of working on a fish still-life was to lay in his whole picture in the morning, using varnish as a medium. By the time he returned from lunch the surface was agreeably "tacky," which is to say, in just the right condition for that interesting manipulation that he used to call playing with the paint. When he laid down his brushes that afternoon the picture was finished.

Once a landscape painted as a joke by his wife with enamel house paint suggested to Chase that that pigment was worthy of serious consideration as a means of effect, and the next time he painted a fish picture he added white enamel house paint to his palette. The ingredients of the paint were perfectly good; he knew that there was no reason why it should not last.

On his trips to Pittsburgh for jury duty Chase used to pass a certain fence painted red, an offense to the landscape, but in itself a strong, beautiful color. As he noted in passing it twice a year that the color did not fade, even outdoors in the sunlight, it was evident that the pigment had great permanency, so the next time Chase went to Pittsburgh he hunted up the source of

MOTHER AND CHILD.

Chase's portrait of his wife and their first baby.

the paint. Having finally trailed it to the manufacturer, he bought all the red paint the man had on hand and had an artist's color firm put it up in tubes. With characteristic generosity he scattered it among his painter friends. With this red many of his red notes were touched in—those characteristic accents which caused Kenyon Cox to say that in his use of a red note Chase had signed his canvas.

While Chase was in England not long before Abbey's death, Abbey sent him an urgent request to come and see his Harrisburg decorations. At first Chase thought it impossible, but at the last minute he took a flying trip to Abbey's country house by motor. When he saw the decorations his diagnosis sounded proverbial, but it was as Abbey realized afterward quite right. "What your canvas needs is a spot of red." Abbey took his advice.

Always generous in passing on anything that he discovered, evolved, or spontaneously knew, Chase was almost non-understandable to the kind of painters who guard their little trade secrets with jealous care; especially did the continental painters, who as a rule consider such generosity sheer madness, marvel at his lack of self-protection.

Chase always told freely in so far as the thing was explainable just how he had obtained his results. In

painting the Whistler portrait he said that he started by laying in the whole atmospheric envelope, then literally drawing out the significant masses and spots with a paint-rag, gradually refined the masses and drawing as he painted.

Chase always drew with the brush. It was the way natural to him and the method he believed in as the best means to the end. He encouraged his students to paint almost as soon as they drew. With his own children he gave them color at once.

Chase used to lay great stress (perhaps too great stress for the understanding of the student) upon what he called the "happy accident," although one interested in the psychic would explain such happenings by the workings of the artist's subjective mind. Along somewhat the same line of belief was his advice to students to use all sorts of brushes. House-paint brushes he considered excellent for many purposes, also ragged brushes, moth or mouse eaten brushes had, he maintained, great possibilities for certain effects.

There are painters who think that Chase did not help the student by this insistence upon what might be called the temperamental rather than the studious side of art training. But such an estimate is superficial. There is no royal road to art. Any student who has achieved any-

thing in this world, whatever schools may have done for him, has worked out his own salvation. Chase was concerned with the student's *attitude*. In laying emphasis as he did upon the light-hearted side of art, the spirit of play in work, he was no doubt urged by his belief that the academic attitude he had to combat in his own career was as false in feeling as it was in result. He was just as much opposed to the striving for effect without knowledge as the most didactic academician.

Chase's unerring perception as to what a canvas needed to achieve harmony or effect caused him to do or advise at any moment the exactly right thing. Noticing in one of his own canvases after it was placed upon an exhibition wall that the face and hands seemed to lack color, he brushed over them with a little red in his varnish as it hung on the wall. It looked to the younger painter watching him much too pink at the moment—he was, to tell the truth, filled with consternation at Chase's rashness—but when he saw the canvas again a day or two later after the exhibition had opened, he realized that when the surface was no longer wet the effect was exactly right.

Another time Chase offered artistic first aid on hanging day to a confrère, a painter of less spontaneous gifts than his own, who was very melancholy over his realiza-

tion that his canvas did not "hold together" when he saw it on the exhibition wall. Chase cast a quick eye over it. It was a decorative picture with patches of blue in its scheme which were distinctly "out." The picture had been worked over until its freshness was gone and the original idea lost. Chase instantly advised the painter to go over the whole with blue in his varnish. The other artist accepted the suggestion, and when his entire canvas had had a wash of blue, the whole was not only drawn together, but had regained the appearance of freshness it had lost.

As a portrait-painter pure and simple, Chase's work was uneven. Not infrequently he failed in the matter of likeness which, while having no bearing upon the art value of a canvas, is undoubtedly a necessary consideration in the valuation of a portrait as such. Chase has, however, painted some masterly portraits, strong in characterization as well as in technic. In these he seems for some reason to have been more successful with men, despite such brilliant exceptions as the *Woman with the White Shawl.*

Among his finest portraits of men are those of Emil Paur, Louis Windmuller, Watson Webb, Spencer Kellogg, A. B. Gwathmey, Edward Steichen, William Howe, Robert Underwood Johnson, and Dean Grosvenor. And, last and most brilliant of all, his portrait of Whistler.

CHASE, THE ARTIST

In this memorable canvas the figure stands a dark silhouette against an atmospheric golden-brown tone. Quiet, elusive, insidious in treatment, it conveys the very essence of the man—fantastic, diabolic, egotistic, malicious, yet holding unmistakably the light intangible quality of genius. It is even touched with the very art personality of the subject—an added subtlety on the part of the painter, for though the manner recalls Whistler, the canvas as it stands is unmistakably a Chase, not a Whistler.

Chase, as may be readily imagined, had no desire to paint the pretty feminine subjects, yet he was not entirely proof against the effect of the outer man or woman, and there were types before which his muse fled in revolt when he flatly refused a portrait order.

Some one in conversation with him once mentioned a well-known man of his acquaintance, to which Chase's only reply was, "Is his wife still living?" which his companion thought a rather singular answer. The explanation proved to be that the man had once asked Chase to paint his wife's portrait, but Chase after meeting the lady felt that he could not possibly do it. Not knowing how to refuse flatly, he had simply evaded making any definite date and had been avoiding the excellent gentleman ever since.

On one occasion Chase was commissioned to paint the

portrait of a woman unsophisticated in art but with very definite personal tastes. When she went for her first sitting Chase, who had understood that he was to paint a half-length, found that she wanted a full-length portrait. Looking about he discovered that he had no canvas large enough in his studio. There may have been several in the storeroom across the hall—for Chase must have suffered from fear-thought where painting supplies were concerned judging from the amount of material he had accumulated—but in any case he did not find what he wanted in the studio. He did however, come upon a very large, almost square canvas upon which a pupil who sometimes painted in his studio had started a group portrait of a mother and two children. Turning it upside down so that the picture already laid in should not prove confusing, thinking, if he thought at all, that necessity knows no law, he began his portrait.

But after his sitter had left he was smitten by a sense of guilt, and going to the telephone confessed to the owner of the canvas what he had done. She reassured him however, having the pupil's feeling that whatever Chase did was right, and Chase retained possession of the sixty-foot canvas.

Being so large it contained more space than he would naturally have used, and within this space the picture

had to be composed. He seated his subject therefore to accommodate the shape of the canvas and made a background of studio accessories deliciously and illusively touched in. Indeed the Japanesque pattern of the whole was one of Chase's most successful effects. His sitter, however, had her own point of view, with reasons if they were not artistic ones. She preferred a plain background, she said—anyway those were not her things in the background, why should they be there? She did not want them.

Chase was in despair. It needed the sure relentless shafts of a Whistler to pierce a conviction so simple and firm. Chase could only despair and groan: "What shall I do?"

Luckily the subject's husband had a different viewpoint. With some innate feeling for beauty perhaps, or with the realization that it was a desirable thing to have the record of the painter's beautiful studio decorations in his possession, he told his wife that the picture must remain quite as it was, and so fortunately it did.

Chase's work in pastel is worthy of special consideration. In his effects one never feels any obtruded sense of the medium, only so much consciousness of it as enables him to utilize its special quality—the delicacy, suggestiveness and lightness of pastel, and the transparent

quality obtainable with water-color. He often commented to his pupils upon the fact that the water-colorist so often seemed to discard all idea of values and naturalistic effect in using this medium. Considering one of these fictitious productions, he would murmur protestingly in his eliminative fragmentary fashion: "The state of mind with which you approached it, madam." [Chronic water-colorists are usually feminine.] "Think of it as if it were something else."

In addition to his work in oil, pastel, and water-color, Chase made a few etchings, among them one of his *Court Jester*, one of Currier's *Whistling Boy*, and a dry-point from his portrait of one of the Piloty children. He also experimented with monotypes from time to time, but it apparently interested him little to work without color.

Not a small part of Chase's contribution to the understanding of art lay in his demonstration of the painter's seeing of his subject. He once said that it was in contemplation of the art of the old masters that he first realized that the subject was of no importance, that the painter's interest must lie in the quality of his art. He called attention to the fact that Raphael's best pictures were not his religious subjects but his portraits of the men and women of his time. "Rembrandt's *Beef* in the Louvre is finer than his religious pictures," he once re-

PASTEL SKETCH OF THE ARTIST'S WIFE IN THE SHINNECOCK STUDIO.

marked. "From that one canvas I feel that I know Rembrandt."

In his student days Chase was deeply impressed by the remark of his teacher, Piloty, that the next great art development would take place in America. He never ceased to believe in the art destiny of his country or to work for its fulfilment. He never expatriated himself despite the lure of the Old World, yet none can say that his art was the sufferer thereby.

Chase's work, it must be admitted, was uneven. So was Tintoretto's, perhaps for the same reason. Both men had an incessant impulse to paint. But it is a Philistine misconception of the art impulse to call this creative activity industry as it often is by the layman. Rather is it the result of a great and exclusive concentration upon and a tremendous and absorbing enthusiasm for just one thing. But it is, perhaps necessarily, not the type of talent that produces the greatest average in results. The conventional Victorian painter was as even as a machine in his correctness. The true artist is never even; but the degree of his unevenness, the amount of inspiration, present or absent, from the special piece of work varies with the individual type. With Chase, despite his technical brilliancy, it varied considerably. That fact does not make him the lesser artist.

CHAPTER XXV

CHASE, THE ARTIST (CONTINUED)

THE artist's material may be found anywhere; the subject exists in the eyes of the painter. It becomes art when he shows us how he has seen it. The lay mind does not imagine the ancient fish-basket to be a paintable object; yet there is one in a Chase canvas, allied to a pink fish and others, subtly brushed in in rose and brown, that is as unforgettable to the artist or student as a Botticelli Madonna is to the sentimentalist. Few painters could discover the possibilities of the too neighborly seaside cottage as a subject; yet Chase has so treated a group of these drearily trim little houses that they have the light charm of a Japanese print.

In short, all art is translation. Pictorial art is the record of the exterior beauty of the world as seen by the eyes of the artist. Beauty, it is hardly necessary to explain in these days of the eccentric, grotesque, and decadent in art, does not mean smooth and obvious beauty. The sin of prettiness against which William Chase revolted was the vice of the Victorian age. Before he died he came to inveigh with equal consternation against the sin of meaningless ugliness and inept pretentiousness rampant in the secession art of the hour.

"Try to queer your composition somehow. See it in some way in which it would never occur to you to approach it," he used to say to the conventionally minded pupil, hoping to jog the routine mind out of its rut. But such "queering" of composition and everything else as has run riot for the last nine years in Europe and the last three or four in America was surely the furthest thing from the imagination of this intrinsically sane painter.

In defining the qualities of a great work of art, Chase has said that it must contain three things: "truth, quality and interesting treatment." Truth, of course, includes all the technical necessities; quality he characterized as the ring of gold compared with that of a baser coin; style he included in interesting treatment. But since it is evident that a picture can have interesting treatment and yet lack the subtle tang of style, the definition, excellent as it is, may only be considered as broadly inclusive—"and that is the trouble with talking about art," says the painter.

It seems incredible to those of us who have known him in his later years that in the first days of his return to America Chase was considered an intolerant, aggressive, opinionated person by the older painters whose dry and dusty art he was demolishing. We who are fa-

miliar with his kindness, tact, and breadth of view, his tolerance of all sorts and kinds of achievement, find this difficult to imagine. He used to expend his scornful wit upon Murillo, yet for contemporary Murillos, in his later days, he came to feel a kindly toleration, admitting that they had accomplished something that they had set out to do however it might differ from his own idea of art. His charity extended to all, even, to a degree, to that cult calling itself variously cubist, futurist, postimpressionist, in so much as he recognized it as a manifestation of the law of periodicity or rhythm in art (although he did not call it that). For since all schools tend to crystallization, revolt, break-up must occur in order to prevent stagnation. This fact Chase fully realized. The bizarre or eccentric he appreciated for what it was worth if professionally executed, but for inefficiency and failure masquerading as revelation, even to the weak-headed professional painter led astray by that singular epidemic, he had nothing but scorn.

At one time he was asked to talk before an audience very sympathetic to secession art. Only a few minutes before he had been discussing the subject with a pupil in his broad-minded way, remarking that absurd as the productions of the young revolutionists usually were in themselves—"a consolation," as he expressed it, "for

their stupidity"—they were nevertheless the inevitable protest against the set standards created by schools. But it chanced that Chase's predecessor in his last words had referred to the sketches on exhibition as "these things," certainly with no intention of disrespect since he admired them profoundly. Chase got up immediately afterward. "I am glad that this gentleman has properly referred to these productions as things," he remarked. "*I* was about to make the mistake of calling them pictures." Having been started on this line by the cue he had been unable to resist, Chase proceeded to make entertaining fun of futurist art. The result was that his audience regarded him more or less scornfully as a "back number," whereas the truth was that in his heart and mind he was extending all possible charity and understanding to the spirit that moved the sincere revolutionists, even though unable to take their results seriously.

For the early American painters Chase had the greatest respect and admiration. In one of his public talks on art he remarked that Copley, Stewart, Morse, Inman and Sully deserved to rank among the great painters.

Among the old masters his particular gods were Velasquez and Hals. After them he valued most, Rembrandt, Titian, Holbein, Tintoretto, De Hooghe, Ver-

meer, Chardin and El Greco. Of painters of a later date, Vollon, Goya, Fortuny, Manet, Stevens and Mancini were his favorites. He also greatly admired Boldini, La Touche, Boudin, Sorolla, Brangwyn and Monticelli; to which list must be added, without entering further into his contemporaneous compatriotic admirations, Whistler and Sargent. With his appreciation of his confrères and pupils, Chase was generous almost to the point of overstatement. "I would have been glad to have painted that bit myself," was one of his generous tributes to gifted pupils—adapted from Whistler, it is true, but none the less encouraging to the recipient.

Yet Chase had *au fond* a very just estimate of modern American art, despite that surface tendency to over-appreciation which was the outgrowth of his kindness. "I suppose there never was so much fairly good painting done as is turned out by the artists of to-day," he used to say, "yet there is nothing quite so rare as really good painting."

Chase not only introduced America to the works of Manet, since he was instrumental, as has been told in a previous chapter, in influencing Alden Weir to buy two beautiful Manets for the Metropolitan Museum, but he had much to do with familiarizing the American public with the name of Greco. When the Metropolitan Mu-

seum was considering the purchase of the Greco *Nativity*, Daniel Chester French sent for Chase as an expert upon Spanish art to decide whether or not the work was genuine. Chase was also responsible for the purchase of El Greco's *Crucifixion* for the Wilstach Collection in Philadelphia. One day soon after this last picture had been hung, Chase, who was standing before it in the gallery, was accosted by a gentleman who was also studying the canvas. "Can you tell me," this gentleman anxiously inquired, "if the artist had any authority for making the figure of the infant Christ so emaciated?" Mr. Chase responded with considerable dryness that he was unable to furnish any data upon that point. "And why," pursued the conscientious student of art, "should a picture so unpleasant be hung upon these walls? Who is responsible for its presence here?" Chase turned upon his questioner—we can imagine that blue light of wrath in his eye that came when his shrine was invaded by the Philistine:

"I am proud and happy to state that *I* am the person responsible for the purchase of that picture, and I would have you understand, sir, that you are standing before the work of a great master." With these words the painter made a dramatic exit from the presence of the bewildered critic of art. To Chase such an incident held

no saving light of humor. It was an outrage that rankled in his mind for long afterward.

Chase's collection of pictures at one time included as many as six hundred valuable canvases, including examples of Rubens, Van Dyck, Jordaens, Guyp, Cluet, Corot, Vollon, Daubigny, Ribot, Manet, Roybet, Gericault, Couture, Jules Dupré, Villegas, Isabey, Jacques, Boudin, Bastien-Lepage, Georges Michel, La Touche, Fromentin, Alfred Stevens, Carolus Duran, El Greco, Ribera, Fortuny, Sorolla, Mancini, Boldini, De Nittis, Raffaeli, Martin Rico, Leibl, Von Lenbach, Ziem, Hans Makart, Brangwyn, Sargent, Whistler, La Farge, Blakelock, Duveneck, Frank Currier, William Hunt, Twachtman, George Innes, Blum, Wyatt Eaton, Gedney Bunce, Irving Wiles and F. C. Frieseke.

His collection of rings is famous, also the interesting and varied collection of crosses that he made for his wife. In addition to these he collected at various times clocks and watches, samovars and old locks.

Wherever he went in Europe or America Chase had a studio. His Philadelphia studio was said to be quite as handsome as the Fourth Avenue place. The one in Madrid is described by the painters who saw it as extraordinarily artistic. Even the little California studio was charming. He refused to live without his background.

CHASE, THE ARTIST

In the days of his early conflict with the academicians Chase's apprehensions were sometimes unnecessarily aroused about his own work. Christy tells an anecdote of the Tenth Street Studio days when Chase had painted a brilliant study of the nude. The next day, wanting to see it again, Christy wandered into the adjoining studio where the canvas had stood upon an easel and discovered that Chase had painted it out. "Why, Mr. Chase," he exclaimed, "why did you paint out that beautiful thing?" Chase's eyebrow went up in a worried frown. After a moment he said: "Well, to tell you the truth —— (a "bonbon-box" artist) came in here yesterday and he liked it so well I thought there must be something the matter with it."

Christy tells another anecdote that shows Chase's characteristic view-point amusingly. One day a very impressive-looking artist came to the studio to call on Chase—a person having what is known as a great command of language. Young Christy was much impressed, and decided that this magnificent being could be none other than Sargent. After the visitor had left he went in and questioned Chase. No, Chase replied, his guest was not a great painter. Christy was astonished. But Chase shook his head with a wise smile. "No, they never are—that sort. *Talks too well*," he added confidentially.

WILLIAM MERRITT CHASE

Chase had to the utmost degree the quality of disinterested and impersonal judgment; he could value the work and rejoice in the success of the man who had wronged him as sincerely as if the painter had been his loyal friend. He was himself a generous patron of the arts, buying not only the pictures of arrived artists but those of his own pupils before they had achieved recognition, thus conferring it upon them.

Chase was Jonas Lie's first patron; he also bought the first picture sold by Salvatore Guarino. He interested himself in Jerome Meyer, who studied with him, and in Everett Shinn, who was not one of his pupils. His assistance to his pupil C. W. Hawthorne in his beginnings was of the greatest value to him. He also encouraged and helped his Philadelphia pupil, Leopold Seiffert. He had much to do with starting Schreyvogel on the path to success. During his presidency of the Society of American Artists he called the attention of the jurors to the work of this young painter, who had not previously met with recognition. The fact that Schreyvogel's pictures were not only admitted but that one of them received the prize at that exhibition made a turning-point in his career.

Mrs. Wadsworth, the mother of one of Chase's promising pupils who died young, tells of another characteristically generous act.

One day at Shinnecock he exhibited to his class a number of canvases, the work of a young man who was both poor and talented—a not infrequent combination. The young man was married, it seems, and had children, and had decided because of his responsibilities that he must give up painting and become a clerk. But this the kindly Chase, having seen his work, instantly decided he must not do. He made one of his characteristic appeals for the poor young artist, insisting that his talent justified some effort on their part to give him a start and added: "Just think what a poor clerk he would make!"

Many of the pupils bought sketches at once, Chase, of course, taking several himself, and the young man who had come so close to giving up his career continued to paint, and thanks to this help and encouragement, became a successful artist.

Chase was interested in all talented young artists, whether they were his pupils or not. Another gifted painter, now successful, has never forgotten how when he was stranded in a European city, living in the very poorest quarter of the town, Chase took him out with him and fêted him, apparently unaware of his shabby clothes.

Chase was more than generous in his exchanges with other painters. Henry Poore tells of his own experience,

which made a deep impression upon him. On the opening day of Chase's exhibition at the National Arts Club Poore ran across him. After greeting his fellow artist Chase inquired, with a gesture that swept the room: "Well, have you made your choice?" Mr. Poore, rather overcome by this generosity—for the exhibit was in all respects remarkable—selected a small sketch, but Chase protested, "I had thought you might want this," indicating a splendid fish still-life. What was more, he insisted upon presenting it.

A pupil in one of Chase's European classes remembers how Chase once offered to exchange with a European painter who, although most appreciative of Chase and his art, was yet so far removed from his class as an artist that Chase's act could only seem to the outsider a condescension. Chase selected a little sketch of this painter's in which his kindness found something to admire and gave him in return a beautiful fish picture. When the pupil protested, "Oh, Mr. Chase, you're not going to give him that beautiful thing!" his characteristic reply was, "Why not? When you make a gift give your best." There spoke the innate aristocracy of art.

Concerning his own work and the value the future might set upon it, Chase must have thought frequently, although he seldom spoke of it. Sometimes he believed

that certain canvases of his would last, at other times he only hoped they would. For so great was his reverence for art and so high his ideal, that measuring his achievement beside it he felt a humility perhaps not realized or understood by those who knew only the mask and habit of the outer man. At such moments he would sometimes say in utter sincerity and simplicity to one near and in his confidence: "I am a greatly overrated man."

Birge Harrison quotes one of Chase's rare remarks on the subject of posterity's view-point. When going about the exhibition of the Ten American Painters with Mr. Harrison and his wife, Chase had expended his generous hyperbole upon the canvas of a brother artist.

"*There* is a masterpiece," he said, "a canvas that can hold its own beside any of the old masters," and Mrs. Harrison quickly added: "And those fish of yours could go into the same museum, for they too are a masterpiece." Chase seemed not to hear, but when she repeated her little tribute, he replied: "Yes, yes, I suppose that some day I shall be known only as a painter of fish, a painter of fish."

While it is not possible to predict what value the future may set upon any of the art of to-day, it seems safe to say that the Whistler portrait, *Dorothy and Her Sister*, *The Red Box*, and *Mother and Child*, not to speak

of a number of fine quiet Shinnecock landscapes, will last as long as the most brilliant fish picture Chase ever painted.

Chase's practical services to art were too various and varied to be enumerated. He has served as juror on the committees of most of the important exhibitions for the last thirty-five years, forfeiting by that unselfish allegiance to the cause of art his own eligibility to medals and prizes. In that position alone he did incalculable service to art and artists. He also worked for many years with Beckwith, Blashfield and other painters in attempting to get the Free Art Bill passed so that foreign works of art might be brought into the country free of duty.

That his opinion was valued by his confrères is a fact that is quite generally acknowledged by them. Anything that Chase knew he wanted to pass on for the cause of art. Walter Palmer has commented appreciatively upon the inspiring quality of his criticism.

"I was very fond of Chase and always found him most stimulating with his intense, never-failing interest in painting. One could never do a creditable piece of work without Chase praising it at his first opportunity, and he was just as sure to tell one if he had done a poor thing; but in either case it was a pleasure to have his frank, friendly opinion. I remember his once greeting me

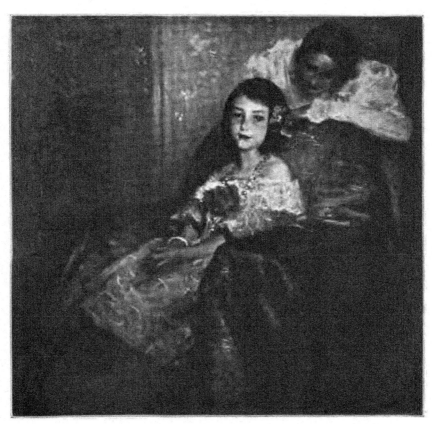

DOROTHY AND HER SISTER.
Portrait of two of Chase's daughters.

after seeing something I had painted with the remark: 'Palmer, how did you do such a damned bad thing?' "

Frank Benson said of Chase: "I always thought of him, as we all did, as one who above most others was an artist in every thought and act."

Sargent has added his tribute: "I should be glad to have my very warm friendship for Chase and my great admiration for his work put on record."

Those who came more closely in contact with him— Irving Wiles, Cecilia Beaux, Alden Weir, Carroll Beckwith, and Frank Duveneck—have spoken with the deepest feeling of Chase as man and artist, a feeling simply and completely expressed by Cecilia Beaux when she said: "He was always so *right*, his judgment was so dependable and his kindness and generosity never failed. We miss him terribly; no one can take his place."

Aside from those artists already quoted, E. H. Blashfield, Sir John Lavery, F. S. Church, Percy Moran, T. W. Dewing, Charles Dana Gibson, Siddons Mowbray, Will Low, Childe Hassam, Birge Harrison and a host of others have paid their tribute to Chase's achievement, his generous attitude toward the work of other painters, and his unselfish devotion to the cause of art.

Professional jealousy was not only non-existent in him, it was not understandable to his nature. He wanted first

and always that the purposes of art should be served. To that end he devoted his life. All that was best, finest, most generous, most unselfish in Chase's character was centred in art, not just in his own personal expression but art in the abstract, art the eternal illusive goddess. As his old friend and confrère, Frank Duveneck, said of him, he "did not care whose art it was, his own or some other painter's, so long as it was good art."

CHAPTER XXVI

CHASE, THE TEACHER

CHASE once said: "I believe I am the father of more art children than any other teacher." And indeed it seemed in some such paternal light that he regarded his pupils. The side that he turned toward them was one of unceasing helpfulness and generosity. Anything that he had to give he gave freely. The very way in which he said "an old pupil of mine" seemed an expression of affection. Mrs. Chase used to say that a person need only claim distant relationship to a pupil to insure his instant attention. He invariably thought of them in the affectionate diminutive.

The feminine students, whatever their height, weight, or years, were all "little Miss So-and-So," the men all "young This or That," whatever their age or condition.

Chase had classes in New York, Brooklyn, Philadelphia, Hartford and Chicago. He taught altogether twenty-one years at the Art League, twelve years at the New York School of Art, thirteen years in Philadelphia and five in Brooklyn, in addition to the classes held in his own studio. He had summer classes in California, England, Italy, Belgium, Holland and Spain, and taught for eleven summers at Shinnecock. Also while he was

teaching in Philadelphia Chase had a free class for students who could not afford to pay for instruction. The city gave him the use of a public school for this purpose.

"Association with my pupils has kept me young in my work," he often said. "Criticism of their work has kept my own point of view clear."

There are comparatively few painters who do not actually dislike teaching, and among those who do not the majority are men whose gift is rather for verbal criticism than for expression with the brush. With Chase the case was entirely different. He loved to teach, but his criticism was always a painter's criticism, suggestive rather than explicit.

"Try to think of it as if it were something else," he would say to the pupil using water-color in the conventional tinted water-color manner. "Could you see as much as that?" he asked another too faithful in detail. And to the honest young student in the museum who said she did not like the Manet *Woman with the Parrot*, his kindly, amused reply, "No? Oh, but you will," was always remembered as a starting-point. Concerning those things that can come only with the growth of perception, he did not instruct but left them to time.

In this connection he often referred to a well-known collector who used to consult him about his pictures.

This man had begun collecting alone and unadvised with no real knowledge about pictures and Chase considered him an excellent illustration of how the taste might be educated by the contemplation of art. "He has still in his collection," Chase used to tell us, "the first picture he ever bought, a small thing"—he would pause there while an expression of pain contorted his eyebrows—"small but terrible. . . . That picture he has kept on the walls of his gallery to show his starting-point, for his collection is now one of the finest in this country."

To the pupil with a tiresome literal manner who needed a vigorous shaking up he spoke more incisively, but never unkindly. Indeed, more than one unpromising pupil who seemed in student days utterly lacking in the sense of art has somehow under his inspiring influence become a real painter.

With all sensitiveness he refrained from making any criticism that might deflect or restrain the individual tendency of a talented student. The way in which Chase from his first years of teaching studied the needs of the pupil with individuality was well illustrated in the case of Livingston Platt who had a natural bent for decorative art before the period when that was an available talent.

Chase noticed how this student in his life class at the

League drew from unusual view-points and always did something that got away a little from the actual pose of the model. After watching Platt's work a while he told him to paint still life, but the same tendency manifested itself. Platt seemed to paint not what he saw but something that the thing he saw suggested. Finally Chase requested his unconventional pupil to paint a single object, but when he came to criticise him he found that he had been disobeyed. Platt, unable to resist the temptation to make "an arrangement," had, contrary to his master's instruction, combined other objects with his solitary jar.

The next experiment Chase made with this non-conforming young disciple was to invite him to go with him when he painted in the park. Chase noted that his pupil's sketches were invariably done in a lighter key than his own and were rather a harmonious disposition of the facts before him than a regulation landscape such as might have been expected from a student.

"You ought to be a decorator," Chase said then, "but I don't know what you will find to decorate. You should do something like theatrical scene-painting if such things were sufficiently artistic to justify the painter in using his talents that way."

That, however, was exactly what came to pass in time.

Several years later when such openings first presented themselves, Platt started to make decorative stage-settings, first in Belgium, then in America. His sketches and costumes for De Koven's "Canterbury Pilgrims," given at the Metropolitan Opera House last winter, were chosen in the prize competition. The fact is interesting not only as an example of Chase's treatment of the pupil's special gift but because it shows how he foresaw even in that day of conventional stage-setting what the artist might do for the theatre.

In another way Chase might have contributed to theatrical art had managerial enlightenment been greater. He was once asked to design the costumes for a play whose scene was laid in the sixties. He made some exquisite drawings in color, enjoying the wide sweep of the hoop-skirt with visions of Velasquez's use of that effect flitting through his imagination. But when the manager saw them he laughed the artist to scorn and brought out his play with costumes made in the current fashion. A few years later however, when the manager's education had progressed, he quietly utilized Chase's idea in the costuming of another play.

Chase's patience with the rebel student was unfailing. When his knowledge or his standards were questioned it was not resentment that he felt but toleration and un-

derstanding. "Because, you see, I was a rebel once myself," he exclaimed. He had at one time a talented young pupil who scorned his interest and assistance even to the point of discourtesy to his master. "I would have liked to help him, but he didn't seem to want my help," was his only comment. The student afterward went abroad to study and did good work which Chase liked so well that he bought one of his canvases. When the ambitious young artist heard of this purchase his heart was touched—through his vanity, it is to be feared—and after that he had nothing but admiring things to say of Chase.

Chase's less original pupils imitated him, sometimes later to find their own manner, but he never encouraged such imitation. His patience in explanation even with the apparently ungifted pupil was unfailing, for he realized that sometimes the student who seemed to show little progress at first, afterward developed most satisfactorily.

He never ceased to warn against the sin of prettiness. "I have often thought that those old Dutch painters were fortunate in having such ugly subjects," he would say in his talks to students (but that was before the day of ladies with one eye and no mouth, executed as with the ill-regulated brush of the five-year-old, and

solemnly or insincerely signed by the mature painter!).
To find beauty in the thing that does not obviously suggest it, to realize that nothing in art is more difficult and dangerous than the painting of the frankly beautiful thing—such comments are sign-posts for the student, and should go far to make the painter's attitude understandable to the layman.

Often in praising the sketch of a student in which the impression had been freshly caught, he would say: "I envy you the good time you had doing that." It was his belief that the great canvases of the world were easily done, since it is true of all art that a thing can be completely expressed only when all preliminary processes are assimilated and have become second nature. The painter of the Rossetti type possessed by the sentimental or literary idea usually neglects the essential technical foundation. The very mention of such a painter or such a standpoint was sufficient to bring a cloud to Chase's usually serene brow, but he did not believe in argument on these subjects. He used to say: "I would cross the street any day to avoid a man who differs with me on the subject of art and insists upon discussing it." One's convictions and choice once established, he believed that nothing was gained by dispute. He invariably cautioned his pupils against it, advising them to associate with

those whose artistic convictions agreed with their own, since the artist's mental state should always be as serene as possible.

Chase used to be called by those artists and commentators upon art who have literary leanings, a painter of the outside merely.

Although remarks concerning the so-called "soul" of the subject, that mysterious thing which is supposed by picture-lovers with the emotional and literary viewpoint to be impaled upon the canvas, somewhat disturbed the painter, he was willing to discuss it in his suggestive fashion with the pupil not yet free from sentimental yearnings. "Do not imagine that I would disregard the thing that lies beneath the mask," he said, "but be sure that when the outside is rightly seen, the thing that lies under the surface will be found upon your canvas."

It was amusing when Chase criticised to watch the thing that took place in his mind as he talked. He would begin very kindly and patiently, pointing out the defects, passing on to an indication of the dangers of such defects if uncorrected; then, if the fault chanced to be one of his pet aversions—overconscientiousness or, still worse, prettiness—he continued to warn, picturing the terrible results that might ensue, until he had gradually

lashed himself into a state of indignation that was almost fury over the vision his imagination had conjured up, so that he sometimes left the easel of a favorite and promising pupil crimson with potential wrath.

Chase's associates on juries were sometimes amused by his conscientiousness in considering work that seemed to the eyes of less unselfish painters unworthy of serious attention. One fellow juryman aware of Chase's fatherly attitude toward his pupils who discovered him bending attentive glasses upon a rather unimportant sketch before it was cast aside, called out: "It's all right, Chase, you don't know her."

Certain phrases of his—whimsical, kindly, humorous, impressionistic—will always linger in the memory of his students. In contemplating one of those peculiarly dreary landscapes sometimes offered by students for criticism, the thought that found words was: "How terrible if nature should come to look to you like that." Once, after he had given a long careful criticism upon a most unpromising piece of work, a Central Park sketch executed in raw and clashing colors, only to be met at the end with renewed questions from the complacent amateur showing that she had not understood a word he had said, the painter's patience gave way. "What I mean, madam, is that"—he paused helplessly, then brought it

out desperately—"if it looks like that in the park, *I* don't want to go there!"

To another misguided pupil he said once: "You have put enough work on that one daisy to have painted a whole study." And to one who presented a hard, tight little landscape: "You might crack a nut on that sky."

In considering a canvas false to some basic principle of color, line or value Chase would often remark: "If it looks like that to you, perhaps you'd do well to consult an oculist, sir [or madam]."

Upon one occasion, criticising a pupil working with deliberate affectations, the young man after Chase's protest—"Why don't you paint things as you see them?" —thought to forestall his master and with impertinent insincerity suggested: "Perhaps there is something the matter with my eyes, Mr. Chase." But he had reckoned without his Chase. The master adjusted his glasses, lifted one eyebrow, and gave the young man a brief glance. "I think not, I think not! In your case, sir, the trouble is a little higher up."

Yet his comments, even when they seemed but the seizure of an irresistible opportunity, were never merely amusing. The fundamental art principle was always there. They could illumine a whole pathway for the student.

As positive advice he suggested, "Be a picture worm";

and as negative but important hint, "Beware the bird's-eye view!" Another comment that always seemed to me a rule for the sincere student to carry all his days for preservation of the right state of mind and nerves was: "Combine a certain amount of indifference with your ambition. Be carefully careless. If you don't succeed to-day, there is always to-morrow."

"Do not try to paint the grandiose thing. *Paint the commonplace so that it will be distinguished*," is a rule that his own work well exemplifies and that the artist can never afford to forget. Another, "Learn to paint so well that you can conceal your own dexterity," is an answer to those older academic painters who maintained that Chase cared only for the externals of art. On that same subject he said: "I fear some people confuse technic with slashing brush strokes. Consider Holbein, whose calm surfaces show him to be one of the world's greatest masters of the technical side of art."

Another bit of advice helpful not only for student days but through the painter's entire career is: "Don't try to make comparisons between your own pictures. Forget what you have done and think only of making the best of what you are doing."

"Don't try to say the last word," "Don't paint in an apologetic way," "When you begin to wonder what to

do, stop," are a few out of a long list of Chase's suggestive maxims.

Another remark remembered by Reynolds Beal is very characteristic of Chase's humor and his clear common sense: "If the artist paints his picture squinting the public will not see it as he saw it and he should put over his canvas when he exhibits it, 'Please squint at this picture.'" Sargent, Chase told his pupils, opened his eyes wider than usual when he looked at a picture in order to cover with his vision as large a space as possible. Mr. Beal tells another anecdote that shows how Chase struggled to make his pupils understand the purpose and destiny of the artist. "Try to paint the unusual thing," the master said—of course, referring to the manner of painting, not the choice of subject—to which Mr. Beal replied: "Then people will say, 'Whoever saw such a looking thing!'"

"Exactly," replied Chase; "it is the artist who points out the unusual and educates the public."

Chase's instructions if seldom specific enough to suggest the recipe were always definite enough to carry understanding to the pupil ready to receive what he had to give. He would speak upon occasion of such purely technical points as how to start a canvas. "Note first your highest lights and darkest dark." Another suggestion

designed to make the student remember the charm and subtlety of delicate values and the light touch was: "The successful picture ought to look as if it had been blown on the canvas with one puff."

One of his few concrete suggestions dealt with the use of white which he considered rather a dangerous pigment for the student to handle, since white painted is in reality anything but white, and at one time he did not keep it on his own palette. Instead, he mixed a light gray and had a paint-dealer put it up in tubes for him. The next time he went to the shop he was surprised to find it on sale under the name of "Chase gray."

What William Chase gave to his fellow artists and pupils in his living, creating presence, his beautiful enthusiasm ever helping to keep alive the spirit of art, he can give no more save as his deeds live in our memories. But the stamp that his influence left upon his time is ineffaceable.

Essential artist that he was, he was ever humble before the great spirit of art. In his mind there remained always the distance between his ideal and his achievement, a deep feeling expressed once when, after showing a number of his pictures to a guest, he pointed to a blank canvas. "But that is my masterpiece," he said, "my unpainted picture."

CHAPTER XXVII

THE END

THE winter of 1915–16, as has been said, Chase continued with his private class, but he did less painting than usual. Although not aware that he had any serious ailment, he was conscious of not feeling himself. He painted a small self-portrait the last year of his life and several others, among them one of Mrs. Eldredge Johnson and one of Mr. A. B. Gwathmey. Both are brilliant and characteristic examples of the real Chase.

In the spring he gave a talk to the students of the Art League—his last. In May he went to the meeting of the Federation of Arts in Washington, the last public function that he was to attend. In June the New York University conferred the degree of Doctor of Laws upon him. That same month he painted a portrait for the Allied Bazaar.

Not wishing to leave his physician, he remained in town through the summer, growing steadily weaker. He continued to go to his studio, working as long as his strength permitted. The portrait of Mr. Gwathmey, referred to above, was his last work.

In September he went with Mrs. Chase to Atlantic City. Before he left he dragged himself to his studio and gathered together his paints.

PORTRAIT OF A. B. GWATHMEY.
The last portrait painted by Chase.

"You aren't going to try to paint while you are there?" exclaimed a distressed pupil who was in the studio, but Chase answered with his pathetic cheerfulness: "Of course I am! There's nothing like painting . . . nothing like work."

On the way home he stopped at a Chinese shop to see if the man had anything new and interesting. It was his last walk in New York.

The first days of his stay in Atlantic City Chase was able to walk a short distance. He bought a few rings at a near-by shop and yearned for a very expensive piece of brocade, which he was finally persuaded to do without. He strongly desired a Japanese hanging of dark blue and silver that he saw in a window. This Mrs. Chase had sent to the hotel as a surprise for him. He took a great fancy to this decoration, and when he went home had it placed where he could see it from his bed.

From Atlantic City he wrote a short, pathetically optimistic letter to his sisters-in-law to whom he had been attached for so many years.

"MY DEAR GOOD SISTERS:—

"Just a line to say that I fully appreciate your concern about me. I think we did well to come down. Toady has of course written and told you of the perfect weather we are having. With all that and the ideal nursing I am

getting from Toady, I believe I am getting better. I hope both of you are feeling well (I have come to envy anyone who does). Time for medicine so I will say goodbye for this time. With my blessing to you.

"WILL."

He was too weak to paint during those last weeks, but he continually begged his wife to take out his paints, as if through her he might give out the thing he wanted to express. Perhaps, too, the unfailing instinct of the teacher still survived in him. Too ill to read and not wanting to be read to, he cared only to talk of pictures and art, reviewing with his wife, as she has told in her foreword, the art treasures of the European galleries—playing a sort of game of "remembering" each detail of a canvas, even its placing upon the gallery wall, and what other pictures were in that same room.

He did not realize that he could not live and spent hours talking over his future plans with his wife. At last as he only grew weaker, he was taken back to New York. The last two days of his life he was unconscious. On October 25th he died.

A few days before his death, while he was still able to talk, his friend Irving Wiles came to see him, the only person outside the family to see him after his return to

THE END

New York. Although very weak and near the end, he had sent to his studio for some pictures which he requested to have hung upon the wall to show his painter friend. An artist to his innermost soul, that last characteristic act has a touching significance to those who knew and loved him.

As his wife was leaving the room to tell Wiles to enter, he called her back. He wanted the Japanese hanging, his newest toy, arranged so that it would show all its beauties to the other artist. Before he died he expressed the wish that Wiles should finish his unfinished portrait commissions.

The debt of American art to William Merritt Chase has yet to be computed in its entirety. It will gather interest with the years, for whatever valuation the future may put upon his work, his lifelong service to the art he loved must last as long as there are records and histories of art.

LOCATION OF CHASE'S PICTURES

The following is a list of Chase's pictures owned by museums and public galleries:

BOSTON—Museum of Fine Arts:
 Still Life—Fish.

CHICAGO—Art Institute:
 Alice.
 North River Shad.

CINCINNATI—Museum Association:
 The Mirror.
 Still Life.
 Woman with Basket.
 Still Life.
 Robert Blum.

DETROIT—Museum of Art:
 Yield of the Waters.
 Self-Portrait.

FLORENCE, ITALY—Uffizi Palace:
 Self-Portrait.

INDIANAPOLIS—John Herron Art Institute:
 After the Shower.
 Dorothy.
 Still Life.
 Fish—Still Life.

NEW YORK CITY—
 Brooklyn Museum:
 The Antiquary's Shop.
 In the Studio.
 Japanese Study; a Portrait.
 Fish.
 Lydia Field Emmett.

LOCATION OF CHASE'S PICTURES

Metropolitan Museum of Art:
>Lady in Black.
>Carmencita.
>Seventeenth Century Lady.
>Still Life.
>Shinnecock Hall.

Union League Club:
>Ready for the Ride.

PHILADELPHIA—
Pennsylvania Academy of the Fine Arts:
>Lady with a White Shawl.
>Still Life—Fish.

Wilstach Gallery:
>Still Life.

PITTSBURGH—Carnegie Institute:
>Mrs. Chase.
>William N. Frew.
>English Cod.
>Tenth Street Studio.

POUGHKEEPSIE—Taylor Art Building, Vassar College:
>James Monroe Taylor.

PROVIDENCE—Rhode Island School of Design:
>The Lady in Pink.
>In Venice.
>Study of Girl's Head.
>Dorothy.
>Still Life.

RICHMOND, INDIANA—Art Association:
>Self-Portrait.

ST. LOUIS—City Art Museum:
>Still Life.
>Courtyard of an Orphan Asylum.
>Holland.
>An Old Salt.
>Contemplation.

WILLIAM MERRITT CHASE

WASHINGTON, D. C.
 Corcoran Gallery of Art:
 The Model (pastel).
 An English Cod.

 National Gallery of Art:
 Shinnecock Hills.

YOUNGSTOWN, OHIO:
 Master Roland.

The following portraits by Chase are owned by colleges and other public associations:

Doctor Andrews—Brown University.
Doctor Reynolds—Chicago University.
Doctor James Taylor—Vassar College.
Doctor Angell—University of Michigan.
Reverend Arthur Brooks—Church of the Incarnation.
Captain Casey—Seventh Regiment Armory.
John F. Kennedy—Presbyterian Hospital.
Frederick S. Sturges—Presbyterian Hospital.
Dean Grosvenor—Synod Hall, Cathedral of St. John the Divine.
Robert Buchanan—The White House.
Seth Low—Borough Hall, Brooklyn, New York.
Clyde Fitch—Amherst College.
Emil Paur—Lotus Club.
Louis Windmüller—Reform Club.
Doctor De Forest Willard—University of Pennsylvania.
Sir William Osler—University of Pennsylvania.

Of Chase's copies from the old masters the following are owned by public galleries and associations:

Cooper Union Buildings—
 Committee Women by Frans Hals: Museum of Decorative Arts.

Game, Original in Schleisheim Gallery, by Ferdinand Bol: Museum.

Painting of a War Scene by Karl von Piloty: Museum of Art.

Portrait by Van Dyck: Woman's Art School.

Menippus by Velasquez: Woman's Art School.

Figure from St. Joris Shooting Company by Frans Hals: Woman's Art School.

Æsop by Velasquez: Woman's Art School.

Portrait by Rubens: Woman's Art School.

The Nelson Collection of Copies of Old Masters, Indianapolis—
The Standard Bearer, Frans Hals. Detail of La Compagnie Maigre from the Rijks Museum, Amsterdam.
Las Meninas, Velasquez: Prado Museum, Madrid.

The Players' Club, New York—
The Actor, Velasquez.

Owned by the Chase Estate—
The Queen.
The Infanta, Velasquez.
The Man with the Red Knee. Detail from the group of men in the Haarlem Rathhaus.
Detail from the Officers of St. Joris, Haarlem Rathhaus.

Other copies of old masters by Chase sold at the sale of 1896 are:

Velasquez, Don Diego—
Head of Philip IV.
Portrait of Himself.
Philip IV.
The Spinners.

Van Dyck, A.—
Die Heilige Magdaline.
Portrait of a Lad.

Ribera, José—
Portrait of a Man.

Van Rhyn, Rembrandt—
Portrait of Himself.

Watteau, Antoine—
The Seven Ages.

[329]

LIST OF MEDALS RECEIVED
BY WILLIAM M. CHASE

Bronze medal, Munich, 1873.
Bronze medal, Munich, 1874.
Silver medal, Munich, 1874.
Bronze medal, Munich, 1875.
Bronze medal, Munich, 1876.
Medal, Centennial Exposition, Philadelphia, 1876.
Massachusetts silver medal, 1878.
Honorable mention, Paris Salon, 1881.
Gold medal, Munich, 1883.
Gold medal, Paris Salon, 1889.
Member, International Jury of Awards, Columbian Exposition, Chicago, 1893.
First prize, Cleveland Art Association, 1894.
Gold medal of honor, Pennsylvania Academy of Fine Arts, 1894.
Shaw prize, Society American Artists, 1895.
Shaw fund prize at the Society of American Artists, 1895.
Gold medal, Paris Exposition, 1900.
Temple gold medal, Pennsylvania Academy of Fine Arts, 1901.
Gold medal, Pan-American Exposition, Buffalo, 1901.
Gold medal, Charleston Exposition, 1902.
First Corcoran prize, Society Washington Artists, 1904.
Gold medal, Louisiana Purchase Exposition, 1904.
Member, International Jury of Awards, St. Louis Exposition, 1904.
Gold medal, Buenos Aires, 1910.
Bronze medal presented by the Hispanic Society, New York City.

LETTERS AND SKETCHES
BY
CHASE AND HIS FRIENDS

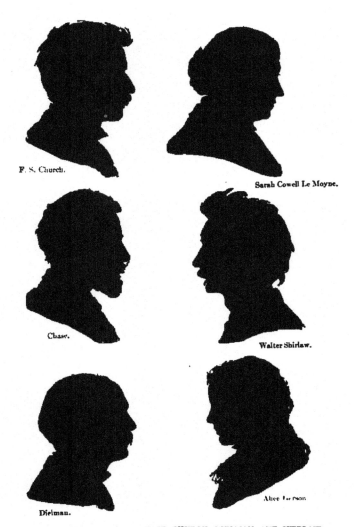

F. S. Church.

Sarah Cowell Le Moyne.

Chase.

Walter Shirlaw.

Dielman.

Alice Gerson

**SILHOUETTES MADE BY CHASE, CHURCH, DIELMAN, AND SHIRLAW.
AT THE GERSONS' HOME ABOUT 1879.**

LETTER FROM F. S. CHURCH TO MISS GERSON, ABOUT 1879.

LETTER FROM BLUM TO CHASE, 1881.

Madrid Aug 6th /81.

My [illegible] Tordie.

LETTER FROM CHASE TO ALICE GERSON, 1881.

Toledo
July 24.

Dear Chase

The above can perhaps express better than 8 pages of close written foolscap the state of mental serenity ~~enjoyed~~ in this delightful old place. I think I can safely include this in the above statement;

LETTER FROM BLUM TO CHASE, SPAIN, 1882.

LETTER FROM BLUM IN VENICE, 1885.

CARICATURES OF TWACHTMAN (left) AND CHASE (right) IN A LETTER
FROM BLUM TO CHASE, 1885.

We hope you are in good health.
Please answer - Splendid mild
and the air is cool especially
the washing water in the morning.
Where are you going next summer
oh yes I forget See you in Holland.
I didn't get your Christmas present
yet. What is it? You ought to see
the hat Frenchman wears. He
has his hair cut and looks like this,

Don't you think
so too! What!
What do you think
of pastels.
Hoping you are well
and in good health I
now lay down my
pen telling you that
I am the same and
hoping to hear from you soon
I remain your friend
write soon. -Bob Blum

LETTER FROM BLUM TO CHASE FROM VENICE, 1885.

Dear Will

I said I would write you another letter before I left but I haven't any thing of importance to communicate and so to fill up with Venetian news fell to telling you them pictorially — I'm off next monday or Tuesday and will go home with Mayer in the Pennland sailing the 3rd of Dec — If you have time and it don't bore you too much come down to see me off the ship — will you —

Good bye old fellow till then

Bb.

LETTER FROM BLUM IN VENICE TO CHASE IN NEW YORK, ABOUT 1889.

VENETIAN SKETCHES IN LETTER FROM BLUM TO CHASE, ABOUT 1889.

VENETIAN SKETCHES IN LETTER FROM BLUM TO CHASE, ABOUT 1889.

VENETIAN SKETCHES IN LETTER FROM BLUM TO CHASE, ABOUT 1889.

Tokyo Hotel.
Aug 18. 90.

Yes! I suppose it does Kind of make a man feel big — this raising a family — sort of im-

LETTER FROM BLUM TO CHASE, 1890.

I found Mr. J. H. Wigmore (the man who is to write two articles for Scribners.) very nice and Mrs Wigmore charming — both of that open kindliness that always wins my heart and they understood to make me feel very much at home. Mrs Wigmore who mentioned Miss Gill as a friend of hers tells me that she - Miss G. is expecting to come over here. There that is all I'm going to write and it will depend upon how you treat me whether I write you again!

Kiss Cosy and Robertin and my kindest remembrances to Mrs C.

My address at present will be
Tokyo Hotel
Tokyo
Japan.

LETTER FROM BLUM IN JAPAN TO CHASE, 1891.

INDEX

INDEX

INDEX

INDEX

CPSIA information can be obtained at www.ICGtesting.com
Printed in the USA
BVOW06*1054040716

454352BV00007B/50/P